J O S E F A L B E R S: A Retrospective

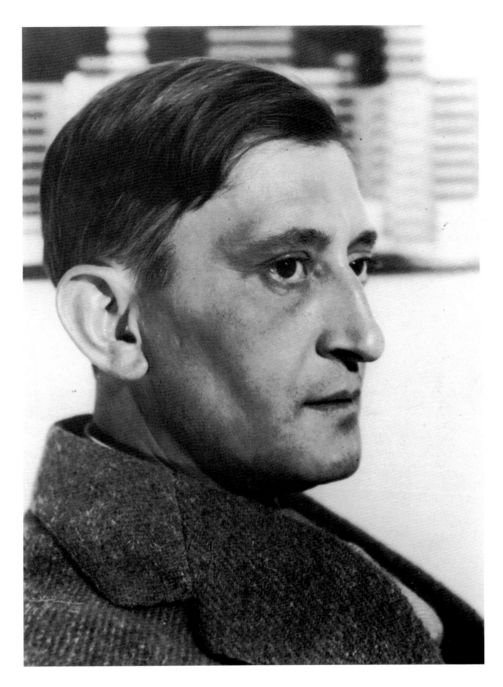

Albers in his Bauhaus studio, Dessau, 1928
Photo by Umbo

JOSEF ALBERS

A Retrospective

Solomon R. Guggenheim Museum, New York

Harry N. Abrams, Inc., Publishers, New York

1988

This exhibition has received grants from BASF Corporation and the Federal Republic of Germany.

Library of Congress Cataloging-in-Publication Data

Albers, Josef.

Josef Albers: a retrospective/Solomon R. Guggenheim Museum, New York.

p. cm.

Text by Nicholas Fox Weber et al.

Catalog of an exhibition held at Guggenheim Museum, New York, 1988.

Bibliography: p. 293

Paper ISBN 0-89207-067-6

Cloth ISBN 0-8109-1876-5

1. Albers, Josef–Exhibitions. I. Weber, Nicholas Fox, 1947-
II. Solomon R. Guggenheim Museum. III. Title.

N6888.A5A4 1988 709'.2'4–dc19 87-36930

Published by The Solomon R. Guggenheim Foundation, New York, 1988

"Josef Albers" by Jean Arp published by permission of Fondation Arp, Clamart

Cover: cat. no. 190, *Variant: Four Reds Around Blue*. 1948. Private Collection

for Anni Albers

Lenders to the Exhibition

Anni Albers

Bill Bass, Chicago

Ernst Beyeler, Basel

Mr. and Mrs. James H. Clark, Jr., Dallas

Esther M. Cole

Theodore and Barbara Dreier

Mr. and Mrs. Lee V. Eastman

Mr. and Mrs. Paul M. Hirschland, New York

Maria and Conrad Janis, Beverly Hills

Donald and Barbara Jonas

Don Page, New York

Maximilian Schell

Hannelore B. Schulhof, New York

Mark Simon, Connecticut

Andrea and John Weil, Saskatoon

Martina and Michael Yamin

Addison Gallery of American Art, Phillips Academy, Andover, Massachusetts

The Josef Albers Foundation

Josef Albers Museum, Bottrop, W. Germany

Australian National Gallery, Canberra

Bauhaus-Archiv, W. Berlin

Solomon R. Guggenheim Museum, New York

Hirshhorn Museum and Sculpture Garden, Smithsonian Institution, Washington, D.C.

Hollins College, Roanoke, Virginia

Louisiana Museum of Modern Art, Humlebæk, Denmark

The Metropolitan Museum of Art, New York

Musée National d'Art Moderne, Centre Georges Pompidou, Paris

The Museum of Modern Art, New York

San Francisco Museum of Modern Art

Staatliche Museen Preussischer Kulturbesitz, Nationalgalerie, Berlin

Wadsworth Atheneum, Hartford

Yale University Art Gallery, New Haven

Ex Libris, New York

Prakapas Gallery, New York

Table of Contents

JOSEF ALBERS

The beautiful pictures of our ugly age should be seen and read
with the eyes of a child.
The pictures of Albers are not only a treat for the eye but they also
convey meaning.
They grow in profundity as they are looked at with eyes
uncorrupted, and grasped penetratingly.
They are like the wood into which one calls and from which it echoes
as you are called.
Like nature they are a mirror.
Each of his pictures has a heart.
They never break into bits, crumble, turn into dust.
The are not castigated lashes.
They have a clear and great content:

> *Here I stand.*
> *I am resting.*
> *I am in this world and on earth.*
> *I do not hurry away.*
> *I won't have anyone harass and exasperate me.*
> *I am not a frantic machine.*
> *I am not faint-hearted.*
> *I can wait.*
> *I do not drive myself from the picture into the incommensurate.*
> *I do not drive myself into bottomless depth.*

Many of my friends and their pictures do no longer want to be here.
Neither friend nor picture have any longer an existence.
They want to go to the devil.
How one longs in their presence for an Albers.
The world that Albers creates carries in its heart
the inner weight of the fulfilled man.
To be blessed we have to have faith.
This holds also for art and above all for the art of our time.
Who would have forseen that our earth would be so led by our brain
to unbelief, to noise, to mechanical frenzy, to carefully recorded
raggedness, to teleguided disbelief.

JEAN ARP, Ascona, 1957
Translated from the German original by Anni Albers

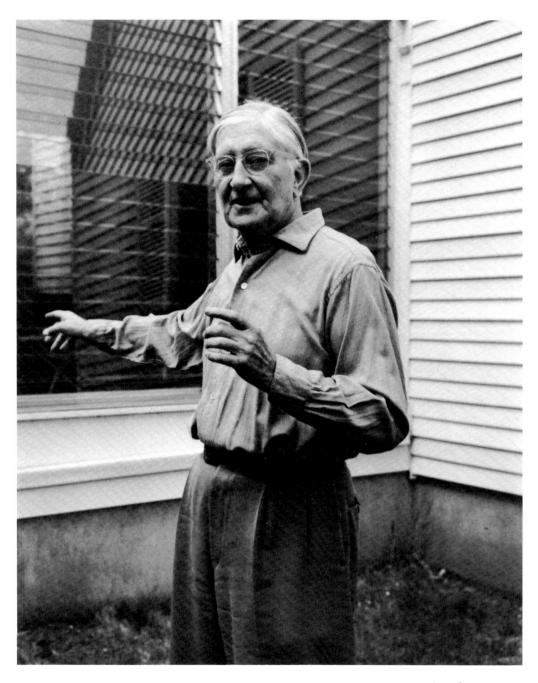

Albers at his home in New Haven, 1965
Photo by Jon Naar

Sponsor's Statement

BASF is pleased to be the corporate sponsor of the first major retrospective of the works of Josef Albers.

Upon his emigration from Germany to the United States in 1933, American artists had as yet little exposure to the advanced trends and ideas then current in Europe. Albers became their recognized champion in the New World. His achievements served as a major influence in the training of artists, architects and designers.

In later years, Albers's theories on light, color and perception influenced computer techniques, particularly in color control of videos. It can be truly said, as the noted art historian Werner Spies remarked, "He did not teach painting, but seeing: not art, but the psychology and philosophy of art."

As a company rooted in European pioneering of chemical synthesis, BASF is also accustomed to seeing the world in new ways. The company's innovativeness in science and technology has become well established in North America.

BASF is therefore proud to sponsor this unprecedented chronological overview of the rich and varied scope of Albers's work at the Solomon R. Guggenheim Museum.

JUERGEN F. STRUBE, Chairman
BASF Corporation

Preface and Acknowledgments

Josef Albers was the sum of many parts: painter, designer, teacher, theoretician. The first of several Bauhaus faculty members to come to America after that school closed in 1933, he came to Black Mountain College, near Asheville, North Carolina, to assume the position of professor of art. There he taught with his wife Anni Albers, the distinguished weaver and herself a Bauhaus graduate, and developed a curriculum that revolutionized art education in America.

In 1919 the architect Walter Gropius consolidated two separate schools of arts and crafts in Weimar to create the Bauhaus. Gropius was convinced of the need to abolish the distinction between fine and applied arts, an idea that had already been put into practice in the English arts and crafts movement and the Deutscher Werkbund. The nucleus of Bauhaus teaching was the principle that the architect, painter or sculptor should be soundly trained as a craftsman. To that end, the school was to be a practical workshop for design with emphasis placed on the study and use of materials. As George Heard Hamilton has noted:

> The curriculum was based on Formlehre (instruction in problems of form) which was arranged in three degrees, moving from Observation (the study of nature and analysis of materials) through Representation (descriptive geometry, techniques and constructions, etc.) to Composition (theories of space, color and design).[1]

A focal point of Bauhaus teaching was its preliminary course, which was initially developed and taught by Johannes Itten. Albers, who had come to study at the Bauhaus in 1920, was invited by Gropius to teach the preliminary course in 1923. In 1928 he took charge of the course.

As a result of the growing Nazi threat in Europe, a number of the figures associated with the Bauhaus emigrated to America and disseminated the principles of the school here: Gropius joined the faculty of Harvard University, László Moholy-Nagy founded the new Bauhaus (now the Institute of Design of the Illinois Institute of Technology) and Albers, as we have noted, went to Black Mountain College. Albers wrote in German in 1933:

> …the student should first become aware of form problems in general, and thereby become clear as to his own real inclinations and abilities. In short, our art instruction attempts first to teach the student to see in the widest sense: to open his eyes to the phenomena about him and, most important of all, to open to his own living, being, and doing. In this connection we consider class work in art studies necessary because of the common tasks and mutual criticism.[2]

For Albers these studies revealed: "On the one hand the intuitive search for and discovery of form; on the other hand the knowledge and application of the

fundamental laws of form…." And, as he also noted, "All rendering of form, in fact all creative work, moves between polarities: intuition and intellect, or possibly between subjectivity and objectivity. Their relative importance continually varies and they always more or less overlap."[3] In his own work Albers expressed the concepts that he set before his students.

Albers's continuing investigation of artistic absolutes led him to isolate the motif of the square and create his most rigorous format in 1950. The *Homage to the Square* series allowed Albers to present color in its infinite variations. As he observed in 1952:

> *The painter chooses to articulate with or in color. Some painters consider color an accompaniment of, and therefore subordinate to, form or other pictorial content. To others, and today again, in an increasing number, color is the structural means of their pictorial idiom. Here color becomes autonomic.*
>
> *My paintings are presentative in the latter direction. I am interested particularly in the psychic effect—esthetic experience caused by the interaction of colors.*[4]

In 1949 Albers left Black Mountain and in 1950 he became chairman of the Department of Design at Yale University. At Black Mountain he had invited a wide variety of artists to teach during the summer; at Yale he asked many distinguished artists to participate in the program as visiting critics. The dialogue that Albers encouraged at both schools was enhanced by artists whose work often differed radically from his own and contributed to the fame of each institution. At Yale, as at Black Mountain, he organized classes in basic design and supervised courses in drawing and color.

Albers's impact on painting, sculpture and design both as teacher and theoretician are undisputed. Many of his most renowned students, such as Robert Rauschenberg and Eva Hesse, who became important artists developed idioms at odds with Albers's aesthetic. Some students, most notably Richard Anuskiewicz and Julian Stanczak, directly adapted Albers's theories and methods of working to their own ends. The work of other artists like Donald Judd, Frank Stella and Sol Lewitt—indeed many of the Minimalists of the 1960s—owes much to Albers's theories and the example of his painting, engraved plastics and prints. Many differences notwithstanding, the Minimalist aesthetic, based as it is on the use of repetitive units, technologically advanced materials and relationships of highly simplified forms, is indebted to Albers's ideas. And today we are witnessing a revival of geometric painting, albeit in a new form, and it seems evident that Albers has had an impact on the young adherents of this style, among them Peter Halley, Ross Bleckner and Peter Taaffe. It is true that the utopian vision underlying the theoretical positions and work of Albers and other artists and architects of his generation may not be relevant in today's more cynical climate. Neverthe-

less, Albers's art remains as valid and vital as ever, a totality in and of itself, a starting point for younger generations of artists. Indeed the effect of Albers's influence may still be growing; he may be more than the sum of his parts.

This exhibition of Albers's lifework marks the centennial of the artist's birth and is the first comprehensive retrospective ever devoted to him. Nicholas Fox Weber, Executive Director of The Josef Albers Foundation and Guest Curator of this presentation, selected the works shown and contributed the main essay to the accompanying catalogue. We are extremely grateful to him for his enthusiastic and knowledgeable collaboration. Anni Albers, the artist's widow, offered us essential support and advice during all phases of the exhibition's organization. We acknowledge Kelly Feeney of the Albers Foundation for her valuable participation in the project. We could not have realized the exhibition and the present publication without the indispensable cooperation of the Albers Foundation, which shared important archival materials and made crucial loans available.

Our deepest gratitude is extended to BASF Corporation and the Federal Republic of Germany for their generous support on this auspicious occasion.

The scope of the catalogue has been greatly enhanced by the perceptive essays written for it by Neal Benezra, Mary Emma Harris and Charles E. Rickart. We would like to thank the many individuals at the Guggenheim Museum who worked on the project. Most central among these were Susan B. Hirschfeld, Assistant Curator, and Thomas Padon, Curatorial Assistant, who were actively involved in all aspects of the undertaking. Carol Fuerstein, Editor, and Diana Murphy, Assistant Editor, were responsible for the editing of the catalogue and seeing it through the press.

Many works in this exhibition have never before been shown. They shed new light on previously unknown or little understood aspects of Albers's career. We were therefore dependent on the enlightened generosity of the lenders, both private and institutional, of Albers's works. To all these lenders to *Josef Albers: A Retrospective*, we express our deepest gratitude.

DIANE WALDMAN, Deputy Director
Solomon R. Guggenheim Museum

NOTES

1 George Heard Hamilton, *Josef Albers—Paintings, Prints, Projects*, exh. cat., New Haven, Yale University Art Gallery, 1956, p. 13.
2 Quoted in Hamilton, *Josef Albers*, p. 25.
3 Ibid.
4 Ibid., p. 36.

13

The Artist as Alchemist

NICHOLAS FOX WEBER

I

To most people he is known as "the square man." For the last twenty-five years of his life Josef Albers made over a thousand of his *Homages to the Square*, paintings and prints in four careful formats that gave color an unprecedented voice. He called them "platters to serve color": vehicles for the presentation of different color climates and various color effects, above all for the demonstration of the way that solid colors change according to their positions and surroundings.

The *Homages* were quick to enter the mainstream of popular life. Simple yet poetic, they were clearly laden with significance. They became the subject of television specials; magazine articles in *Life*, *Réalités* and *Time*, as well as endless more specialized publications; the basis of cartoons (see figs. 1, 2); the core of the first one-man retrospective ever given to a major living artist at The Metropolitan Museum of Art in New York. One was reproduced on a United States postage stamp embodying the motto of the Department of Education, "Learning Never Ends." With their neutral format, free of history or connotations, not only did the *Homages* show aspects of color that had never before been seen so clearly, but they also became a symbol of artistic modesty and diligence. Rarely had a secular painter so completely suppressed his ego and personal psychology to embark on such a rigorous course of repetition in service of a single cause. But in fact he was not totally secular; although Albers may not have used known religious imagery, what he evoked through color is magical and intensely spiritual.

While Albers's reputation is based primarily on the *Homages to the Square*, he did not begin them until 1950, when he was sixty-two years old. His previous work was in much the same vein. From the start Albers had extolled visual nuance and mixed playfulness with formalism. *Still Life with Russian Box*, ca. 1914 (cat. no. 4), one of his earliest known oils, shares many traits with the *Homages*. Ideas that would eventually be the main point appear in their incipient form in this early painting. Solid colors are surrounded by solid colors. Darker ones make lighter ones look brighter yet. Broad planes have been foreshortened to intensify their impact; the shifts between them are abrupt and startling. Like the *Homages*, *Russian Box* presents a limited number of elements with the portent of high drama.

Here and in the roughly contemporaneous *Masks and Vase*, 1916 (cat. no. 5), Albers had already learned to go his own consistent way. In *Masks and Vase*, as in his much later series of linear geometric drawings called the *Structural Constellations* (see cat. nos. 171-176), he set a plane at right angles to the overall shape with uncanny effect. Again his later themes prevail—you're not sure what you're seeing; blacks and whites sharpen their teeth against one another; red looks one way in white surrounds, another in black. Moreover, the painting is unusual and haunting; it doesn't look quite like anyone else's. The subject and contortions conjure Nolde, Ensor and Picasso's *Les Demoiselles d'Avignon*; the background hints at certain *Blaue*

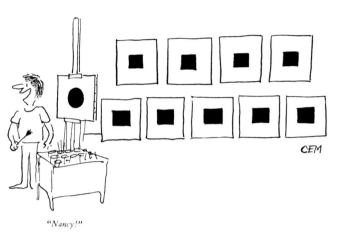

"Nancy!"

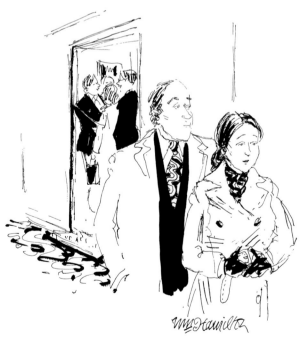

"Bach cantatas, Barcelona chairs, Albers prints, quiche—why do our new people always turn out to be like our old people?"

Reiter pictures; but above all there is something unique, a bit bizarre and mystical, going on here. Its painter may not have found his mature voice, but he had no lack of vigor or self-assurance, and he would freely distort his subject to reach his goals. These pictures relate to a degree to the art being shown at the time in Berlin, where Albers lived and studied between 1913 and 1915, but in their vibrant linearity and bold use of unmodulated colors, they reveal an independent, unusually feisty and spirited artist.

Albers was born in 1888 in Bottrop, a bleak mining city in the highly industrialized Ruhr River region of Germany. He was the son of a laborer, forever proud of the standards of craftsmanship that dominated his childhood. When asked late in his life about his working methods for the *Homages,* he would often explain that he always began with the center square because his father, who, among other things, painted houses, had instructed him as a young man that when you paint a door you start in the middle and work outward. "That way you catch the drips, and don't get your cuffs dirty." Albers revered his practical education and always stressed its preeminence over more esoteric influences that art historians tried to pin on him.

> *I came from my father, very much, and from Adam, that's all....I came from a handicraft background. My father knew the rules, the recipes, and he taught them to me too. He put all the electricity into our house. He could do the plumbing, glass etching, glass painting, everything. He had a very practical mind. I was exposed to many handlings that I learned to steal with my eyes.*[1]

Albers was proud that his mother descended from a line of blacksmiths. "To make a good nail for a horseshoe, it was necessary to have skill of the hand." That dexterity is evident in the entire range of his art, from the early oils through the *Structural Constellations* and *Homages to the Square.* The concern with effective methods and proper technique remained imperative to Lorenz and Magdalena Albers's son not only in his work, but also in his teaching, an area in

which he made some of his greatest contributions. In Germany at the Bauhaus, and in America at Black Mountain College and Yale University, he taught students that technical mastery was the imperative that must underlie all artistic endeavor. Whatever one's artistic bent, it was necessary to develop the ability to write one's name in mirror script, as well as upside down and upside down in reverse. Without skills of this sort, there was no more chance of success than there would be for a musician who could not recognize proper pitch and play scales, or an athlete who did not exercise and was not in shape. As a printmaker Albers would learn to manipulate woodblocks, study the application of lithographic inks and pursue virtually all modern methods; as a painter he would develop his hand so as to be able to apply paints straight from the tube, with a painter's knife, to abut one another without overlapping along clean-edged boundaries.

Albers had his early schooling in Bottrop and continued his education in other towns in the region, Nordrhein-Westfalen. In 1908 he graduated, at the age of twenty, from the Lehrerseminar (Teacher's College) in Büren, where for three years he had been trained as a teacher. His grades ranged from "sufficient" in French, musical harmony and gymnastics, to "good" in agricultural instruction, history and nature studies, to "very good" in conduct, diligence and drawing—fairly precursory of his future strong points. That same year he made his first visits to museums in Hagen and Munich, where he had his initial, crucial exposure to the work of Cézanne, Matisse, van Gogh and Gauguin.

Following his graduation from Büren, Albers held a series of positions teaching elementary school in small Westfalian towns and back in Bottrop. Then, in 1913, he went to Berlin to study the teaching of art for two years at the Königliche Kunstschule (Royal Art School). It was in Berlin that he began to think of himself as an artist. He produced a number of figurative oils (some of which have since disappeared) in addition to *Russian Box*, as well as some remarkable drawings. *Farm Woman with Kerchief,* ca. 1914 (cat. no. 1), the earliest drawing in this exhibition,[2] shows

the effect of the sort of drawing technique he must have observed in Dürer's work in the Kaiser Friedrich Museum in Berlin. Albers by this time could draw competently. He rendered the woman's profile and the details of her knotted scarf and bun with authority and freedom. The head reads as a complex and convincing sequence of curves. And there is ongoing motion here—between left and right as well as foreground and background—of the type that recurs frequently throughout the body of his work.

The approach of Dürer as well as Holbein is also evident in a self-portrait oil of about 1915 (cat. no. 3). Like these other Northern artists, Albers distanced himself from the subject even when it was his own face. When he made this painting of himself, Albers was in his late twenties—an age when self-obsessiveness is often extreme—yet he approached his own individuality with that same eye for generalized phenomena that marks his late color exploration. His attitude at the beginning was what it would be fifty years later; he took hold, becoming the one in charge rather than succumbing to the emotional sway of what he was presenting. This self-portrait puts us face to face with the image, unequivocally, making it a formal visual experience rather than any kind of biography, or—worse yet, from the artist's point of view—psychobiography. If the *Homages* were "platters to serve color," Albers looks like a soldier to serve art, his steely visage a vehicle for balance and symmetry. The painting is divided into four rather pale color zones, and, even if it is not as abstract and rigorous as the *Homages to the Square*, it is as definite in its formal organization.

Like the *Homages, Self-Portrait* juxtaposes upward and downward motion; the sloping shoulders succumb to gravity, while the head is elevated. The early painting is in this way a key to the humanoid character of those later abstractions. With their internal squares positioned low, the *Homages* are weighted toward the earth much as the human body is; with their ascendant upper parts, they, so-to-speak, have their heads in the clouds. We, too, place our feet on the ground, and then lift ourselves upward, both mentally and physically.

The diagonals formed by the upper corners of the squares within squares become arms outstretched in an endless reaching that seems to say that there is more here than meets the eye at first glance. This mix of a strong earthly base and a transcendent spirituality is a key to the fascination of all of Albers's work.

The drawings Albers did after returning from Berlin to Bottrop in 1915 suggest the serenity of going home after a time of restless experimentation. In style and content, these drawings of 1915-18 are a particular surprise to those who are familiar only with his later work. In their essence they are totally of a piece with it, in spite of the different nature of the subject matter. Visually articulate, they convey their themes with minimal, carefully chosen forms. Most of them abound in open space. There is no clutter: neither visual confusion nor personal psychology intrude. Or, from another viewpoint, what psychology there is is that of an artist who deliberately sought to keep his nonartistic sides at bay. At this time and ever after, Albers opted for a deliberate detachment: from history, from artistic trends, from personal experience. This cutting off did not pain him; to those who knew him well it was clear that his life as an artist was almost all that mattered to him. The tenor of his work did not alter in response to historical events or fluctuations in private or professional relationships. Connections between the character of his art and the state of his emotional life—the sort of links that exist between Picasso's various artistic phases and his tumultuous love-life—have no bearing. Emotional circumstances shed no more light on Albers's art than on the formulations of Einstein.

But the drawings are not cold. They suggest deep affection for what they represent. They are also full of grace and virtuosity. While bowing slightly in the direction of certain historical and contemporary styles, Albers kept his sights focused on his own objectives. Dexterous technique and true but economical evocation of the subject matter were of paramount importance. The high-spirited drawings of schoolgirls (see cat. nos. 16-18) are carefree in tone but present vital details—a foot sliding out of a wooden shoe, a head bent over a writing tablet—with precise articulation. In the drawings of animals (see cat. nos. 7, 8, 19-26), a few deft gestures of the crayon—almost as minimal as Albers's later arrangements of solid planes—capture quintessential birds, plump and preening; an imperious owl who meets us with all of his startling nocturnal force; the ultimate stocky rabbit. In all of them, white paper creates the vital masses. The trademarks of the artist—a simplification and intensification of detail, meticulous attention to the assemblage of elements—already shine. So does the almost mystical reverence for what can be taken in with our eyes.

What is curious, considering the quality of these drawings, is that he kept them secret throughout his life. While most of Albers's figurative prints from the same years were all later exhibited and included in publications,[3] all but a dozen of over a hundred figurative drawings were completely unknown, even to the scholars and critics with closest access to his art. But at least he saved them for posterity, in carefully marked folders. This exhibition is their first public showing.

While he was living and teaching in Bottrop between 1916 and 1918, Albers took courses at the Kunstgewerbeschule (School for Applied Arts) in nearby Essen. He did several series of linoleum-cut prints and lithographs there. Better known than the drawings, and somewhat similar to them, the linoleum cuts (see figs. 3, 4) have been linked to the work of many artists, including the German Expressionists and Delaunay.[4] They raise the question of the degree to which Albers's early visual vocabulary was dependent on the work of others. Viewpoints range from the artist's total denial of most influences to art historians' exacting claims. The art historian E. H. Gombrich, who writes about Albers specifically in *The Sense of Order* and implicitly in *Art and Illusion*, got to the essence of this question in a discussion we recently had. "There may have been a little bit of Zeitgeist there," but the idea of an often-mentioned connection to Expressionism, to the work of Kirchner and other *Brücke* artists, is "nonsense."

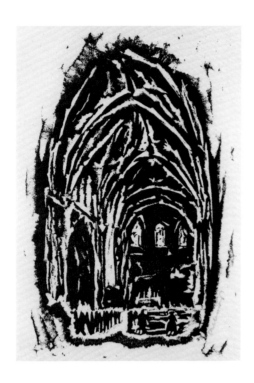

3 Josef Albers
In the Cathedral: Large Middle Nave. 1916
Linoleum cut on paper, 9½ x 6″
Collection The Josef Albers Foundation

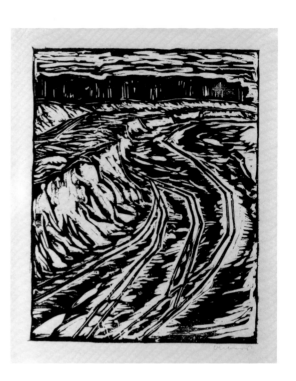

4 Josef Albers
Sand Mine I. 1916
Linoleum cut on paper, 11⅞ x 9⅜″
Collection The Josef Albers Foundation

Albers inevitably used aspects of the language of his time, but, whatever the slight superficial resemblance to the work of the Expressionists, he was far more controlled and far more personally distanced from his response to his subject matter than they. His primary concerns were with rendering the visual theme and exploring the materials of art. Gombrich addressed this second point as well: "You can submit to materials, which is the ideology of the truth to material. Or you can display your mastery in making the material submit to your will. Albers knew both."[5] These prints are intensely flavored by the tactile possibilities of the linoleum gouge—we practically feel the tool cutting through—as well as by the rich ink coverage. But the means are always in service of the neutral rendering of the subject matter: mine, nave or head.

The artists whose work seems to have affected Albers significantly by this time were Cézanne and the Cubists. In his personal chronology, which he often rewrote throughout his lifetime, he always listed as the pivotal event of 1908 his initial encounter with Cézanne's art in the Folkwang Museum in Hagen. By 1915 he had seen Cubist works in Berlin as well as through reproduction. From then on Albers took a new approach to the presentation of so-called reality and used planes to suggest movement. The technique of a ca. 1917 self-portrait drawing preparatory to a lithograph (cat. no. 15) distinctly reflects Cézanne's works and Cubist methods. Having sketched the right profile, mouth, eyes and a few other details with the point of his lithographic crayon, Albers then used its side to construct, very subtly, a sequence of adjacent

planes that describe most of the subject. There is vigorous planar movement and the use of blank spaces to define mass. The labyrinthine composition is completely legible. The artist would be exploring a similarly dynamic interaction of the picture plane and illusionary three-dimensional space fifty years later in both the *Structural Constellations* and the *Homages*. This self-portrait also shows one of the salient features of Seurat's drawings (although it is not likely that Albers knew them at this time, even in reproduction)–the use of the ridges of the laid paper to enrich, and give mystery to, the gray expanses.

As a teacher Albers was to emphasize the value of "maximum effect from minimum means." Some of the early lithographs and related drawings achieve just that. A large print and two study drawings of ca. 1917 for a series of lithographs illustrating the Chinese folk tale *The Green Flute* (cat. nos. 27-29) have the economy of means, the combination of exuberance and restraint, and the gentle, flowing movement of the best of Albers's later, abstract work. Oddly enough, they also anticipate Matisse's *Dance Movement* drawings of 1931-33 (see fig. 5). This is not a case of a direct development or influence, but, rather, of shared objectives: concentration, a simultaneous articulation and reductiveness, the restless life of line.

The drawings for the *Workers' Houses* lithographs of ca. 1917 (see cat. nos. 11-13) are equally free and convincing. With a sure sense of what to do and, almost as important, of what not to do, Albers made a few deft strokes with the point of his lithographic crayon and dragged and twisted it on its side to capture the street. The lower middle-class neighborhood of a bleak industrial city emerges for us. Albers used to claim that even one's spit was black there; the expanses of lithographic crayon become the soot itself.

On their own, these sweeps of crayon are free-wheeling abstractions. In context they make sky and buildings and road. That eye for context, the recognition that it is the juxtaposition of forms and of colors that matters more than the individual components, is a key to all of

5 Henri Matisse
Dance Movement. 1931-32
Pencil on paper, 10⅝ x 8¼″
Private Collection

Albers's art. So is his ability to impart a charm to a subject that, like a flat undifferentiated square or a dull brown hue, is not necessarily appealing. Perhaps through his remarkable neutrality–he was, after all, showing the sort of grim neighborhood where he had spent most of his life until that point, yet we have no sense of any details of his personal connection with it–he gave it a certain lightness. He was exactly faithful to what those streets and buildings were, yet at the same time he transformed them. What might depress, entices. This has to do with the artist's special and inexplicable sense of things. It is as if his deliberate distance and sturdy control of his situation–here as in the later geometric abstractions and color work–put him directly in touch with an enchantment hidden to others.

Easy—to know
that diamonds—are precious
good—to learn
that rubies—have depth
but more—to see
that pebbles—are miraculous.
 J.A.[6]

In 1918, when World War 1 ended, Albers had a chance to travel. He made drawings in some of the small towns of the Münsterland (see cat. no. 32), in Cologne and Würzburg, and in one case in the Sauerland, the region where his family originated and his grandmother lived. *Pine Forest in Sauerland* (cat. no. 33) is one of his most careful drawings. The dense, short strokes that form the distant background are opened up with larger intervals in the foreground: black and white have telling roles in distinguishing near and far. And white equals light; it becomes dappled sunlight on tree trunks and between leaves on the forest floor. Albers would respond to the different voices of black and white throughout his work. He would play them against one another, and allow each to perform in fullest force on its own. Here their interaction creates both matter and void. It is the basis of a living world that is at once airy and succoring.

In 1919 Albers went to Munich, to study at the Königliche Bayerische Akademie der Bildenden Kunst (The Royal Bavarian Academy of Pictorial Art). What he valued was the painting technique class he took with Max Doerner. He gave little credit to his study of painting and drawing with Franz von Stuck, with whom his future Bauhaus confreres Paul Klee and Vasily Kandinsky had worked over a decade earlier. He disliked Stuck's practice of having students draw from the figure, which as a teacher he eventually disavowed. ("They teach them in front of naked girls to draw. When they called me to teach at Yale, I saved them $7,000 a year for models.") Yet his drawings of nudes are impressive. He knew how to get the life and twist of the torso, and when to stop (see cat. nos. 37-

39). In a loose and free style, he could articulate the curves with total accuracy.

While he was living in Munich, Albers made some brush and ink views of the Bavarian mountain town of Mittenwald (see cat. nos. 34, 35). These exuberant drawings are the work of a man who was breathing deeply in the mountain air and who had the ability to turn the free sweeps of his brush into hills and buildings, into mass and void. The Bottroper gone south was feeling his power. So much so, that in little time he would have no problem giving everything up for a new place, new people and a radically different form of art. From here, he might go anywhere.

II

I was thirty-two…threw all my old things out the window, started once more from the bottom. That was the best step I made in my life.[7]

In Munich Albers saw the simple four-page pamphlet describing the new Bauhaus school in Weimar. The pamphlet had on its cover a woodcut by Lyonel Feininger of a Gothic cathedral that symbolized the integration of all the arts, and a statement by Walter Gropius, the founding director of the school, stressing proficiency in craft. Albers quickly arranged funding from the regional teaching system of Nordrhein-Westfalen, with which he was still affiliated, and headed to Weimar.

He had been a hometown schoolteacher and in his spare time a figurative artist; even when he had the chance to break away to the big cities to study art, he had worked within the accepted mode of representation. Suddenly he was an abstract artist. There was nothing he wouldn't try. He was in a different orbit, and the possibilities were endless.

Albers arrived at the Bauhaus in 1920, a year after the school had been founded. Once there, he assembled broken glass shards to extract a radical and startling beauty from them. He juxtaposed flat planes of wood in sharp geometry to make furniture that was boldly

and toughly functional. Later, after the Bauhaus moved to Dessau, he bent wood to create chairs that could be assembled in minutes and were as simple and elegant as they were portable. He designed an alphabet as different from traditional German script as the new aircraft from the Junkers factory near the Dessau Bauhaus were from a horse and buggy. He sandblasted glass to mirror-like smoothness and radiant tones, making art with no reference whatsoever to the known world, but with a power and energy all its own. He bent metal into fruit bowls and tea glasses whose shapes still look new sixty years later. In Dessau and in Berlin after the Bauhaus moved there, he taught an unprecedented approach to form and the possibilities of materials.

The Bauhaus opened new worlds to the young Westfalian. He danced at the festivals. He made friends from all over, eventually with some of the artistic pioneers of the century. He fell in love with and married a young woman from Berlin who had departed as radically from her childhood world (comfortable, tradition-bound) as he had from his own past.

The story of the Bauhaus has been told repeatedly. Josef Albers was there for longer than anyone else—from 1920 until the time of its closing in 1933. How much of his creative evolution and achievement of those years depended on what was intrinsic to Albers—and how much was realized because of the school itself—is impossible to determine. What is clear, however, is that as radical as his break was, he did not really, as he claims, throw everything out the window. Nietzsche wrote, "If a man has character, he has also his typical experience, which always recurs." As a draftsman Albers had already chosen to avoid ornament and use the most economical means; at the Bauhaus he continued along the same path. From the start he had played flat planes against illusions of three-dimensional space; now he explored that device in new ways. He had previously succumbed to the enchantment of the black-gray-white spectrum; now he investigated it further, abandoning the encumbrance of subject matter. If *The Green Flute* and other early works are, as Georges Duthuit said of his father-in-law Henri Matisse's drawings, "mirrors on which the artist's breath is barely perceptible—bel canto, without dissonance,"[8] Albers's work of the Bauhaus years also reveals little of the man himself and exalts technical finesse and visual harmony.

When he first arrived at the Bauhaus, Albers could scarcely afford materials. Documents in the town hall in Bottrop give voice to his extreme financial stress during those early years. Time and again he had to appeal to the regional teaching system to keep up his funding. He would periodically assure the officials that after just a bit more training at the Bauhaus he would return to his schoolteaching in Bottrop—a promise he clearly had no intention of keeping. The duress that might have been the dominant theme of another man's art became a source of beauty in Albers's. Unable to pay for paints and canvas, he went to the town dump not far from the Weimar Bauhaus, pickaxe in hand and rucksack on his back. He returned with glass shards that he assembled into works of art (see cat. nos. 40-43). What had been garbage became jewels. The discards of others were now arranged with care into balanced compositions that set up ongoing rhythms and interplay. Resurrected, the elements took on the life and dynamism they lacked when they lay on the ground. And light—the medium ever dear to the artist—penetrates the colors in full force. That light functions much as the copious blank spaces of the early drawings do, not only imparting luminosity but also creating an upbeat, positive mood. Years later, in the *Homages*, Albers would prime his panels with six to ten coats of white gesso to create light of the same sort, a neutral and generous ground that would allow colors to show themselves freely.

The Bauhaus masters told Albers he had to study wall painting. He refused. At the end of his second semester, Gropius "reminded me several times, as was his duty, that I could not stay at the Bauhaus if I persisted in ignoring the advice of my teachers to engage first of all in the wall-painting class." Albers, however, continued to work with bottle shards on flattened tin cans and

wire screens, and showed them in the required exhibition of his work at the end of the second semester. "I felt that my show would be my swan song at the Bauhaus....But soon thereafter I received a letter from the Masters' Council informing me, first, that I could continue my studies at the Bauhaus and, secondly, asking me to set up a new glass workshop for them. Thus suddenly I got my own glass workshop and it was not long before I started to get orders for glass windows."[9] Between 1922 and 1924 he did windows for the Bauhaus director's office in Weimar, the Otte and Sommerfeld houses—both designed by Gropius—in Berlin, the Grassi Museum in Leipzig and the Ullstein Publishing House in Berlin. All destroyed during World War II, the only records of these windows today are photographs (see cat. no. 45A,B). Vibrant and highly charged, their designs must have added a vivid sense of the new to the structures they graced.

———

Increasingly drawn to regularity and systematization, Albers soon organized his glass work with a rigorous geometry. *Grid Mounted*[10] of 1922 (cat. no. 44) depends, obviously enough, on a grid. Later he would elaborate on the grid in myriad ways, using it as the basis for highly refined compositions. But here it is plain and simple, with the resultant motion up and down and left and right. Albers had incorporated a checkerboard within his Sommerfeld house window; now the motif was sufficient unto itself. For *Grid Mounted*, he filed down glassmakers' samples to small, uniform squares which he bound together with fine copper wire within a heavy iron grill.

Checkerboards come and go as themes. They recur in ancient art and in American nineteenth-century hooked rugs. The Cubists had employed the motif in the early teens and Johannes Itten had used it as a teaching tool in the Bauhaus *Vorkurs* (preliminary course) between 1919 and 1923. Klee was to explore it extensively later in the decade. In any event, Albers's checkerboard has its own alchemy. Up front in material and technique, with the underlying units nothing more or less than a tradesman's selling tools, *Grid Mounted* has a celestial radiance. With his practical absorption and eye for the most effective means of making something happen—here the creation of vigorous movement through color juxtapositions—he achieved eloquent results. His first foray into the effects of pure, flat, unmodulated color—and his most carefully planned composition to date—it richly anticipates the *Homages* that came some thirty years later. This is Albers's earliest assertion that he valued squares in and of themselves.

Albers's new awareness of his own preferences contributes to the quality of jubilation in the piece. The artist had thrown himself into the making of *Grid Mounted* with the eagerness of one who had found his way. Having discovered the grid, what delighted him was to breathe life into it. In an ordered, regular world his imagination was boundless; those tied down squares of color are full of surprises, totally free-spirited without ever violating their boundaries. How like Albers himself, especially as he was later in life: the ultimate law-abiding, tax-paying, good citizen, his lawn neatly mowed, his bills promptly paid, who never hesitated, while obeying the rules, to dare the outrageous. *Grid Mounted* is euphoria within the confines of structure.

———

In 1925, after the Bauhaus moved to Dessau, Albers was made a master. He was among the first students to be so elevated. The appointment put him in a position to ask for the hand in marriage of Annelise Fleischmann, the weaving student with whom he was to share the rest of his life. In Weimar, in addition to working in glass, he had made furniture and taught practical workmanship to basic-design students. He continued all these activities in Dessau. Eventually he became head of the preliminary course and director of the furniture workshop; he also explored metalwork and graphic design.

It was in the medium of glass, however, that Albers's art was developing most fully. By 1926 he had turned completely from assembling shards and fragments to

using flashed glass. He invented a technique for sandblasting layers of opaque glass that were fused – or flashed – together (see cat. nos. 55-60, 62-66, 68-74, 96, 98, 99). He started with a sheet of opaque, pure white milk-glass coated with a hair-thin layer of glass in a second color: red, yellow, black, blue or gray. The front color was melted on by blowing the glass a second time. On top of it Albers placed a stencil cut from blotting paper; then he sandblasted with a compressed-air blower to remove all the areas of the surface that the stencil allowed to remain exposed. (Sandblasting enabled him to obtain sharper contours than would have been possible to achieve through chemical treatment with acids.) After removing the stencil, he generally added another color with paint (often a glass-painter's black iron oxide); finally he baked the entire piece in a kiln to make the paint permanent. There were variations on the process. Intense sandblasting would reveal the milk-glass background (see for example cat. nos. 73, 98); sandblasting for a shorter time would dull a top layer of black to produce a dark gray (see cat. no. 95). Sometimes Albers used more than one stencil on a single work.

Much as he would when he painted the *Homages to the Square,* the artist thrived on both the limitations and the possibilities of the program he had devised for himself. In America, at the time he was working on the *Homages,* he reminisced about the glass constructions in a way that stressed the links between the two bodies of work. "The color and form possibilities are very limited. But the unusual color intensity, the purest white and deepest black and the necessary preciseness as well as the flatness of the design elements offer an unusual and particular material and form effect." In glass he made constructions very closely related to one another, adding or deleting only one or two elements (line or color) to make variations in rhythm and movement (see cat. nos. 69-72). His careful probing of the multiple uses of the same stencil elements led to subtle yet bold permutations.

The sandblasting method enabled Albers to achieve the detachment he preferred and which he considered requisite for the optimal functioning of color and form; except in the painted parts of these compositions, the artist's hand is nowhere evident. Albers sometimes did not even execute the pieces himself. Rather, he designed them in his studio and had them made in a commercial workshop – in Leipzig when the Bauhaus was still in Dessau, and in Berlin once the school moved there.

The medium offered maximal intensity and sheen. Like cut jewels, the glass constructions are both radiant and pristine – and at a remove from everyday textures and substances. That quality and fineness of material emphasize the elevated status of art. "Instead of using colored glass to decorate, to create atmosphere, or to praise God, Albers isolated color from the effects of light, and glass from its architectural context, thus exalting color, man and machine."[11] It was one thing to use transparent glass for a stained-glass window to serve the idea of holiness – Albers had made such a window for St. Michael's church in Bottrop in 1916 – but to use this even bolder sort of multilayered glass for abstract art was a radical departure. It fixed abstraction into confident materiality. It gave heightened status to nonobjective form. Interlocking lines and solids were put on a par with religious imagery – deemed worthy of careful premeditation and exacting execution in a marvelous and mysterious substance generally used to treat miraculous events, the process of light passing through glass long having been seen as an analogue to the Immaculate Conception and holy radiance in general.

Albers was able to achieve light of a striking quality with the opaque milk-glass. It is, in fact, a light reflected off an opaque surface that gives the illusion of being light shining through a translucent medium. We feel as if the main light source is behind the object, whereas in reality it comes from the side that we are on (although back lighting can be an important secondary source). Albers outdid nature in these flashed-glass pieces. He used opaque glass to create an apparent translucency more powerful than actual translucency, and he made reflected light appear to be light coming from a direct source.

This is the sort of artifice he later explored in *Interaction of Color,* the book he published in 1963 which has influenced the study of art throughout the world. For centuries artists had tried to render light accurately, to capture the truth of its appearance in forms as various as the mirror-like surfaces of sixteenth-century Flemish painting or the fragmented impasto of Impressionism. Albers admired the ability of these earlier artists to control the appearance of light effects and to create illusions of luminosity. However, his concern was not faithfulness to nature but rather the taking of matter into his own hands and making something happen in art that would not occur in reality.

What results is a deliberate artificiality. The colors and light quality are as explicitly manmade, as distinctly invented and unrelated to the natural world as the arrangements of carefully ruled and premeditated shapes. His three versions of *Skyscrapers* of 1925 to 1929 (cat. nos. 64-66)—made with identical stencils on different types of layered glass—have textures and color tones unlike any in nature or, for that matter, earlier art. This is deliberate fiction, based on the latest technology. Like the *Homages to the Square* which are so blatantly dependent on manufacturers' paints and machine-made panels and were developed in laboratory-like conditions, it extols the unique capabilities of the most modern artistic methods. The artist has taken as much control as possible. In the earlier glass work, variables are at play in the irregularities of found glass and the changing nature of the light that passes through it. But now the artist has really taken the helm; nothing can alter; little is subject to chance. If Braque's and Picasso's Cubist collages, Schwitters's *Merz* pieces and the achievements of the Dada group all reflected the inherent vagaries of human life and depended to an overwhelming degree on the element of chance, Albers and many of his Bauhaus confreres wished to assert their control over their environment. Rather than assemble industrial detritus, they developed industrial processes for their own ends. With the magic of right angles and a carefully organized geometry, they show the unique and triumphant possibilities of a manmade, premeditated harmony.

The flat planes of the glass constructions relate to *De Stijl* and Russian Constructivism. *De Stijl* was in the air; Theo van Doesburg lectured at the Bauhaus. Albers, however, was not one of his admirers. "We had right away a clash…that cruel insistence on just straight lines and right angles. It was for me just mechanical decoration. So we came apart…no, better…we never joined."[12] There was some resemblance between van Doesburg's and Albers's work—Albers was clearly not averse to using straight lines and right angles—but he found van Doesburg's paintings, like much other geometric abstraction with which his own art has been erroneously linked, limited to the point of being empty. A closer connection is to Piet Mondrian, with whose work Albers certainly was acquainted at the time, and whom he came to know personally in America, where he invited him to exhibit at Black Mountain College. Mondrian's idea of "the living rhythm" achieved by a balance of properly proportioned lines and angles pertains to the full range of Albers's art from the glass works through the *Variant* series of the late 1940s and early 1950s and the *Homages.* So does his notion that "abiding equilibrium is achieved through opposition and is expressed by the straight line (limit of the plastic means) in its principal opposition, i.e. the right angle."[13] Albers never used the term Neo-Plasticism in reference to his own ambitions, but he adhered to some of its tenets, like the idea that "to be concerned exclusively with relations, while creating them and seeking their equilibrium in art and in life, that is the good work of today, and that is to prepare the future."[14] Those who knew Albers may question the perfection of his personal relationships—he did not exactly thrive on their inevitable variables—but time and again he claimed the link between moral behavior and the attributes of his own work. He saw his art as representing an ideal for the integration of the individual in society both in its tone and in the simultaneous independence and interdependence of its

forms and colors. He surely would have subscribed to Mondrian's view that "Equilibrium, through a contrasting and neutralizing opposition, annihilates individuals as particular personalities."[15] To be neutral rather than subjective, to voice universal truths rather than personal experience, was of pivotal importance to both artists.

———

The sandblasted glass constructions are based on the kind of planning and preparation that would mark Albers's work from then on. Never again did he allow spontaneity comparable to that of his early drawings to appear in a finished work. There are two possible interpretations of this development. One is that he was afraid of his emotions and sensuality. The other is that the allegedly cool art is as full of life as the figurative pieces.

What is certain is that from 1920 on Albers wanted his work free of reference to earthly life. (The only possible exception to this is his photography, but he apparently regarded this as separate from the rest of his art since he never showed it to others, referred to it or suggested that it be included in exhibitions or in publications.) In even the earliest pre-Bauhaus drawings, he had avoided the extraneous in favor of refinement and simplification; now he went further in his embrace of limitations and generalized form. It was a move toward absolutes, and toward the eternal.

The fundamental character of Albers's art was in ways constant and invincible, but its appearance and methods from 1920 on were a total departure. Geometric abstraction represented a total change for Albers, in keeping with the leap signified by his entire experience of the Bauhaus. He had come from a provincial working-class background; to break from it completely, he had to give up as much of what he had been before as he could. By taking up the new credo, and revealing nothing of his personal experience, he made it possible for the new world of the Bauhaus to be his. Through abstraction, people from all over and of diverse economic backgrounds came from the same place. Albers's mastery of the abstract idiom was his stepping stone: first at the Bauhaus, and then in America where it eased his transition to a new society by making him instantly a hero, and where it later led him to considerable financial well-being. The distancing of himself from his past, and subsequent turning to an unprecedented vision and methods, was his means of achieving freedom. The work, appropriately, looks like an awakening.

———

In a ship, what is so indispensable as the sides, the hold, the bow, the stern, the yards, the sails and the mast? Yet they all have such a graceful appearance that they appear to have been invented not only for the purpose of safety but also for the sake of giving pleasure.
CICERO[16]

Albers's achievement in furniture design, typography, architecture and metalwork is as dependent on the machine aesthetic as are the glass works. Here too are the cleanly honed edges and flat smooth planes of the flashed-glass constructions. Geometric forms respond to one another in precise arrangement. Aesthetic decisions seem to have been the result of a careful study of the technical possibilities of the material. They derive from formal invention rather than from any reference to the natural world or organic structures.

The work in other disciplines is less innovative than the glass pieces, but it nevertheless has its striking qualities. Essentially Albers worked in the current vernacular style in these realms, contributing to it his own eye for simplicity, purpose and scale. In view of what the people around him were doing, his accomplishment in typography, furniture, metalwork and architecture is not startlingly original; it does, however, represent considerable refinement of the contemporary idiom.

There were three periods in which he worked extensively with furniture: 1922-23, 1926 and 1928-29. In

Weimar in 1922-23, he made the magazine shelves and conference table, since destroyed, that are shown in this exhibition in vintage photographs (cat. nos. 46, 47). Albers designed them, along with some pew-like seats, for the reception room outside Gropius's office. The table and shelves resemble to some degree Marcel Breuer's Bauhaus furniture of the preceding two years. Yet Albers's designs are distinctive in both their relative airiness and their sureness of form. The voids have a sculptural richness. Planes interlock in crisp rhythm. The way in which elemental shapes embrace and respond to one another clearly betrays the painter's eye. And the pieces that he designed around 1926 for the Berlin apartment of his and Anni's close friends Drs. Fritz and Anno Moellenhoff (cat. nos. 53, 54) are wonderfully inventive and surprising in their juxtapositions of forms and materials.

The furniture design for which Albers is best known is his chair of 1929 (cat. no. 76).[17] It was made of units that could readily be assembled and dismantled and could fit into a tidy flat box for shipping. These pieces of bent laminated wood—veneers that had been molded around matrixes and glued—were as thick as they were wide. Over the years some fairly grandiose claims have been made for this chair: that it represented the first use of laminated bent wood in modern furniture and that the way it came apart and went back together was original.[18] Perhaps because Albers was a true innovator in the fields of glass and painting, people believed he was equally pioneering as a designer of chairs. However Heinz and Bodo Rasch, Josef Hofmann and other designers had already worked in bent laminates, and knock-down chairs had been made, and sold through catalogues, since the mid-nineteenth century. In form Albers's chair was very similar to ones made between 1924 and 1928 by Erich Dieckmann and to some of the tubular steel designs popular at that time. What does distinguish Albers's knock-down chair is the subtlety of its proportions and the perpetual flow of its gracefully modulated right angles.

A chair design of the preceding year (cat. no. 75) incorporates large squares, albeit with rounded corners; like *Grid Mounted* it shows Albers's early affinity for the form to which he later paid extended homage. The simple forms and relationships give the object a purity, and the contrast of its light and dark woods makes it quite elegant. Sitting in it, we think of many of Albers's attitudes toward life. We are held upright, ready to read attentively or talk alertly. We have an impression of firmness, of definition. The chair is not tough or hostile—the seat is cushioned, the wood smooth—but it will not allow us to slouch. While the supporting elements give essential structure, a cantilever causes a slight oscillation; the result is that like most of Albers's work, the chair is steady yet vibrant, grounded yet floating—at once earthly and fanciful.

In furniture as in glass, Albers moved from largely following the dictates of the material to manipulating it to suit his will. In the first furniture designs the dimensions of the available lumber, like the broken bottle fragments in the Weimar dump, had the upper hand. He arranged, rather than transformed, them. But in the later chairs he bent and molded wood in much the same way that he sandblasted multilayered glass, respecting the intrinsic properties of the material but taking charge of it in a new way. The attitude toward material that he had developed in these two disciplines by the end of the 1920s was to characterize his work forever after. The *Homages to the Square* explicitly honor paints straight from the tube, each listed with the manufacturer's name on the back of the panel in a way that shows unusual reverence for the tools of the trade. Yet despite this meticulous listing and the almost scientific method of application, the paints in the *Homages* seem incorporeal and metaphysical: they become light, atmosphere, mood. Ironically, it is the apparently methodical application of the medium that facilitates the attainment of this spiritual quality. Albers felt that to revel in impasto, to succumb to the sensual properties of the medium, would have emphasized his own physicality and personal feelings and been detrimental to the expression of the cosmic and other-worldly dimension. Similarly, in his furniture, he polished that plain, uncarved wood, and

avoided blemishes and accidents, to create form that seems almost ethereal while at the same time offering considerable physical comfort.

Albers used his chairs in a design for a hotel living room that represented his one known attempt at space planning (cat. nos. 92, 93). Although it was reproduced in three different publications in the early 1930s, neither this design nor Albers's drawing of 1926 for two shops for the Ullstein Publishing Company (cat. nos. 51, 52) have until now appeared in the literature on the artist or in any of his exhibitions. He designed the hotel room for the 1931 Bauausstellung (Building Exhibition) in Berlin. It was assembled on the second floor of the house that Ludwig Mies van der Rohe built for that exhibition. The room spoke in the voice of the day, but with its own fine proportions and openness of form. And it included one particularly ingenious touch: on the wall, Albers had placed a map of the city of Berlin, so that visitors could find their way.[19] One wonders why this is not always done in big city hotels.

The Ullstein shop designs, meant to be built in the area of the Kurfürstendamm in Berlin, point to a fascinating and unknown side of the artist. We know very little about them, except that they were reproduced in the 1927 publication *Offset* and that Anni Albers's mother was an Ullstein, the daughter and sister of the men who owned the large publishing house. The shops were never built, and there is no record of them other than the reproductions and an accompanying text citing Albers's intention that window shoppers should be both attracted and protected. The shop designs look, even today, like something out of the future. They have the adventurousness and imagination, as well as the total disregard for tradition, that characterized the Berlin of their epoch. It is unfortunate that we have no record of their actual plan and the technical details, except for the lettering for their signs, which is from the alphabet Albers designed in 1926 specifically for outdoor use.

That alphabet, which Albers called his *"Kombinationsschrift"* (cat. no. 50), was based entirely on permutations of circles and rectangles. Here, as in his chair designs and his later painting, he restricted himself to the bare minimum of underlying units. The result is that the letters were easy to construct; ten types of pieces—circles, rectangles and combinations of the two—were all that was required. While the design is not completely unique—it relates closely to other Bauhaus typography and stencil lettering—it is unusually practical and has an appealing aesthetic unity. Albers later explained that "these forms were combined in a way that did not collect dust or water or both, and thus [were] for outdoor use";[20] he had carefully worked out the arrangements so that there were no upward facing concavities into which leaves, snow or other elements might fall. In addition there were openings to facilitate drainage. His goal was to outsmart nature.

Albers also designed a fruit bowl and tea glasses (cat. nos. 48, 49A,B). In its use of a shiny stainless-steel framing element with a simple flat ebony handle supporting a thin glass vessel, the tea glass, designed in 1926, was very similar to one that had been made three years earlier at the Bauhaus by M. Krajewski and W. Tümpel. As with the chair, Albers broadened and simplified a known form. His tea glasses are more restrained and elegant than their predecessors, thanks to their use of fewer forms in more graceful proportion. And the delicate juxtaposition of absolutely minimal elements makes the fruit bowl especially striking.

———

At the Bauhaus Albers had continued his technical explorations and further refined his eye. Eloquence and simplicity of composition are consistently apparent in his work of the period. But around the year 1930 he also immersed himself in visual mischief. For example, he pursued the creation of illusory transparency—a theme he would treat in *Interaction of Color*. In works such as *Flying*, 1931 (cat. no. 94), he gave the false impression that forms overlapped and that one was visible through the other. He did this by finding the precise tone that would have been created if these

shapes were transparent and superimposed. It thrilled the artist to find that art provided experiences that nature could not offer.

Albers also developed forms with multiple, apparently contradictory readings. Two-dimensional imagery offered possibilities unknown in three-dimensional reality, and so we get the ambiguous cylinders of *Rolled Wrongly*, 1931 (cat. no. 98), and the complex interplay of the flashed-glass piece *Steps* of the same year (cat. no. 96). In *Steps*, the larger steps to the right clearly move upward and away to the right; however, the smaller steps first appear to recede upward to the left, then upward to the right, and then to go up half way in one direction and reverse. With their distinct movement in a single direction, the large steps are an effective foil to the more ambiguous course of the smaller ones. That image of the smaller steps, related to both Gestalt psychology and the art of M.C. Escher, would always remain important for Albers. Believing that the original glass construction had been destroyed after he left Germany, he re-created it in oil in 1935, and had it reproduced in screenprint in his retrospective portfolio *Formulation: Articulation* in 1972. The many possible readings of the left-hand flight of stairs continued to fascinate him, and he repeatedly republished his writing about it. *Steps* is included in much of the literature on Albers, generally with the information that the original glass construction was destroyed. That original has now reemerged, and is included in this exhibition.[21] Many qualities are apparent in the glass piece that are not clear in either of the later versions. For one, the chameleon-like life of the smaller flight of the steps is more effective in the glass construction than in the other mediums. In addition, the original is remarkable in its textural variations: the sheen of the jet black plays against the slightly pebbled surface of the more matte, grayer black; that lighter black, while carefully machined and constant when viewed close up, is full of atmosphere and takes on a white bloom when seen at a distance. The gray is altered ad-infinitum as a result of its adjacency to the white. Hence *Steps*—like many of the *Homages* a three-color composition—uses three solid colors to achieve the impression of more than three. This glass construction shows the enormous life that Albers could wrest from three colors and simple forms, and the richness with which he could imbue black, white and gray.

Albers continued to investigate the black-gray-white spectrum in some of the *Treble Clef* works of 1932 to 1935 (see cat. nos. 100-105). The forms in each of these grisaille paintings are almost identical, but rhythm, motion and direction all change according to the placement of monochromatic tones. At around the same time Klee and Picasso, in such works as the latter's *The Milliner's Workshop* (fig. 6), were also exploring the effects of light and dark hues in the black-white spectrum on spatial motion—an issue that had already intrigued both of them previously. Albers ventured into the realm of this spectrum in a very different way in his photographs and photo-collages (see cat. nos. 77-91). Dexterous and unerring in yet another medium, he manipulated light and dark powerfully and articulately in these works. The photographs are rich in linear rhythm and abstract qualities, and the photo-collages juxtapose related images dramatically. At the same time the photographs further indicate the strength as a portraitist and representational artist which Albers revealed in his earlier paintings, drawings and prints.[22]

———

At the Bauhaus Albers formed many of the most significant personal relationships of his life. Foremost was his marriage to Anni; they remained together until the artist's death in 1976. For over fifty years the two shared an abiding faith in the pervasive power of art, and a reverence for materials and technical proficiency (Anni Albers became known as one of the major weavers of modern times). They developed a modest and functional way of life geared above all to their work. Intensely moral in their work standards, humble yet confident, they were like a two-person religious sect. Particularly during the Bauhaus years, their art bore a strong mutual resemblance—a point that has led

to endless conjecture as to who influenced whom (fig. 7). Later it diverged in very different directions, but the work of each was always marked by real innovation and a reverence for geometric abstraction. The grid, its prevalent rightness and order, was part of their shared creed.

Albers also became close to some of his other fellow students at the Bauhaus, especially Breuer and Herbert Bayer, with whom he later maintained connections in the United States. His relationship with Gropius remained significant for him until the 1960s, when he designed murals for several of the American buildings designed by the first Bauhaus director. And while he had little taste for the work of Itten and László Moholy-Nagy, he deeply respected both Klee and Kandinsky, with whom he continued to correspond warmly after the Bauhaus closed in 1933. Klee and Kandinsky, along with Mies van der Rohe, were the

7 Anni Albers
Untitled Wall Hanging. 1925
Silk, 102 x 40″
Whereabouts unknown

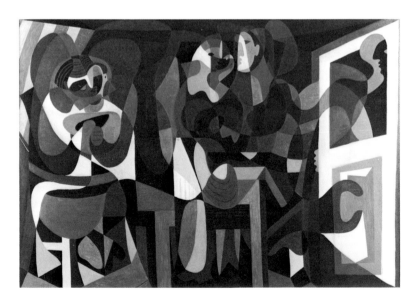

6 Pablo Picasso
The Milliner's Workshop. January 1926
Oil on canvas, 67¾ x 100⅞″
Collection Musée National d'Art Moderne,
Centre Georges Pompidou, Paris

people with whom Albers carried on his most profound exchanges about the processes of art.

Albers was one of the most experimental teachers at the Bauhaus. The students in his preliminary course say that it influenced them irrevocably. In it he stressed the manipulation of materials, particularly the folding and cutting of paper to create astounding plastic effects. He encouraged students to work creatively with cardboard, wire mesh, newspaper, ribbons and other substances not formerly thought of as belonging to the realm of art. The goal of the course was to develop both dexterity and imagination. Albers's own artistic achievement demonstrates the extent to which he realized the directives of his teaching.

———

In 1932 the city legislature of Dessau, dominated by the Rightist Radical party, voted to dissolve the Bauhaus, of which Mies van der Rohe had become director in 1930. The school moved to Berlin, into a building that formerly housed a telephone company. It was, however, the city of Dessau that continued to pay faculty salaries, because the courts had deemed that the city's contract with the masters had been terminated prematurely. On June 15, 1933, the *Oberstadtinspektor* of the Dessau City Council wrote Josef Albers a letter in which he stated:

> *Since you were a teacher at the Bauhaus in Dessau, you have to be regarded as an outspoken exponent of the Bauhaus approach. Your espousing of the causes and your active support of the Bauhaus, which was a germ-cell of bolshevism, has been defined as "political activity" according to part 4 of the law concerning the reorganization of the civil service of April 7, 1933, even though you were not involved in partisan political activity. Cultural disintegration is the particular political objective of bolshevism and is its most dangerous task. Consequently, as a former teacher of the Bauhaus you did not and do not offer any guarantees that you will at all times and without reserve stand up for the National State.*[23]

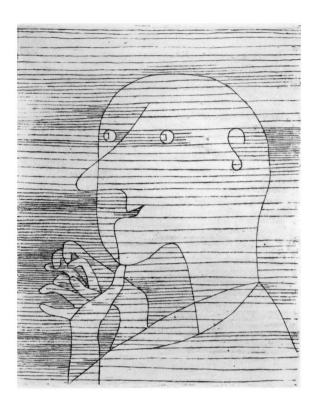

8 Paul Klee
Old Man Figuring. 1929
Etching, printed in brown-black, plate 11¾ x 9⅜"
Collection The Museum of Modern Art, New York. Purchase

The *Oberstadtinspektor* informed Albers that he would no longer receive a salary. On July 20, as a result of increasing harassment from the National Socialists, the Bauhaus faculty, at a meeting in which Albers was one of seven participants, voted to dissolve the school. Mies van der Rohe notified the Gestapo accordingly.

At age forty-five Albers was without a job. As a pioneer modernist in Nazi Germany he had little hope of finding one. Married to a Jew, he must have feared a bleak future. Yet his art of the time was as unruffled as his life was tumultuous. The prints he made in 1933 (see cat. nos. 106-108) bespeak the serenity Albers must have lacked but craved. To look at *The Sea* (cat. no. 107) is to feel the role of art as a source of personal

equanimity through technical absorption. Albers first applied a soft linoplate to a wooden backing, and then incised a continuous curve into it before using a chisel to remove strips of the linoplate on either side of that curve to reveal the rich wood grain underneath. The processes of art, and the power of their result, were the mainstay that assured Albers's survival, physical as well as emotional. His sense of his own identity was impervious to crisis.

There was something increasingly international and timeless about Albers's art. The forms were familiar to many cultures in ancient as well as modern times. If the early linoleum prints were in ways identifiably German, and the first oils characteristically of an epoch—both in their subject matter and their relationship, however tenuous, to Jugendstil and Expressionism—*The Sea* speaks less clearly of place or era. This universality, as well as many of its visual elements, link it to Klee's *Old Man Figuring* of 1929 (fig. 8), which similarly juxtaposes slightly irregular horizontal lines of varying thickness to larger and more precise undulating curves. In both prints the interplay creates a complex visual diversion, and blends levity with serenity.

III

For both Anni and Josef Albers, art offered opportunities for a balance and repose less certain in the real world; it was an antidote to the pressures of everyday living. The emotional detachment from their locale was to make transmigration to another society relatively easy. In the summer of 1933 the American architectural student Philip Johnson, who had met Anni and Josef and seen their work at the Dessau Bauhaus, visited their Berlin apartment. He asked if they would like to go to America. Without giving it more than a moment's consideration, they answered yes. Six weeks later, Josef received a telegram from Johnson asking if he would like to teach art at a new and experimental college being formed in Black Mountain, North Carolina. The founders of Black Mountain had approached Johnson in his office at The Museum of Modern Art in search of the name of a teacher who could make art the focal point of the curriculum, and he had immediately suggested Albers. There would also be an opportunity for Anni to give instruction in weaving.

The Alberses had no idea where North Carolina was; at first they thought it might be in the Philippines. But they cabled back their acceptance, with the warning that Josef spoke no English. The reply from the Black Mountain faculty was to come anyway. And so began the process of obtaining passports and visas, all of which they felt went surprisingly smoothly. (Unknown to the Alberses at the time, the procedures were expedited by the Committee to Rescue German Artists, a newly formed group of affluent Americans already aware of the realities of Nazi Germany.)

Anni and Josef Albers arrived in Black Mountain, North Carolina, in November 1933, just in time for their first American Thanksgiving. They quickly and easily took up the teaching and making of art. Language, however, was a problem. At first Albers taught with a translator at his side. After several weeks Anni, who as a child had had an Irish governess and therefore spoke some English, sat in on one of his classes. She noticed that the translator, whom she suspected of Nazi sympathies, was making Josef sound far more Teutonic and dictatorial than he actually did in German. She convinced him to go unaided. Since Josef felt that the essence of his teaching depended on visual demonstration more than words, this did not pose major problems for him. At least he knew the new tongue well enough to state his teaching goal with succinct clarity – "to open eyes." These words were to remain a personal credo of his aims as an educator.

Anni took it upon herself to teach the new language to her husband. Sometimes the results were dubious. Once, when the two were walking in farm country near the college, Josef saw the word "pasture" on a signpost and asked his wife what it meant. "That is perfectly clear," she replied. "It is the opposite of future." But in spite of the rough start, both Alberses were eventually to lecture and write books in English with vast success.

The language of art was less troublesome. Albers produced a print series (see cat. nos. 109-111) with a publisher in Asheville that was very similar to one (see cat. nos. 106-108) he had been working on in Berlin when the Bauhaus closed. When the Berlin and Asheville prints were shown in Italy at the very end of 1934, Kandinsky wrote in the preface to the catalogue that accompanied the exhibition, "These beautiful sheets...reflect all Albers's qualities: artistic invention, clear and convincing composition, simple but effective means: and finally a perfect technique."[24] The work embodies points that had become central to Albers's teaching and which he articulated in a lecture published at the Bauhaus in 1928. "An element plus an element must yield at least one interesting relationship over and above the sum of those elements."[25] Thus in *Wings* (cat. no. 109), there are not only the left- and right-hand configurations, but also the constant interplay between the two. The viewer becomes engaged in a game of opposites. Is the rectangle on the right the negative of the one on the left? Why do the horizontal stripes on the left appear to be white on black and those on the right black on white? What is the nature of the strange attraction between the two bodies, which resembles the forces exerted against one another by two magnets? Relationships of forms are as essential to these prints as are relationships of color in the *Homages to the Square*. "Frugality leads to emphasis on lightness....In any form, nothing should be left unused," Albers also wrote in that 1928 essay.[26] In the economical *Showcase* (cat. no. 111) essentially all we see are two rectangles—one with its corners flattened—and a third configuration in which a single line is contorted to create two interlocked beings that appear to lean into one another. There is no gravity here, either physical or emotional. The larger rectangle appears to elevate the whole configuration, the second one to hold it down so that everything does not float heavenward. We read the composition as chambers within chambers, as a stage, as comedy. A few thin lines, carefully positioned, provide endless entertainment.

Like his earlier glass pieces and the later *Homages*, the paintings Albers executed during the first years after he arrived in America (see cat. nos. 112-117) revel in the power of pure, undiluted color. They seem far more carefree and improvisational, with their rougher textures and forms, than the preceding works, but like the earlier pieces they present solid areas of pigment—in abstract, nonreferential shapes—that are kernels of energy. This new work reveals nothing of the uncertainties of the artist's life; rather it makes paint and panel a source of high spirits. In spite of the appearance of randomness in these paintings, their positive mood is always the result of conscious decisions. The untitled abstraction of ca. 1940 painted on an RCA Victrola top (cat. no. 115) demonstrates the precise approach that characterizes even Albers's seemingly offhand work. Like the forms in so many of Albers's two-figure paintings of the thirties and forties (see cat. nos. 126-128, 134, 140), the two cloud-like central bodies have been conceived with great care. Their colors accentuate their personalities. The jaunty pink suits the tall and rangey one; the green, somehow a more settled hue, is perfect for the stockier, more compact shape. The relationship of these bodies elucidates Albers's point that the sum of one plus one in art can, in fact must, exceed two; the tense void between the two forms is as interesting as the forms themselves.

Albers was at Black Mountain College from 1933 to 1949. In a world in which oppression was spreading, he had come to a haven for freedom and relative tranquility. This was his typical move. In a hierarchical, class-conscious Germany he had found his way to the Bauhaus, an island of intellectual and social experimentation. Now, with totalitarianism overcoming his homeland, he had arrived in a pocket of America free from most of the restrictions of conventional middle-class society. Albers's freedom did not come just from physical place, however; his independence above all derived from his own character. In the 1950s he easily, and with total awareness of what he was doing, distanced himself from the multiple pressures of academia at Yale and of the New York art world to go his own route. Luck, along with an intense determina-

tion to shape his own destiny, enabled him always to make his life and work exactly what he wanted.

Mary Emma Harris's essay in this catalogue describes Albers's role as an administrator and teacher at Black Mountain College, where he was a pivotal figure, the drawing card for great numbers of students and visiting faculty members. During his years at Black Mountain not only did he become one of the two major art teachers in America (the other was Hans Hofmann), but he also peaked in his adventurousness and diversity as a painter and printmaker. His work from this period reflects the freedom of his surroundings and the power of his own imagination. He took straight lines and geometric forms further than he had at the Bauhaus (see cat. nos. 118-122, 135-137, 146). He showed geometry to be at once clear and rational and a source of mystery and ambiguity. He made precise shapes that offered multiple readings. He was like a laboratory chemist who, for all of the exactitude of his measurements and purity of his elements, delighted most of all in some inexplicable alchemy.

In a remarkable group of drawings from 1936 (cat. nos. 119-122), which are exhibited here for the first time, planes shift and fold in contradictory ways as we look at them. The flat pieces of white paper begin to take on as many facets as a prism. The thin, lilting lines suggest that Albers was reaching for something, moving into the unknown. We enter the process with him. Standing still, we constantly change our viewpoint. We gain and lose surfaces, feel volumes grow and then collapse. The work has a questioning look to it and invites our musing. So does a sequence of paintings of the late 1930s and early 1940s (see cat. nos. 133, 166). Here geometric forms interlock in ambiguous ways, alternately appear to be transparent and opaque, and rapidly shift their location from foreground to background. We cannot quite pin the movements down, or understand how they coexist with the potent stillness that dominates the compositions.

Janus, 1936 (cat. no. 146), exemplifies the kind of double imagery that increasingly preoccupied Albers

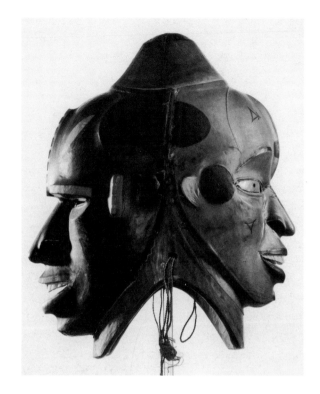

9 *Janus Helmet Mask*
Nigeria, Anyang or Keaka
Wood, leather, paint and other materials,
20⅝″ high
Collection Staatliches Museum für Völkerkunde,
Munich

in the late 1930s and early 1940s. The Staatliches Museum für Völkerkunde, which Albers almost certainly visited when he lived in Munich in 1919-20, seems the only likely place for him to have seen actual Janus heads, as opposed to reproductions of them. A Janus-face helmet mask acquired by the museum in 1903 (fig. 9), shows remarkable similarities to Albers's painting. Both mask and painting contain individual elements that are distinctly separate and unified at the same time. The mask offers two independent angular profiles that of course belong to the same head. They simultaneously appear to jut away from that head and to be contained by it, to be linear and jagged yet part of something massive and round. Similarly the lines of Albers's *Janus* move with power and certainty away

10 Josef Albers
Study for "Bent Black A" (detail).
ca. 1940
Pencil and oil on paper, 24 x 19″
Collection The Josef Albers
Foundation

from the main elements of the composition while being centered by it and dependent on it. Movement outward and inward occurs at once, and there are both lightning-like bands and large central masses. And in mask and painting alike the contrast of white and black is as strong and deliberate as the play of mass against void and edge against bulk.

Three variations on a theme – *Bent Black A* and *B*, both 1940, and *Bent Dark Gray*, 1943 (cat. nos. 135-137) – represent the earliest instance of Albers's deliberate use of equal quantities of different colors in a single composition. This intent is apparent in the pencil notation on an oil on paper study for *Bent Black A* (fig. 10). Here Albers has carefully worked out the composition so that there are precisely forty and one-half square-centimeters of each color: the black, the dark gray, the white and the light gray border. This strict system serves a number of purposes. For one, it sets forth restrictions of the sort Albers enjoyed imposing on himself. He felt that tough rules, like the poet's sonnet and the composer's sonata, by their very nature imparted harmony to the end results. He did not expect viewers to read the system precisely, but, rather, to gain a sense of order and regularity through it. Additionally, the use of equal amounts of different pigments demonstrates an important point about color, which would become a central theme of his *Variant* paintings. Albers

asked people what color they felt they saw in greatest quantity in these works. He was pleased to get different answers; there was no right or wrong response, for everything depends upon individual perception. One person sees more black, another more white. The point is that although there are equal quantities of each, the properties of the white or black themselves give the viewer an erroneous impression. This was what Albers called "the discrepancy between physical fact and psychic effect," the demonstration of which was an imperative of his art.

Albers used a grid for these compositions in which he strictly apportioned color. The notations in the studies for *Movement in Gray*, 1939 (cat. no. 133), show the premium he placed on schemata, and how important it was for him to be the master of the destiny of the picture. For *Penetrating B*, 1943 (cat. no. 165), he made both a full-size hand-drawn grid and smaller drawings in which he tested different widths and angles before determining the final measurements. Control – perhaps in all of its negative as well as positive associations – is at the root of all Albers's art.

Despite his careful forethought, Albers did not eschew a degree of spontaneity. Having charted his course, he would occasionally succumb to an on-the-spot intrigue with paint and surface, which might produce unusual textures that could never have been planned in ad-

vance. The results of such spontaneity are apparent in the nature of the paint coverage in works like *Penetrating B*, whose tidy shapes, by virtue of their internal textures, encompass a mysterious, unfathomable sea. A precise framework yields the infinite.

Equal and Unequal, 1939 (cat. no. 134), is another work in which Albers deliberately pursued ambiguity. It seems no accident that this is the painting that Anni Albers has, at least for the past fifteen years, chosen as the sole art work in her bedroom, where she faces it for hours on end. In many ways the picture is analogous to the Alberses' marriage as well as to other close two-person relationships—a point supported by its title. Two independent, freely floating shapes appear both to attract and resist one another. These very similar beings remain separate, each powerful in its individuality, yet at the same time seem drawn toward one another by strong, inexplicable forces. It looks as if highly charged, invisible rays of energy cross the void between them. Anni Albers says that the painting has never failed to elude her; however many times she tries to grasp the connections between the two forms, she loses whatever system she first reads.

———

Throughout the late thirties and early forties Albers used identical formats to present different color combinations, as he had done with several of the glass constructions and the *Treble Clefs.* The changes in color affect both the internal rhythms and the emotional climate of the compositions. In the three versions of *Open* of 1940 (cat. nos. 142-144), very slight proportional variations are accompanied by particularly subtle color permutations. These are among Albers's early forays into making flat expanses of unmodulated color appear to be intersecting planes. They are weightless and light-touched, like four other paintings from 1940, *Growing, Layered, Tierra Verde* and *To Mitla* (cat. nos. 138-141). In the flow of their forms, their use of color to make movement and their vague reference to natural phenomena, these four pictures again recall Klee's work. They show Albers

could get everything right without using a rigid format. Here his combination of thoughtful articulation and apparent insouciance reached its apogee.

———

At Black Mountain Albers often had his students use autumn leaves to investigate the importance of position, considering both the way that the individual leaves change according to their relationship to other leaves, and the effects of cut-paper backgrounds on these leaves. In his own leaf studies of ca. 1940 and 1942 (see cat. nos. 147-151), which have never before been on public view, leaves appear to dance, float, fly and swim. Position and adjacency are shown to be laden with possibility. In a collage that is oddly like a painting by Magritte, two leaves are in front of a background that explicitly represents sea and sky, and inanimate objects become majestic presences (cat. no. 150). Albers has painted a sort of shadow box effect alongside the leaves so that they appear to be in relief and tilted toward one another, jauntily conversing through the elegant void that separates them. Their wings spread, they look as if they can soar through space. Here as in much of Albers's work of the period, the imagery of individuals afloat in a magical universe embodies a major goal of his life and work: the achievement of grace and stasis in the presence of the spiritual.

———

The appearance of Albers's prints of the early 1940s ranges from childlike to precisely machined. In either case the results are full of esprit, bordering on the frenetic. In the small drypoint etching *Eh-De,* 1940 (cat. no. 158), named for the young son of Anni and Josef's Black Mountain College friends and associates Theodore and Barbara Dreier (see cat. no. 159), lines leap and bulge to encapsulate the pudgy toddler. Its use of nothing more than two continuous, unmodulated lines recalls the exercise in which Albers mandated his drawing students not to lift pencil from paper. The issue is how much you can get from how little. Two

other etchings, both dated 1942, are similarly restrictive yet evocative of their subjects: the etched lines of *Maternity* (cat. no. 157) envelop and succor, while those of *Escape* (cat. no. 156) dart furiously in a way that suggests that Albers did not always keep his concern about the plight of refugees at a remove from his art.

The *Graphic Tectonic* series of zinc-plate lithographs and related drawings of 1942 (see cat. nos. 160, 161) also range in mood from intensely animated to penetratingly calm. Here movement and resolution are combined within single images. And like the drypoint etchings, they achieve compositional complexity through minimal means. Their appearance, however, is highly mechanical. But for all the exactitude of the technique, the movement of their forms is completely ambiguous; for all their coolness, they are recklessly lively. Configurations that resemble wiring diagrams are subtly mysterious. The *Graphic Tectonics* show that Albers himself had achieved the goals of his drawing courses at Black Mountain College: a clear head, "seeing eyes, and obedient hands."[27] They embody as well the merits of discipline and accuracy, and of economy of material and labor, which he propounded in his teaching. The series also demonstrates the ability of "black lines [to] produce gray tones and, for sensitive eyes, color."[28] For example, it is almost impossible to believe that the background color of the paper is constant in the drawing *Graphic Tectonic III* (cat. no. 160). Some areas look snowy, some ivory or even purple, apparent tonal variations caused by Albers's manipulation of parallel lines. Once again a scientific, exacting approach yields the unexpected.

A group of prints from 1944 (cat. nos. 167–169) gives evidence that a clever juxtaposition of elements is the key to a transformation of realities. In *Tlaloc* (cat. no. 169) a spare configuration of thin, straight lines on top of a wood-grained background becomes the Aztec rain god, broad-shouldered and all-powerful. In *Astatic* (cat. no. 168) white planes appear as hard and thin as sheet aluminum, and seem bent. Although they are made of the white paper on top of which the surrounding wood grain has been printed, the planes look as if they are in front of the grain, which becomes a background of sea and sky.

———

I had asked of his painting that it should lead me to the understanding and love of things better than itself…not so much that it might perpetuate their beauty for me as that it might reveal that beauty to me.

MARCEL PROUST, discussing the paintings of Elstir in *The Guermantes Way*[29]

In 1947 Albers began what later came to be known, by a public more familiar with the *Homages,* as his "other" series. The artist's own nomenclature for them is the *Adobes* or *Variants.* In the *Variants,* of which he painted perhaps a hundred, he carried further than ever before his idea of a series of works in which the form remains constant or alters only slightly but the colors change radically. Albers had long taken multiple approaches to the same problem, but now his systematic pursuit of a single structure reached a new level.

Albers was driving at certain points in these paintings. A change of colors transforms both the emotional character and the apparent physical action of forms. Two paintings of identical format with different color schemes can have radically different effects. Colors alter their appearance according to their surroundings; a green has one appearance in a sea of pink, and a very different one when it abuts somber browns and grays. In the *Variants* Albers demonstrated techniques he had used in earlier work and which he was increasingly bent on inculcating in his students. These included the application of unmixed colors, straight out of the tube, directly on the white background but never on top of other colors, to create the illusion of transparency. The creation of this illusory transparency was the goal of an exercise in Albers's color course in which the students' task was to find the right "middle" colors to give the false impression that a veil-like band was lying on top of other forms. He had earlier shown his own mastery of this in *Flying* (cat. no. 94) and would later

write about it in *Interaction of Color.* The *Variants* also demonstrate that incompatible forms of motion can appear to occur simultaneously. Many of the configurations in these paintings appear to oscillate forward and backward, left and right along the picture plane and away from it into mysterious depths. Clearly, to contradict reality and induce the viewer's disbelief was part of the artist's continuing mission.

Albers devised systems which he used to call "my madness, my insanity" for the different *Variant* formats. Most are based on formulas of the type that underlies the *Bent Black* paintings. According to these systems there are virtually equal quantities of each color, or, in some cases, equal amounts of three colors and precisely half as much of two others. It was not Albers's intention, however, for viewers to recognize his formulas. Rather they were to think they saw more green than blue or more yellow than gray even if this were not true. The idea is that perception and truth are not the same. This is because of the superiority of color. A devout missionary of the power of color, Albers studied its possibilities and gave it as effective a voice as he could develop. He had learned that color can deceive; it has qualities that enable it to give the impression that there is more or less of it than is actually present.

Albers's art both reflected his pedagogy and nourished it. Some of the concepts it reveals were byproducts of the purely aesthetic decisions that went into its making. And although the works make certain points, they are far more than exercises. It is not primarily their demonstration of fascinating principles, but above all their formal grace and dramatic color juxtapositions, their enticing blend of serenity and animation, that beckon us. If the *Variants* serve as exemplars of theories, they do so in forms rich in artistic values. The frontal stance of their forms, immobile and fluid at the same time, and their effect as reduced reliefs, which recalls the shallow bas-reliefs of the sandblasted glass-constructions, transfix us.

Consider *Variant: Harboured,* 1947-52 (cat. no. 182).

11 Josef Albers
Variant: Harboured (detail of reverse). 1947-52
Collection Don Page, New York

First, from the back (fig. 11), we can learn about its technical makeup, and hence its didactic side. Here Albers, in very neat small script, wrote his recipe. To begin, there were four coats of white, with varnish mixed in. Then came the colors. Starting with the large pinkish area and working outward, there are 1) mixture of cadmium red light and zinc white, 2) mixture of Alizarin cadmium and zinc white, 3) Venetian red, 4) Reilly's Gray #5 and 5) yellow ochre light on top of Reilly's Gray #4. The list has several unusual, although not unique, elements. Two of the colors are mixtures—because Albers found that to obtain certain pinks and lavenders he could not use paints straight from the tube but needed to combine a darker color with zinc white. Then there is the overpainting of the fifth color. In a study for *Harboured* Albers had used only the

gray in the outermost area; in the course of working on the final painting he must have decided he wanted to try something else. He frequently changed his mind in this way; in many works, especially *Homages,* Albers painted one color on top of another. For all the preparation and careful planning, he remained receptive to change, his eye always dictating his ultimate decisions as he proceeded.

The breakdown of units follows the listing of colors on the reverse of the picture. The painting is twenty units high, thirty wide; each measures two by two centimeters. There are seventy-five units each of colors "1" and "2"; one hundred and fifty units each of the remaining three. It is as precise as the contents of a chemist's flask.

The owner of *Harboured,* a highly astute graphic designer who had studied with both Anni and Josef Albers at Black Mountain College, did not know about the system for all the years he possessed the painting, before we examined its reverse in preparation for this exhibition. He always felt its proportionate rightness without understanding the precise origins of that quality. Nothing would have pleased Albers more. The artist did not want the reading of the method to interfere with the pleasure of looking: knowledge should not obstruct experience. He did not want to make visible the nuances of his technique any more than he wished to bare his psyche. Discretion and understatement marked the means through which he suggested the otherness, the virtually inexplicable sense of depth and the unknown, crucial to his art.

The results of Albers's premeditation are especially pungent in *Harboured.* A beacon of light shines out at us. The pink and orange, played against the darker brown, gray and gold, radiate luminosity like that of the opaque glass constructions, where reflected light seems to come from behind. That resonant light is a key to the character of Albers's art. Scientific research in the 1980s has revealed the positive effects of light on the pysche, the perils of the long dark Scandinavian winter, the human need for exposure to sunshine and for brightness inside the home. Light is a positive,

uplifting force. It is invigorating, in part because we associate it with the sun: the source of earthly growth, the parent of our world. And it is central to all of Josef Albers's work. He had investigated light in his glass constructions, and he continued to use it as an essential element in his paintings from then on.

He craved light in his working situation. He was so desperate for it that, rather than subject himself to the uncertainties of the natural world (which might have forced him, like Bonnard, to forgo painting on dark days) he painted—at least from the time of his move to New Haven in 1950—inside a studio where he was assured of an ideal brightness. He invariably executed the *Homages to the Square* under fluorescent lights. The paintings lay flat on simple work tables—four- by eight-foot plywood panels on sawhorses. Over one table the fluorescent bulbs were arranged warm, cold, warm, cold; over the other they were warm, warm, cold, cold. He wanted to see each painting under different, but always highly luminous, conditions. Presumably he did the *Variants,* as well as his earlier work, in a comparably controlled situation. Although his paintings do in fact look best in natural daylight, Albers would not allow his working method to fall victim to its vicissitudes.

Clear light was imperative to more than Albers's process. It is always present in the finished art as well. Even when Albers worked exclusively in blacks and dark grays—as he did in several *Variants* and many *Homages*—at least one of the grays is luminous. And often the blackest of blacks is radiant as well. To have used darker tones entirely without luminosity would have produced a negative feeling antithetical to Albers's approach. The light physical nature of the forms parallels the luminosity of the tones. Heaviness would have denoted encumbrance. Murky colors or weighty masses would have suggested internal doubt or a bowing to external forces. The function of art was to provide an alternative to uncertitude or negativism, to surmount rather than succumb.

The luminous character of Albers's paintings

spiritualizes them. It elevates them from the mundane to the celestial plane. Their iconic presence also enhances their other-worldly aspect. In a century when many artistic movements and trends in thought have stressed a probing of the self, Albers's work is geared toward transcendence.

In his *Variants* and *Homages* Albers investigated the saturation of colors, a theme he would also explore in *Interaction of Color*. The pink and orange of *Harboured* have comparable degrees of saturation, different as their hues are. The reason the two colors appear equally bright may be that they contain similar proportions of zinc white. Because they are the same intensity, the boundaries where they abut one another are almost illegible. A bloom occurs at their junctures. They are like lovers, radiant on their own and glowing even more fiercely at all their points of contact. On the other hand, the boundaries between pink and brown and orange and brown are distinct. That brown is like some sort of serious, mature container for the romantic pair of brighter colors.

In *Harboured* Albers also pointedly demonstrated the way that colors change according to their surroundings—another concept he was to pursue in depth in *Interaction*. It is hard to believe that the central vertical rectangles and the horizontal gray band nearer the perimeters of the picture are the identical color. But that is the fact. The illusion occurs because the gray looks greener when it is surrounded by pink. Not only does the hue of the gray change in relation to its neighbors, but so does its apparent spatial position: it seems closer to the picture plane in those vertical rectangles than it does in the broader horizontal expanse, where it reads as background.

IV

Anni and Josef Albers left Black Mountain College in 1949. The atmosphere of the school had soured, with intense feuding within the administration, and the Alberses tendered their resignations. After a year in New York Josef made the last of the three major moves of his life: to New Haven, where he took a position as head of the department of design at Yale University.

He was sixty-two years old. In the twenty-six years that remained to him, he would achieve more as a painter, teacher and writer than ever before. In the year of his move to a city laid out in the seventeenth century with a carefully gridded square at its core, he began the *Homages to the Square* on which he would work forever after. For almost a decade his name became synonymous with the Yale University School of Art, and he had an indelible effect on thousands of students there. Whether they went on to become professional artists, architects or designers, or entered totally unrelated fields, they give repeated testimony that his color and drawing courses and the impact of his personality made an unparalleled educational experience. Albers gave up full-time teaching in 1958—once again under some duress—but he remained in the New Haven area and retained peripheral affiliations with Yale for the rest of his life. The most important ongoing link with the university was his work with Yale University Press on *Interaction of Color*.

It was after his retirement from teaching that Albers could fully devote himself to painting. He became far more prolific. He designed record covers, fireplaces and murals. He also made numerous *Homages* in virtually every possible print medium, and developed and wrote about his *Structural Constellations*. He published other books and essays. And in time he had what was virtually a full-time job with the pleasures and tribulations of celebrity: the visiting photographers (Henri Cartier-Bresson, Arnold Newman and Snowdon among them) and interviewers, the correspondence and a stream of exhibitions. His modus operandi for almost all of his dealings with the world were his own long handwritten letters—ever careful and gracious—and a clear-headed and endlessly accommodating wife.

He continued to paint *Variants* until 1955, after which he only took up the theme on a few rare occasions. But

12　Josef Albers
Homage to the Square: Early Ode
(detail of reverse). 1962
Collection Maria and Conrad Janis,
Beverly Hills

the paints were from the same batches, perhaps even the same tubes.

Despite the similarity of color, the paintings produce very different effects. *Early Ode* gains its haunting presence from the mysterious, luminous yellow that seems the perfect middle tone between the cadmium and the gray. In a certain light, that yellow almost disappears into the gray. *Arrival* has more of a look of victory to it, thanks largely to the two bold and weighty colors that separate the same cadmium and gray. You can have the same starting and end points, but if you alter the internal course, everything changes with it. In *Arrival* the colors appear to move in and out, in accordion fashion. In *Early Ode*, however, the second square out from the middle of the picture appears to be a tissue, which seems alternately to lie over and under the central square. In truth, each color has been painted directly on the white ground, in accordance with Albers's self-imposed rule that he must never put one square on top of another. (He did, however, sometimes repaint single squares.) Yet it looks as if a thin film, held taut in space, keeps shifting from a position in front of the cadmium yellow pale to a place behind it. Morever forms seem at one moment to be translucent, at another opaque, a play of the type that Albers first explored in the glass construction *Steps*, 1931 (cat. no. 96). Albers must have looked far and wide and done countless blotting paper studies (see cat. nos. 192, 194-199) to find the Schewingen Yellow Light, made by Old Holland, that would achieve this perpetual motion and transformation.

Nowhere is the effect of a single color on its neighboring ones more astounding than in the diptych *Despite Mist*, 1967 (cat. no. 245). In this pair of paintings, which Albers hinged together (giving them their altarpiece-like quality as well as coupling them permanently), all the elements except for the outermost squares are identical. There are no variations whatsoever in size, format or the middle and second colors, although under most light conditions this seems unbelievable. Not only do the tones in the interior of the composition look entirely different in the two

in the *Homages* he maintained some of their central themes. One was the mutability of color perception. Albers sometimes made two *Homages* with identical colors in the central and outermost squares and different colors in the interval between them. The intervening colors make the identical colors look totally different from one another. If we compare *Early Ode*, 1962, with *Arrival*, 1963 (cat. nos. 221, 222), we would scarcely surmise that the central and outermost squares of the two paintings are precisely the same color, but Albers's notations prove that they are. In the *Homages*, as in the *Variants*, Albers always listed all his colors, with their manufacturers' names, on the reverse of each panel (see fig. 12). In both *Early Ode* and *Arrival*, the middle square is a Cadmium Yellow Pale manufactured by Blockex, the largest square a Chapin Neutral I from Shiva. Since the two works were done within a year of each other, we assume that

paintings, but the movement, shapes (the degree to which the corners appear rounded) and internal proportions of the squares also seem to change. That someone could take paints called "Optic Gray #1 Warm" and "Optic Gray #1 Cool," both made by Marabù, and so thoroughly alter their appearance by placing them next to either Chapin Neutral #1 by Shiva (on the left) and Reilly's Gray #8 by Grumbacher (on the right) is testimony not only to diligence and craft, but also to imagination and faith.

Sometimes two *Homages* vary only in the order in which sequences of identical colors have been painted. In *Tenacious*, 1969, and *Warm Silence*, 1971 (cat. nos. 225, 226), which hang as a pair in a private New York collection, the same four yellows are painted in precisely reverse order. This reversal yields more than the simple transformation one might anticipate, which is that the central square seems to be closest to the viewer in one painting and furthest away in the other. Not only does this directional difference occur, but, additionally, identical paints appear to be very different colors solely because their position has changed. The Cadmium Yellow Pale by Rembrandt in the center of *Tenacious* scarcely resembles the same paint in the outermost square of *Warm Silence*. Similarly, the Naples Yellow by Blockex that forms the border in *Tenacious* looks different in the middle of *Warm Silence*. Moreover, the sizes of the squares in *Tenacious* and *Warm Silence*, although the same, appear at odds. And the paintings have two very different emotional climates, the essential characters of which are conveyed by their titles, which Albers gave to his works after they were completed.

———

In an essay on Italo Calvino, Gore Vidal quotes from an Italian television interview that took place shortly before the novelist's death. Calvino claimed that, "Only a certain prosaic solidity can give birth to creativity; fantasy is like jam; you have to spread it on a solid piece of bread. If not, it remains a shapeless thing, like jam, out of which you can't make any-thing."[30] Albers's precise manipulation of paints on those unyielding Masonite panels was his "prosaic solidity." It gave birth not only to fantasy, but also to considerable spirituality and philosophical complexity.

First of all color behavior can be compared to human behavior. People, like colors, have one appearance when they are alone, another when they are with a group of family members whom they resemble physically and psychologically, and yet another when they are surrounded by strangers. Their relatives often mitigate their distinctiveness, while foreign visitors can intensify the dominance of certain characteristics by contrast. Even if people themselves do not change, our view of them, just like our perception of colors, varies according to their surroundings.

Additionally the work suggests, with powerful effect, the compatibility of contradictions. The *Variants*, emphatically horizontal in both their overall dimensions and in the narrow, rectangular bands that sweep across their broad surfaces, are given an upward lift by the two central vertical rectangles that resemble twin doors. That lilt, by putting a springy bounce into a gentle sweep, interjects cheer into sobriety. Pensive forms—they suggest furrowed eyebrows and a creased brow—are full of laughter. Viewing the *Variants* and the *Homages* as well, we experience a sense of overwhelming calm, a repose that is especially effective because it is very light-hearted. High spirits coexist with solemnity. What is phlegmatic is also fiery; what is somber, playful.

In both the *Variants* and the *Homages*, not only opposite moods but also irreconcilable motions coexist. We feel stretched across that picture plane, our arms pulled taut; at the same time we are pulled upward. We are looking at a two-dimensional object, its single flat plane carefully subdivided and decorated, yet suddenly we find ourselves pursuing a complicated course through a proscenium stage. We move inward and outward at the same time, then simultaneously left and right. With color too there is a confluence of opposites. Albers might juxtapose a midnight black with the blue of a noonday sky, a cold, distinctly

13 Pablo Picasso

Guitar. 1912

Charcoal on paper, 18½ x 24⅜″

Collection The Museum of Modern Art, New York, fractional gift of Mr. and Mrs. Donald B. Marron

manmade steely gray with a verdant green and a sunny yellow. Art was to accomplish what nature could not.

Irreconcilable elements are also joined in a body of work of 1949 to 1976 which Albers called his *Structural Constellations* or *Linear Constructions* (see cat. nos. 171-176). These are discussed by Neal Benezra and Charles Rickart in their essays in this catalogue.[31] This series is to the *Graphic Tectonics* and some of the other earlier geometric prints and drawings as the *Homages to the Square* are to the paintings that precede them: a further development, in the most reductive form possible, of ideas with which the artist had long been grappling. As Albers said in an interview with the English critic Paul Overy, "Though my paintings and linear constructions are not connected, they stem from the same attitude, the same urge to achieve from a minimum of effort a quantitum of effect. While I was still teaching in Europe, I used to say to my students, 'Do less in order to do more.'"[32] In the *Structural Constellations* he pursued linear geometry in a more refined format than ever before. He devised a system based on minimal variables and

subsequently worked on it diligently for over two decades. It took form first in rough working sketches, and then in large drawings, embossed prints (white on white, white on black, white on gray), white-line engravings on black Vinylite, prints made from engraved brass and large architectural commissions. The subject is always ambivalent forms, which simultaneously appear to be flat and three-dimensional and are penetrated in a variety of incompatible ways.

In offering multiple approaches to the picture space, these *Structural Constellations* descend directly from Cubism. Like Picasso's 1912 drawing *Guitar* (fig. 13), they use simple, well-drawn, unmodulated lines to make planes that shift perpetually and forms that appear to unfold first one way and then another. The discrepancies seem both like magic and like accurate reflections of the variables in the human grasp of reality, psychological and physical. Both Picasso and Albers questioned the nature of all perception. They discarded old notions of truth and standard ideas about vision. And both artists took a formal approach to their themes, developing a sequence of internal

parallels and echoes and a careful balance of elements that impart unity and serenity to the disrupted subject.

Because the spatial configurations in the *Constellations* appear to change constantly, volumes become weightless. Here Albers seems to have started out earthbound and then moved heavenward; having first given us implicitly weighty three-dimensional bodies, he makes them float. The transformation through which masses are rendered weightless, and the interjection of movement into static objects, were among Albers's constant preoccupations. In the sandblasted glass works he had countered the heavy mass of the materials with the effects of light. In the *Variants* and the *Homages* he began by methodically applying paint grounded to the panel, but subsequently made the forms buoyant and the colors ethereal. This negation of weight and mass both establishes and denies such physical properties, the sort of contradiction essential to Albers's achievement of poetry through the application of overtly scientific means.

The *Homages* have their feet on the earth and their heads in the cosmos thanks to their 1:2:3 formats. The central, or first, square is like a seed: the heart of the matter, the core from which everything emanates. The intervals underneath that first square, created by either two or three larger outlying squares, are doubled to the left and right of it and tripled above it. In the four-square format, for example, which is ten units wide and high, the middle square is four units wide, each of the outer squares is half a unit wide underneath the middle square, one unit wide at left and right and one and a half units high above. In *The Power of the Center*, Rudolf Arnheim explores the ways this ratio shifts the normal balance of earthly (horizontal) and heavenly (vertical) elements of a single square in favor of the heavenly. "This asymmetry produces the dynamics of the theme, a squeezing below, an expansion above. It promotes a depth effect, which would be counteracted if all the squares were grouped symmetrically around the same center." The asymmetry is subtle—the squares are *almost* centered—so consequently the upward thrust is gradual rather than pronounced. Thus the spiritual element is achieved with a soft voice rather than a loud shout. Like all true spirituality, Albers's is achieved in poignant, muted tones, rather than with evangelical ardor.

In analyzing the ascendant quality of the *Homages*, Arnheim points out that if we follow the four diagonals created by the corners of the squares within squares, they converge on a point precisely one quarter of the way up the painting. The diagonals created by drawing lines through only the two bottom sets of corners and carrying those lines all the way across the panel make an X that demarcates the rectangle that is the lower half of the composition. "A solid base is thereby provided on which the sequence of squares can rise with confidence from step to step—not so different from the coffin in Piero's *Resurrection*, from which the movement toward heaven takes off."[33] This strong foundation is similar to the waves in a seascape by Courbet; its submission to gravity emphasizes the weightlessness above.

Like the image of a cathedral on the original Bauhaus brochure which beckoned Albers to Weimar, his *Homages to the Square* have massive, sanctuary-like bodies and the attributes of steeples. In buildings and paintings alike, there is a mix of solid craft with philosophical concerns. That blend of factuality and spirituality parallels the issues of mortality and immortality that loomed large for Albers in his later years. Determinedly anti-Bohemian, in persona he was the honest craftsman, clean shaven and well scrubbed, dressed in neat, almost uniform-like clothing (mostly drip-dry grays and beiges). In 1950, when he and Anni moved to New Haven so that he could take his teaching position at Yale, they chose a small Cape Cod style house that looked like everyone else's: a no nonsense place good for living and working. Twenty years later, when they were more affluent and able to enjoy the rewards of the art boom of the 1960s, they simply moved to a slightly larger raised ranch on a quiet suburban street a few miles away, convenient to a cemetery plot they selected so that after the first one died the other could drive by on the way to the post

office. But the matter-of-fact Albers knew well that through his achievement he was guaranteed a degree of immortality. Returning to Catholicism in his late years, he may well have believed that not only his art but also his soul would outlive his body. He lived as austerely as a monk; and like a monk he thought often of the afterlife. The words of George Eliot—"It is strange how deeply colours seem to penetrate one, like scent....They look like fragments of heaven"[34]—might describe his state of mind.

The world beyond our individual earthly existence was in Albers's thoughts when he made a blue green *Homage* in 1976 (cat. no. 246), some two months before his eighty-eighth birthday and his death a week later. By the time he made this *Homage* he was working on very few paintings—his hand was too unsteady, so he focused more on printmaking—but he did this panel as a study for an Aubusson tapestry that had been commissioned for a bank in Sydney, Australia.

I discussed the painting with Albers on several occasions. He told me that he had one problem with it. He had found a combination of his chosen colors that interacted perfectly in an *Homage* format when the central square was four (out of ten) units wide, but that did not work as well in the format with a larger (six-unit wide) central square. Showing me studies of halves of these paintings (he often worked in half *Homages*, especially when designing prints or tapestries), he explained that, in the version with the larger middle, "downstairs" was fine, but not "upstairs." He wanted both a spatial flow and a color "intersection." Albers described this intersection in *Interaction of Color*. It is the process by which a correctly selected color lying between two other colors takes on the appearance of both of those colors. When colors properly intersect in a three-square *Homage*, the color of the innermost square will appear toward the outer boundary of the second square out. The color of the outermost square will also appear within the second square, toward its inner boundary. "The middle color plays the role of both mixture parents, presenting them in reversed placement."[35] This is entirely illusory. The second square is not in fact a mixture, but is paint straight from the tube, applied flatly. It is just that at a distance our perception tells us that it is modulated, and that some of the first and third colors are visible within it.

Albers then pointed to the version with the small central square. Here the intersection occurred, but he was not satisfied. Moving his hand over the sky blue center, and then over the more terrestrial forest green and the sea-like aqua surrounding it, he explained that these colors were the earth and the cosmos, the cosmos being in the center. In the version with the smaller middle, the cosmos was too distant.

While the earlier *Homages* generally depend on sharp light-dark contrasts, the later ones are more subtle, with closely related hues. Here Albers's development parallels that of Cézanne and Monet, who in their late work also moved toward hazy, atmospheric effects. In the version of this last blue green painting with the larger middle, Albers wanted all boundaries and edges virtually to disappear. Additionally, there should be no sharp corners on the inner square. (He said that Cartier-Bresson once told him that he made "circular squares," which delighted him.) To achieve these effects he needed to find colors with the identical light intensity. The cosmos should have neither sharp boundaries nor corners.

He said that even the supreme colorist Turner had never been able to match light intensities exactly. Yet by making studies with painted blotting paper, Albers found precisely the paint he needed for the middle square. With Winsor Newton Cobalt Green, code number 192, he could obtain both his desired intersection and the match of light intensities. At that moment, however, the only Winsor Newton Cobalt Green available was from a newer batch, code number 205. He admired the paint company for changing the code number to indicate a change in the pigment, but was frustrated not to be able to duplicate a paint that had been discontinued several years earlier. After some searching, however, he found a supplier with some old tubes of 192, and he made the painting. The intersection he achieved is like magic. Looking at that

Homage with me, Albers demonstrated it by interlocking all of his fingers, and praised the ability of the outer and inner squares to span the middle color. Again he spoke of the need of "the universe" (here rather than "the cosmos") to be immaterial and without boundaries. This was his last painting.

———

Calvino wrote of his character Marcovaldo:

> *He would never miss a leaf yellowing on a branch, a feather trapped by a roof-tile; there was no horsefly on a horse's back, no worm-hole in a plank, or fig-peel squashed on the sidewalk that Marcovaldo didn't remark and ponder over, discovering the changes of the season, the yearnings of his heart.*[36]

There is no color tone or scrap of line that Albers did not see as full of latent meaning, evocative of mood and spirit, able to exert a decisive, life-altering effect on another color or line. Detail and nuance were his deepest nourishment. Calmly and systematically receptive, like Morandi looking at bottles, he found multitude and stability in a few forms.

We cannot label him. "Constructivist," "Father of Op Art," much used, do Albers a disservice. We should apply his understanding of color to our understanding of him; words, and the attempt to pinpoint diversity, fall short. All that is certain is variability. Albers used to say that no two people pictured the same thing upon hearing the word "red." Like the controls of language, all of Albers's precise systems were only a guide to, and a celebration of, mystery. To accept ambiguity and revel in it is the great message of his poetry of the laboratory.

If Albers did not belong to any group of artists, he was, nevertheless, not without his artistic soulmates. In addition to his affinities with Klee and Mondrian, he had links with some Russian Suprematists. Kazimir Malevich's paintings of squares, which were illustrated in Bauhaus publications, may have influenced him slightly. The way Malevich juxtaposed solid squares and emphasized the beauty of their form by isolating them may have inspired him (figs. 14, 15). But the

14 Kazimir Malevich
Suprematist Composition: White on White. 1918?
Oil on canvas, 31¼ x 31¼"
Collection The Museum of Modern Art, New York

15 Kazimir Malevich
Suprematist Composition: Red Square and Black Square. 1914 or 1915?
Oil on canvas, 28 x 17½"
Collection The Museum of Modern Art, New York

Russian and Albers used the motif to very different purposes. For Malevich the square was a full stop, a reductionism; for Albers it was a tool, a device to serve the revelation of color, a stepping stone to vast riches.

In fact, the *Homages* descend more from Renaissance precedents than from revolutionary twentieth-century movements which attempted to sever ties with the artistic past. The calm and balance of Albers's harmonious arrangements, and their combination of elegant frontality and spatial progression, gives them some of the feeling of fifteenth-century Madonnas. Their traditional base separates them not only from more modern idioms such as Suprematism but also from the Minimalism of the 1960s and from contemporary hard-edge abstraction with which it is often linked. So too does its use of spare geometric form as a device more than an end product. Today it is a cliché of museum installation to hang *Homages to the Square* in the same room as paintings from the 1960s by Frank Stella, Ellsworth Kelly, Kenneth Noland and other hard-edge artists. For a number of reasons Albers's art looks out of place in juxtaposition to theirs. Paul Overy commented that it was "ironic" that Albers was shown with Minimalists in an American festival in London in 1986:

> *Albers lived in America for nearly half of his long life and taught a whole generation of American painters. Yet his work remained strongly European in its "relational" qualities and, even though he used a "centered image", the way he placed the bottom edges of the squares closer together created effects quite different from the symmetrical 1960s work of Stella and Judd. Albers applied his paint with a palette knife and deliberately left the edges rough, with a tooth for the interacting colours to bite on one another. He never used masking tape and his works are not hard edged (except in reproduction). The largest paintings are about three and a half feet square; small by American standards. The values they affirm are not American values but European.[37]*

The *Homages* do not belong to any one movement but are an individual and unusual expression of a familiar human drive. Gombrich sees them as unique embodiments of the "economy of means that is one of the driving forces of art works" throughout history. He feels that some of Albers's objectives only came to the fore in the late nineteenth and early twentieth centuries when the Beuronschule began to emphasize monumentality and proportion and Hodler became interested in parallelism and formal organization. However, he maintains that the driving force behind the *Homages to the Square* and Albers's other series is timeless and universal. These works derive from "the interest in producing constraints and then overpowering them. You have to concentrate and see just how much you can make of an element or elements." This is a tradition that exists in both music and the decorative arts, and has "parallels in poetry also." Gombrich compares Albers to a Mogul Emperor who spent his whole life making variations on two lines. Both were devoted to "this problem of how much to get out of simple elements; the making of permutations of every kind, in order to prove them inexhaustible."

Albers was fond of saying that he descended from Adam, and in some ways the *Homages* go all the way back to the cave paintings at Lascaux. There too we find only three colors: yellow, red and black. In the *Homages*, of course, Albers reduced his palette by choice rather than necessity, selecting his three or four hues from a reserve of thousands. Happier with some of the limitations of the early cave-dweller, he was not unlike those of us who head for mountain tops—where only the contents of our knapsack, rather than the abundance of supermarkets, are available.

The generalized *Homages* are "everyman," and Albers was everyman, reduced to essentials like the ancient cave-artist with his oil lamp, facing the gritty reality of a coarse surface. In the caves at Lascaux as on the rough side of the Masonite panels on which Albers worked, the variegated surface gives the colors richness and variation, and lends a crucial irregularity to both the textures and the edges of forms. In that irregularity,

16 Paul Cézanne

Le Château Noir. 1904-06
Oil on canvas, 29 x 36¾″

Collection The Museum of Modern Art,
New York, gift of Mrs. David M. Levy

and in the sturdy application of paint on top of it, is the kernel of the humanity of the work. It gives both the paintings at Lascaux and the *Homages to the Square* an intensity that suggests that the artist's life depended on his ability to make images. Albers, like the cavemen, grasped at visual experience as a source of the truth underlying human existence. Part of the power of his vision is that it is clearly the product of the most pressing and urgent necessity.

The *Homages* descend more directly from Cézanne's example than from any other: by Albers's own admission Cézanne was the key figure in his development. In works like *Le Château Noir* (fig. 16) Cézanne in essence presented three planes of color, all parallel to the picture plane, and he used the properties of color to hold each plane in space. But in spite of these links Cézanne's and Albers's goals were not the same. The Frenchman sought to capture the natural world—and so in his painting the green clearly signifies the fore-ground, and the tan helps place the chateau—firmly in

the middleground, while Albers's colors occupy abstract, nonrepresentational form so as to create an other-worldly reality in which planes constantly shift position. But each artist devised a space that is foreshort-ened and compressed yet suggests depth, and each employed planes that are both frontal and recessive. In *Le Château Noir,* the sky does a suprisingly Albersian thing: it moves up and back and in and out—the way the sky, which is everywhere, really does. Cézanne's focus on the technique of painting, like Albers's, yields the unfathomable mysteries that nature ultimately offers. Moreover, Cézanne's rough surfaces, along with Albers's well-worked painted planes, receive light; like the artists themselves, they do not hold forth so much as respond.

The poet Rainer Maria Rilke wrote of Cézanne's work, "As if these colors could heal one of indecision once and for all. The good conscience of these reds, these blues, their simple truthfulness, it educates you; and if you stand beneath them as acceptingly as possible, it's as if they were doing something for you."[38] Rilke visited the 1907 Cézanne exhibition in Paris time and

again—with a vehemence comparable to the ardor that Albers felt when he returned daily to his square panels and tubes of paint—and observed:

> *You also notice, a little more clearly each time, how necessary it was to go beyond love, too; it's natural, after all, to love each of these things as one makes it: but if one shows this, one makes it less well; one judges it instead of saying it.... This labor which no longer knew any preferences or biases or fastidious predilections, whose minutest component has been tested on the scales of an infinitely responsive conscience, and which so incorruptibly reduced a reality to its color content that it resumed a new existence in a beyond of color, without any previous memories.*[39]

Rilke's intensity and Cézanne's visual connoisseurship and the resultant distillations are in ways comparable to Albers's own. Indeed the colors of the *Homages* do have a "simple truthfulness," and do "educate you." Their confidence and decisiveness penetrate us. Here is the art of someone who overcame normal human ambivalence, who followed the advice he frequently gave to his students—"Don't jump on bandwagons. Sit on your own behinds"—and found both his own methods and course.

Here, too, is an art devoid of memories. Describing timeless phenomena, it transcends individualism. It reveals color rather than opinions about color. The *Homages* become, in a generalized way, living beings. As such, like much great late work, they grapple with ultimate, essential truths. Grounded solidly in their craft, they touch upon sublime mysteries. Stripped bare, they caused minimal disruption between the communicator and the means of communication. They conquered the gap between speaker and statement, between writer and words, between painter and medium: Josef Albers and the *Homages* were one.

NOTES

This catalogue is dedicated to Anni Albers. Her public person is well known; she is a pioneering abstract textile artist, designer and printmaker, and an innovative writer on aesthetics. For fifty years she was visible as an intensely devoted, though never docile, spouse, a position she has retained with the much detested term "widow." But the role in which I have been lucky enough to know her is less familiar: that of a true and giving friend.

Most of those who helped put together this exhibition and book are acknowledged in the preface. I must, however, single out a few from my point of view. The staff of the Guggenheim Museum has shown just how hospitable a great institution can be. Thomas M. Messer and Diane Waldman have been unusually gracious and supportive. Susan B. Hirschfeld has not only been highly efficient and, when it was required, supremely diplomatic, but also consistently delightful. Thomas Padon has handled an encyclopedia's worth of details with grace and skill. Carol Fuerstein has been perpetually clear-headed and flexible at the same time. Mimi Poser and her staff have mixed work and laughter with rare effectiveness. At the Albers Foundation Kelly Feeney has not only been the most diligent and patient of aides-de-camp, but also unfailingly imaginative and good humored. And at home my wife Katharine has been, as always, supportive, witty and insightful, and our daughters Lucy and Charlotte full of spirited encouragement.

My deep personal thanks also go to Lee Eastman, a patron in the truest sense, and to his ever gracious wife Monique. For exceptional support and insight I also thank Maximilian Schell, Jochen and Martina Moormann, Paul and Ellen Hirschland, Charles Kingsley, Herbert Agoos, Saul and Caroline Weber, Ulrich Schumacher, Denise René and Ruth Villalovas; for their remarkable skills and diligence in conservation work Patricia S. Garland, Martina Yamin and Ray Errett; and for countless forms of assistance Hans Farman, Phyllis Fitzgerald, Carroll Janis, Emma Lewis, Diana Murphy and Tim Nighswander.

1 Unless otherwise indicated, quotations by the artist come from my conversations with Albers or from unlabeled tape recordings that he left in his studio. This passage also includes some phrases from my translation of an interview in Jean Clay, *Visages de l'art moderne*, Lausanne and Paris, Editions Rencontre, 1969, p. 67.

2 Almost all of the dating of the early drawings is mine. I explain the reasoning behind it in some detail in my book, *The Drawings of Josef Albers*, New Haven and London, Yale University Press, 1984. According to my chronology, there is only one known drawing earlier than *Farm Woman*, a charming but far less sophisticated work that Albers did when he was teaching in Stadtlohn.

3 The first exhibition of the figurative prints was at the Galerie Goltz in Munich in 1918. Subsequent showings included the Yale University Art Gallery, New Haven (1956), the Westfälisches Landesmuseum für Kunst und Kulturgeschichte Münster (1968), The Art Museum, Princeton University (1971), and The Metropolitan Museum of Art, New York (1971).

4 An essay by Margit Rowell, "On Albers' Color," *Artforum,* vol. 10, January 1972, pp. 26-37, shows Albers's earliest prints and paintings alongside work by Munch and Delaunay. On his annotated copies of the article, Albers has written in large red letters, "Why are these together here?" next to the Munch comparison and "No!" after the text linking him to Delaunay. Werner Spies also mentions a "closeness to expressionsim" and a resemblance to Delaunay in his *Albers,* New York, Harry N. Abrams, Inc., 1970, p. 9.

5 Conversation with E.H. Gombrich, London, February 21, 1987.

6 Josef Albers, "More or Less," *Poems and Drawings,* New York, George Wittenborn, Inc., 1961.

7 Quoted in Neil Welliver, "Albers on Albers," *Art News,* vol. 64, January 1966, p. 48.

8 Quoted in Janet Flanner, "King of the Wild Beasts," *The New Yorker,* vol. XXVII, December 29, 1951, p. 40.

9 Quoted in Eugen Gomringer, *Josef Albers,* Joyce Wittenborn, trans., New York, George Wittenborn, Inc., 1968, p. 27.

10 This work is identified as *Lattice Painting* in some of the Albers literature–including Rowell, "On Albers' Color," where it appears on the cover of the magazine–but Albers wrote the title *Grid Mounted* on the back of the frame he had made for it in the 1950s (which has since been removed).

11 Statement by Kelly Feeney. Ms. Feeney is responsible for many of the ideas in this paragraph and the preceding one.

12 Quoted in Welliver, "Albers on Albers," p. 50.

13 Quoted in Michel Seuphor, *Piet Mondrian: Life and Work,* New York, Harry N. Abrams, Inc., p. 166.

14 Ibid., p. 168.

15 Ibid.

16 Quoted in E.H. Gombrich, *The Sense of Order,* Ithaca, New York, Cornell University Press, 1979, p. 20.

17 George Heard Hamilton, *Josef Albers–Paintings, Prints, Projects,* exh. cat., New Haven, Yale University Art Gallery, 1956, p. 18, and Irving Leonard Finkelstein, *The Life and Art of Josef Albers* (Ph.D. dissertation, New York University, 1968), Ann Arbor, Michigan, University Microfilms International, 1979, p. 75, give 1926 as the date for this chair. However, documentation at the Bauhaus-Archiv, West Berlin, as well as in various publications about the Bauhaus, date it as 1929.

18 Among those who make the claim that it was the first bentwood chair intended for mass production are Hamilton, *Paintings, Prints, Projects,* p. 18, and Hugh M. Davies, in "The Bauhaus Years," *Josef Albers Paintings and Graphics, 1915-1970,* exh. cat., The Art Museum, Princeton University, 1971, p. 8. It was Derek E. Ostergard, curator of *Bent Wood and Metal Furniture: 1850-1946,* an exhibition circulated by The American Federation of Arts in the United States from September 1986 to October 1988, who led me to see otherwise.

19 The source of this information is Anni Albers's brother Hans Farman, whose memories of the Berlin exhibition, as well as of other aspects of his brother-in-law's life and work, have been extremely helpful.

20 Letter of August 2, 1975, to The Museum of Modern Art, New York.

21 The present owners of the original *Steps* did, in fact, bring it to the artist's attention several years before his death. While he authenticated it and was apparently delighted that it was in good condition, Albers did not have time to change any of his notes on the painting, so its second reemergence, when the owners kindly got in touch with me before this exhibition, came as a surprise.

22 The photographs are yet another aspect of Albers's art that was substantially unknown during his lifetime. Concurrent with this exhibition, *The Photographs of Josef Albers,* organized and circulated in the United States and Canada by The American Federation of Arts, presents some thirty-five more examples from the artist's estate. It is accompanied by a catalogue by John Szarkowski, Director of Photography at The Museum of Modern Art in New York.

23 Quoted in Hans M. Wingler, *The Bauhaus,* Wolfgang Jabs and Basil Gilbert, trans., Joseph Stein, ed., Cambridge, Massachusetts, and London, The MIT Press, 1969, p. 188.

24 *Silographie recenti di Josef Albers e di Luigi Veronesi,* exh. cat., Milan, Galleria del Milione. Translated by Nora Lionni. The exhibition was on view from December 23, 1934-January 10, 1935.

25 Quoted in Gomringer, *Josef Albers,* p. 48.

26 Ibid.

27 Quoted in Weber, *Drawings,* p. 40. These words are from notes that Albers wrote to himself in February 1941 about his teaching of drawing.

28 This phrase and the complete passage from which it is taken have been quoted in several publications, including Gomringer, *Josef Albers,* pp. 75-76, and François Bucher/Josef Albers, *Despite Straight Lines,* New Haven and London, Yale University Press, 1961, pp. 10-11. Albers wrote the passage the year after he completed the print series.

29 Marcel Proust, *The Guermantes Way,* vol. 2 of *Remembrance of Things Past,* C.K. Scott Moncrieff and Terence Kilmartin, trans., New York, Random House, 1981, pp. 125-126.

30 Gore Vidal, "On Italo Calvino," *The New York Review of Books,* November 21, 1985, p. 3.

31 They have also been analyzed in depth by the artist and François Bucher in *Despite Straight Lines* and by me in *Drawings.*

32 Quoted in Paul Overy, "'Calm Down, What Happens, Happens Mainly Without You'–Josef Albers," *Art and Artists* (London), October 1967, p. 33.

33 Rudolf Arnheim, *The Power of the Center,* Berkeley, Los Angeles and London, University of California Press, 1982, p. 146.

34 George Eliot, *Middlemarch,* Harmondsworth, Middlesex, England, and New York, Penguin Books, 1985, p. 35.

35 Josef Albers, *Interaction of Color,* New Haven and London, Yale University Press, revised pocket edition, 1975, p. 38.

36 Italo Calvino, *Marcovaldo,* William Weaver, trans., San Diego, A Helen and Kurt Wolff Book, Harcourt Brace Jovanovich, Publishers, 1983, p. 1.

37 Paul Overy, "Josef Albers," *Art Monthly* (London), June 1985, p. 9.

38 Rainer Maria Rilke, *Letters on Cézanne,* Joel Agee, trans., New York, International Publishing Corporation, 1985, p. 50.

39 Rilke, *Letters on Cézanne,* p. 65.

Josef Albers: Art Education at Black Mountain College

MARY EMMA HARRIS

In Berlin in the spring and summer of 1933, the Nazis forced the closing of the Bauhaus, the innovative school of architecture and design founded by Walter Gropius in 1919. Simultaneously Black Mountain College was founded near Asheville, North Carolina, by John Andrew Rice and a group of dissident faculty members at Rollins College who had been fired or had resigned in a dispute over academic freedom. This coincidence was ultimately to benefit Black Mountain because Josef Albers, a former Bauhaus teacher, who had received an intimidating letter from the city of Dessau, would come to work at the American school.

Critical to the educational philosophy of the founders of the new college was the idea that the arts should be at the center of the curriculum rather than what Albers later described as "their decorative sideplace."[1] They realized, however, that if they were to achieve their goals, the conventional teacher of painting and sculpture would not be sufficient. In their search for a new kind of teacher they were led to The Museum of Modern Art, where Philip Johnson recommended Albers, to the new college. Despite his warning that he could not speak English, Albers was invited to join the Black Mountain faculty. Idealistic, moralistic, dogmatic, brilliant, disciplined and stubborn, he remained for sixteen years, and his personality, teaching and ideas exerted a profound impact on all areas of college life.

One summer session art teacher commented that every experimental college should have a German schoolmaster such as Albers because he encouraged a sense of order without dominating the school. Of moderate height and slim with a fair complexion and graying blond hair, Albers's physical presence was modest. He was most often seen in light-colored slacks and a shirt or in overalls or coveralls, the attire of a craftsperson or worker. He and his wife Anni, the distinguished weaver and writer, shared a rustic cottage of wood and stone with Theodore and Barbara Dreier and their children at the Lake Eden campus. The common room was furnished sparsely with Breuer tubular steel chairs, chairs of wood and leather which Albers designed, using a traditional Mexican chair as a model, and Constructivist furniture by Mary (Molly) Gregory, who taught woodworking. There were mats of natural materials and freshly cut flowers. Albers's studio, which was in the cottage, was off limits to students and faculty unless they were invited. The Black Mountain years were some of his most productive as an artist, and the demands of community life were such that he did not allow interruptions in those precious hours available for his own painting and printmaking. Nevertheless, aspiring art students had a chance to observe him pursuing the professional activities of an artist, such as dealing with galleries and exhibitions, and to learn from his example the dedication and concentration necessary for creative work. Albers was a member of the Board of Fellows, the central governing body of the college, as well as the

committees that took care of the practical problems of daily living. In addition, he organized the special summer art sessions.

Though separated by thousands of miles and different cultures, both the Bauhaus and Black Mountain shared a progressive, experimental, adventurous spirit. American technology and architecture and the writing of educators such as John Dewey had been a liberating force for the Bauhaus leaders. Yet when Albers arrived in America, he found a young country hampered in its struggle to establish its own identity by a confusing idealization of older, more established cultures, especially those of the Italian Renaissance and Classical Greece, and by a romantic view of the arts. To the progressive spirit of the founders, he brought the spirit of modernism, which he defined as an attitude toward the present time, a "significant contemporaneousness." In an essay entitled "Truthfulness in Art," Albers insisted that the art of any period is valid only to the extent that it reveals the spirit of the time through form: "truthfulness to art as spiritual creation." Objecting to a position toward the past that moves tradition "from a role of facilitation to one of inhibition," he directed the attention of his students to contemporary architecture, to bridges, to photography, to commercial typography and advertising, to abstract art and to early American crafts. He spent both of his sabbaticals and several summers in Mexico, Central America and the Southwest, and the Pre-Columbian art of these areas had a profound impact on his art and his teaching. In fact he discouraged the obligatory European study period and encouraged his students instead to travel to Mexico.[2]

The role of the arts in a culture and in education was a theme that was reinterpreted throughout the college's history. Albers recalled that when asked on his arrival at Black Mountain what he hoped to accomplish, he "uttered (better stuttered) 'to open eyes.' " Although he later noted that by this he meant "to open [the student's] eyes to the phenomena about him," or to allow him to see, clearly for Albers "seeing" encompassed the broader concept of "vision." He wrote of his goal, "We want a student who sees art as neither a beauty shop nor imitation of nature, as more than embellishment and entertainment; but as a spiritual documentation of life; and who sees that real art is essential life and essential life is art." He objected to the neglect of the manually oriented student in education, to the acquisition of knowledge as an end in itself, and to the emphasis on classification and systems, insisting that life is process and change and far more complex than any system. Because action is inherent in the creation of art forms, he felt that through the practice of the arts the student would develop independent thinking, productiveness and a creative, inventive approach to problem solving. "We are content," Albers wrote, "if our studies of form achieve an understanding, vision, clear conceptions, and a productive will." He referred to the fascist masses in Europe as "an uncreative crew" and made a distinction between the person who by his example gives direction to the lives of others and the leader who needs followers. Furthermore, he wrote, ". . . art is a province in which one finds all the problems of life reflected—not only the problems of form (e.g. proportion and balance) but also spiritual problems (e.g. of philosophy, of religion, of sociology, of economy)."[3]

Critical to Albers's teaching was his perception of the artist as form-giver and of art as a "documentation of human mentality through form." In a key statement which he began formulating soon after his arrival at the college and which appears in the notes of students, Albers summarized his ideas about the relationship between form and cultural values:

> *Every perceivable thing has form.*
> *Form can be either appearance or behavior.*
> *But since appearance is a result of behavior,*
> *and behavior produces appearance,*
> *every form has meaning.*

The shortest formulation of this is:
 Every thing has form,
 every form has meaning.

To understand the meaning of form,
 that is conscious seeing of and feeling for form,
 is the indispensable preliminary condition for
 culture.

Culture is ability to select or to distinguish
 the better, that is the more meaningful form,
 the better appearance, the better behavior.
Therefore culture is a concern with quality.
Culture can be manifested in two ways:
 Through recognition of better form
 and through producing of better form.
The latter direction is the way of art.
Art as the acting part of culture
 is therefore its proof and measurement.

The content of Albers's courses in drawing, design and color was "the knowledge and application of the fundamental laws of form"; the goal, "a sensitive reading of form." Albers observed that though "imagination and vision," both of which are essential to the creative process, can only be a byproduct of study, "discovery and invention" and "observation and comparison" which "aim at open eyes and flexible minds" can be taught. "The layman or spectator," he proposed, "as well as the practicing artist—does see, recognize, compare, judge form in its psychic effect. To produce form with psychic effect, that is form with emotional content, makes an artist." He argued that the general student would benefit more from a course in the study of the elements of form than one in sculpture or painting because "a color correctly seen and understood [is] more important than a mediocre still-life."[4]

At Black Mountain Albers adapted the curriculum of the Bauhaus, a professional art school, to general education. His courses offered an alternative to the predominant methods of art education: the Beaux-Arts practice of copying the art of the past, the use of scientific formulas, and the untutored self-expression encouraged by progressive educators. The core of the visual arts curriculum, designed for both the general student and the beginning art student, was the courses in drawing, design (*Werklehre*), color and painting which were supplemented by projects in the workshops. Ideally the college would have offered courses in painting, printmaking, sculpture and other areas of the visual arts for the advanced student, and the workshops would have been well-equipped and directed by master craftspersons. The size and limited financial means of the college, however, did not allow for so large an art faculty and such elaborate facilities.

The basic course that was taken by most members of the community, including faculty, was drawing. Its goal was "a disciplined education of the eye and hand"; its content, exact observation and pure representation. Beginning students were challenged to draw from memory the motif from their cigarette pack, a favorite candy bar or a soft drink to make them aware of how poorly trained visual memory is. To develop an ability for visualization—"thinking before speaking"—the student looked at a flat sheet of paper or a leaf and drew it as if it were folded on an imaginary axis. Exercises in mirror writing and in disposing—drawing an image like the meander again and again in the same or different sizes—developed motor control and visualization. In one exercise the students drew in the air, and in another they drew "blindfolded," looking only at the model. Quick line drawings were made to capture the essence of forms. Techniques such as crosshatching and shading and consideration of decorative elements were left for advanced studies after the college. Early in his American experience, Albers came into conflict with local mores when some of the women at the college became concerned about possible reaction in the local community to the use of nude models. Though he declared that it was "all nonsense...[and] he wasn't going to let a lot of old women in the outside community who were nothing

but a bunch of prudes run the College," he acceded and models wore shorts and halters or bathing suits.[5]

Albers defined basic design as "practicing planning," not "habit, dreaming, or accident (as nails dropped from a carpenter's pocket as he walks on a road)." Students explored principles of design such as proportion, described by Albers as the relationship of parts to one another and the whole, symmetrical and asymmetrical design, geometric and arithmetic progression, the Golden Mean and the Pythagorean theorem. Spatial studies in illusion, density, intensity, size and foreshortening were investigated using matches pasted flat on surfaces and straight pins applied vertically or diagonally to supports. Streamlining in natural and manmade forms was discussed in terms of the movement of a fish through fluids, a drop of water through air and a knife through solids. Central to all of Albers's courses were the principles of Gestalt theory in which the image is read as a whole and for meaning. He was especially influenced by Indian designs in which the figure and what is usually treated as background are of equal importance, and he challenged doubtful students to determine whether the zebra is a black animal with white stripes or white with black stripes.[6]

Albers initially called the design course *Werklehre*—learning through doing—to distinguish it from the usual course which deals primarily with designs on paper rather than with materials. Studies of materials—both in combination (the surface appearance of materials) and construction (the capacity of materials)—were made in direct contact with material, not from a textbook or at the drawing board. Paper was folded and scored to give it tensile properties. Other materials were examined for the structural qualities that developed as they grew, for surface qualities created by treating with tools, and, of greatest importance, the total surface appearance which Albers called *matière*—"how a substance looks." The constant themes were relativity and interaction: "Matière influences nearby matière, as color influences color." Students were encouraged

to do things to materials to give them qualities they do not normally have in order to extend the possibilities of their use: "Nothing can be one thing but a hundred things." Students learned that "visually a pebble is as valuable as a diamond" and that both the Breuer tubular steel chair and the locally crafted slat-back chair represent good design and "a thinking out of materials." Materials were examined for their tactile as well as their optical qualities. By juxtaposition and changes in quantity the students made cold materials look warm, soft materials look hard, and one material imitate another in appearance. The "swindel" or visual illusion was not trickery for its own sake but an effort to educate the eye "to the discrepancy between the physical fact and the psychic effect" and to learn new ways of seeing and using materials.[7]

Students' color notes begin with the statement, "COLOR IS THE MOST RELATIVE MEDIUM IN ART." The themes of interaction and relativity and the subjective nature of one's reading were central to the color studies, as they were in the design course. Although he taught the color theories of Goethe, Weber-Fechner, Ostwald and others, Albers realized that the visual process, encompassing both the physical and psychic aspects of seeing as well as the interplay of other senses such as smell and hearing, is far too complex to be explained by a single theory. Rather than formulating a new color theory, he provided the tools for a better understanding of the nature of visual perception. In one exercise a single color was placed on different backgrounds to make it appear to be two different colors, and in another different colors were placed on different backgrounds to make them appear the same. Color was studied in terms of quantity, tone, placement, intensity, contrast, shape and repetition. In studies in transparency using opaque paper, the intermediate color created by the overlapping of two other colors was sought. In all color studies colored papers were used rather than paints, as it is too easy to mix pigment to achieve a certain effect and too difficult

to re-create the same color if it is needed. The abundant colorful leaves of the Blue Ridge were also employed in both the color and design classes. Albers's students often were captivated by the exercises; however, he admonished them that "As knowledge of acoustics does not produce musicality, so knowledge of color theory does not produce art."[8]

Painting, which was taught as an advanced color course, primarily involved the use of watercolor. Of this course Albers wrote, "The studies are in principle concerned with the relationships between color, form, and space. Serious painting demands serious study. Rembrandt, at the age of thirty, is said to have felt the need of twenty years of study for a certain color-space problem."[9]

Albers was opposed to the teaching of conventional art history with its emphasis on classification, identification and chronology to beginning students. He posited that it was unproductive and sterile and "ends too often in factual description and sentimental likes and dislikes instead of in sensitive discrimination." Yet in his classes he constantly referred to works of art and architecture. He believed that the teacher and artist had to have a point of view—"let us be no all-eater, no all-reader, no all-believer, let us be selective instead of being curious," he said—and it was largely in his comments on historical monuments that his preferences and prejudices were revealed. Fascinated by structures, Albers was especially critical of the architecture of the Renaissance, which he described as the "dark age of architecture," because it disguised structure and textures with decorative elements and of Baroque art, a style in which he observed, "the wind in the clothing was more important than [the] saint underneath." He favored medieval architecture, comparing it to the tectonic structure of an insect, as opposed to the atectonic structure of the elephant which shows "no bones only skin with flesh under it." In student notes one finds references to the cathedral and Loggia dei Lanzi of Florence, Santa Sophia, Moorish mosques, Russian onion domes

(created to shed snow), the supports of the college dining hall, the structure of the Moravian star and the use of parallel diagonals by the Greeks, medieval masons and Michelangelo as well as a comparison of the old Stone Bridge (Steinerne Brücke) in Regensburg with the George Washington Bridge in New York.[10]

Albers gave "silent concerts" of slides which were projected with little or no commentary. One such lecture showed only pitchers of pottery, glass, aluminum and other materials. In another a series of Pre-Columbian sculptures was followed by a Classical Greek statue and, in still another, only methods of treating eyes in painting and sculpture were shown. Albers was interested not only in formal elements, but also, as exemplified by the eyes in the paintings of Goya, in art that offers "revelation" rather than "representation." Periodically he taught Seeing of Art, a course in which styles of painting or works of art were analyzed. Lectures were supplemented by traveling exhibitions that came to the college and by shows of the work of visiting artists.[11]

In an application for funds for the college workshops in weaving, woodworking, bookbinding, photography and printing, Albers wrote that at Black Mountain art was not limited to "fine arts" but was defined in the broader context of design and "constructive work whose basis may be any one of many crafts." The student had an opportunity in the workshops to apply the principles studied in the basic courses to practical situations and to understand the underlying rules of various crafts. In an article on the value of the crafts to the training of architects, Albers argued that lack of understanding of both new and traditional materials in modern architecture "often discredited good ideas" and that the solution was "to integrate design with craftsmanship." He objected to the rejection of machine products and the romantic glorification of anything made by hand, no matter how poor the craftsmanship. Although most of the workshops had only basic equipment, they served the community's needs by

repairing books and producing furniture, programs for concerts and other performances, administrative forms, publicity photographs and textiles for special uses. Practical requirements and financial limitations precluded visionary or extravagant schemes, yet the products of the workshops demonstrate an inventiveness and imaginative accommodation to the circumstances. Furthermore, the practical demands of the community gave the projects a constructive value not attained in the typical courses in which students merely dabble in several crafts. Albers viewed photography, which at the time was taught primarily in science departments, if at all, as a new handicraft with still unexplored possibilities, noting that "...the photographer does not betray his personality as much by craftsmanship as by the intensity of his vision...." Ceramics was not taught during the Albers years as he felt that clay does not offer enough resistance for the beginning student and is too easily misused as a material. The architecture curriculum, added in 1940 as a consequence of the need for new buildings at the Lake Eden campus, included the basic courses, experience in the workshops and construction.[12]

Beginning in 1944 the students had the opportunity to study with leaders in all areas of the visual arts in the special summer sessions. The faculty included Jean Charlot, Lyonel Feininger, Amédée Ozenfant, Robert Motherwell and Willem de Kooning in painting; Barbara Morgan, Fritz Goro and Josef Breitenbach in photography; Walter Gropius, Charles Burchard and Buckminster Fuller in architecture; Leo Amino, Mary Callery, Concetta Scaravaglione and Richard Lippold in sculpture; and Leo Lionni and Will Burtin in typography. For the summer sessions Albers tried to invite artists whose work was unlike his own, and he did not dictate to them how or what they should teach.

As the college became known throughout the United States for its art curriculum, more students interested in professional careers in the arts came to study there. Among Albers's Black Mountain students are paint-ers and sculptors Ruth Asawa, Elizabeth Jennerjahn, W. P. Jennerjahn, Kenneth Noland, Oli Sihvonen, Kenneth Snelson, Robert Rauschenberg, Ray Johnson, V. V. Rankine, Elaine Urbain, Robert de Niro and Susan Weil; book illustrators Ati Forberg, Margaret Williamson Peterson and Vera B. Williams; fiber artists Lore Lindenfeld, Dorothy Ruddick, Eini Sihvonen and Claire Zeisler; and architects and designers Don Page, Si Sillman, Henry Bergman, Robert Bliss, Charles Forberg, Claude Stoller, Albert Lanier and Harry Seidler. Albers constantly warned his students not to get on his or anyone else's "bandwagon," and the range and quality of the professional work of students and the fact that there is no "Black Mountain School of Art" is perhaps the best testimonial to the success of his curriculum.

Unlike faculty members who spent a great deal of time socializing with the students, Albers's contact came primarily through his teaching. He was not an easy teacher to get along with, and many students objected to his authoritarian manner. He was dogmatic without being doctrinaire, and he expected his students to complete the given exercises. One recalled that Albers's influence could be negative on some of the students who lacked his intensity and liveliness, because he "created a purity orientation on impressionable people sometimes to a fault and they became antiseptic." Robert Rauschenberg commented in retrospect, "Albers was a beautiful teacher and an impossible person....He wasn't easy to talk to, and I found his criticism so excruciating and so devastating that I never asked for it. Years later, though, I'm still learning what he taught me, because what he taught had to do with the entire visual world....I consider Albers the most important teacher I've ever had, and I'm sure he considered me one of his poorest students."[13]

Albers was a "teacher who [gave] his class first-class mail instead of printed matter," and his program bore little resemblance to the sterile, uninspired design and color curriculum that later became the academic standard in the universities. His method

of teaching was "a 'pedagogy of learning' rather than a 'pedagogy of teaching.' " Problems, not solutions, were presented and those assigned in one class were worked on independently and discussed in the next. Rather than constituting a solution, however, each study was the catalyst for another problem. Albers objected to the idea that theory should precede practice just as he distinguished connotative thinking, which produced poetry, from denotative thinking. Opposed to overvaluation of student achievements, he chided those who signed their studies as if they were works of art and encouraged them instead to throw them out in order to keep the process of growth open and learn many ways of doing and seeing the same thing, which was the path "to freedom, avoiding the Demagogue."[14]

Nancy Newhall described Albers as an "electric current" in class. His intensity and animated manner, in which his gestures and eyes conveyed as much information as his words, perhaps grew out of his early teaching experiences, when he knew only a few words of English. He took a paternalistic interest in his students, and he felt it his responsibility to teach values, to give a sense of direction and to warn against blind alleys and pitfalls. For Albers the problems of art and life were inseparable, and student notes are sprinkled with homilies and advice:

> Fight *symmetry because it forces you from habit, as an educational method…it gives self-discipline.*
>
> *In art the concern is not what is right or wrong.*
>
> *Harmonious working together can be dangerous. Education is not a matter of entertainment but of work.*
>
> *Thinking in situations is just as important as thinking in conclusions.*
>
> *Emotionally meaningful form depends on relationship.*
>
> *No solution is an end.*
>
> *Great design is simple. Save your energy, save*

> *your scissors.*
>
> *Creation means seeing something in a new way. A new sensation tickles us.*
>
> *Simplicity means the reduction of complexity. To be simple today is a social obligation.*
>
> *Good design — proportion of effort to effect.*
>
> *One lie told many times becomes truth (!!!)*
> > *Multiplied attention*
> > *See Hitler!*
> > *Value of repetition.*
>
> *Watch what's going on & capture the accident.*
>
> *All art is swindel.*[15]

A Black Mountain student recalled Albers pointing out that a short whisk of the broom before sweeping the trash in the pan will keep the dust from fogging. Another mentioned his raising glass cups at afternoon tea to observe the variation in intensity of color in relation to volume of tea. As a community member Albers did not hesitate to chastise the women students who wore their shirttails out (thus breaking the aesthetic lines of the body) or to caution an aspiring artist to put his time and money into his art rather than a fancy studio. Jean Charlot once found Albers on the farm building a fence for the pigpen. As there was only one hammer, Charlot sketched the horse while they talked. In Albers's own small garden, lilies and cactuses flourished alongside lettuce and radishes, and, unimpressed with American white bread, he had pumpernickel shipped from New York. Truly, at Black Mountain teaching was "round the clock and all of a man. There was no escape. Three meals together, passing in the hall, meeting in classes, meeting everywhere, a man taught by the way he walked, by the sound of his voice, by every movement." For Josef Albers art education at Black Mountain was education of the head, heart and hand. "It is inadequate to call real teaching a job," he wrote. "We like to see it as a kind of religion based on the belief that making ourselves and others grow — that is, making, stronger wiser, better — is one of the highest human tasks."[16]

NOTES

1 Josef Albers, "Art as Experience," *Progressive Education*, vol. 12, October 1935, p. 392.

2 Josef Albers, unpublished lecture given at the Black Mountain College Meeting at The Museum of Modern Art, New York, January 9, 1940 ("significant"); Josef Albers, "Truthfulness in Art," 1939, unpublished essay; Josef Albers, "Present and/or Past," *Design*, vol. 47, April 1946, p. 17 ("role"). Copies of all unpublished material by Albers which is cited are in the Josef Albers Papers, Yale University Library, New Haven.

3 John H. Holloway and John A. Weil, "A Conversation with Josef Albers," *Leonardo*, vol. 3, October 1970, p. 459 ("uttered"); Josef Albers, "Concerning Art Instruction," *Black Mountain College Bulletin*, no. 2, June 1934 ("phenomena," "content," "province"); "Art as Experience," p. 393 ("beauty shop"); Museum of Modern Art lecture ("uncreative").

4 Josef Albers, "Every perceivable thing has form," unpublished essay, n.d. ("documentation," "layman"); "Concerning Art Instruction" ("knowledge," "correctly"); Josef Albers, "ART AT BMC," December 1945-January 1946, unpublished essay ("imagination," "sensitive," "discovery," "observation," "aim").

5 Black Mountain College catalogue for 1936-37, p. 10 ("disciplined"); Josef Albers, "On General Education and Art Education," unpublished lecture given at the Denver Art Museum, July 1946 ("thinking"); Theodore Dreier to John Andrew Rice, March 1, 1935, Theodore Dreier Papers, private archive ("nonsense").

6 "ART AT BMC" ("practicing"); Design notes of Irene Cullis ("habit").

7 Design notes of Irene Cullis ("how," "Matière," "visually"); Design notes of Jane Slater Marquis ("Nothing"); "Truthfulness in Art" ("thinking").

8 Color notes of Irene Cullis.

9 "Concerning Art Instruction."

10 "ART AT BMC" ("ends"); "Truthfulness in Art" ("let us"); Design notes of Lore Kadden Lindenfeld ("dark age"); Design notes of Margaret Balzer Cantieni ("wind"); Design notes of Jane Slater Marquis ("bones").

11 "Truthfulness in Art," p. 3 (Goya); "Art as Experience," p. 391 ("revelation").

12 Josef Albers to F.P. Keppel, March 18, 1941, Black Mountain College Papers, North Carolina State Archives, Raleigh ("constructive"); Josef Albers, "The Educational Value of Manual Work and Handicraft in Relation to Architecture," in *New Architecture and City Planning: A Symposium*, Paul Zucker, ed., New York, Philosophical Library, 1944, pp. 690, 688 ("discredited," "integrate"); Josef Albers, "Photos as Photography and Photos as Art," n.d., unpublished essay ("betray").

13 Interview with John Stix, Black Mountain College Project Papers, North Carolina State Archives, Raleigh, no. 179, May 8, 1972 ("created"); Calvin Tomkins, *The Bride & The Bachelors: Five Masters of the Avant-Garde*, New York, Viking Press, 1968, p. 199 (Rauschenberg).

14 Museum of Modern Art lecture ("teacher"); L.H.O., "A Teacher from Bauhaus," *The New York Times*, November 29, 1933, p. 17 ("'pedagogy'"); Design notes of Jane Slater Marquis ("freedom").

15 Interview with Nancy Newhall, Black Mountain College Project Papers, North Carolina State Archives, Raleigh, no. 139, January 30, 1972; Class notes of Ati Gropius Forberg ("Fight," "Thinking," "swindel"); Si Sillman ("right," "Harmonious"), Jane Slater Marquis ("Emotionally," "No," "Great"), Lore Kadden Lindenfeld ("Creation"), Marilyn Bauer Greenwald ("Simplicity"), Margaret Balzer Cantieni ("Good," "One," "Watch").

16 John Andrew Rice, *I Came Out of the Eighteenth Century*, New York and London, Harper & Brothers, 1942, p. 322 ("round"); Museum of Modern Art lecture ("inadequate").

A Structural Analysis of Some of Albers's Work

CHARLES E. RICKART

I became acquainted with Josef Albers roughly thirty years ago at Yale University. We were both Fellows of Saybrook College and at lunch would often discuss the possible connections of his work with mathematics. Albers suspected that his graphic constructions had a significant relation to mathematics and naturally thought that the connection derived somehow from his use of geometric figures. Although this belief is partially true, there is, in my opinion, a much deeper and more subtle contact with mathematics. I have in mind here the conceptualization rather than the formal presentation of mathematics. The visualization of certain mathematical notions appears to be very close to the perceptual experience produced by an Albers work, and an analysis of the latter suggests that similar experiences may occur in many other fields, including the sciences. In a science, however, phenomena of this kind are normally quite irrelevant to the actual subject matter and so are of little interest to most of its practitioners. This is especially true in mathematics, although there are some notable exceptions to the rule.[1] In any case, one cannot work in a field without thinking about it, so conceptualization must occur whether or not it is formally recognized.

The germ of the ideas presented here dates back to my first serious examination of Albers's art, which occurred soon after I met him. It primarily concerns the illusion of motion that is produced by many of his works. There are some brief comments on this effect in my book *Structuralism and Structures*, where I use it to exemplify certain features of the mind's ability to deal with structures.[2] The present essay grew out of those comments.

Although I communicated my early thoughts on the subject to Albers many years ago, I never obtained a very definite reaction from him. Therefore, since the ideas seemed so natural to me, I concluded that Albers probably regarded them as either obvious or naive, and I did not press the matter. Upon reflection I have come to believe that either I failed to make my point or my rather prosaic ideas did not fit in with his own very poetic explanations of his work. I also recognize that Albers was interested in myriad other visual effects along with a wide variety of techniques for producing them, so the illusion of motion might have appeared a relatively small part of the whole. In any case I believe that the issue of how or why one experiences this illusion is important not only because it bears on most of the other effects his work can produce, but also because it casts some light on the way the human mind processes certain information. Artistic creations like those of Albers, because they are so pure and uncluttered, are especially appropriate for probing such workings of the mind. And as I have emphasized in my book, mathematics, though less accessible, can play a similar role for the same reasons.

Since I am in no sense an expert on art, the point of view outlined here is not only very limited but also lacks the usual embellishments expected in a commentary of this kind. An expert will probably note places where I have overlooked contributions by others or have naively belabored ideas perhaps obvious to everyone else. I hope that the reader will make the necessary allowances. Finally I would like to thank Nicholas Weber, who is so familiar with everything concerning Albers, for his kind encouragement, without which I never would have had the nerve to attempt this project.

The following discussion, as already indicated, proceeds from the point of view of general "structures." Underlying this approach is the observation that the mind, in an attempt to deal with presented material, will automatically structure, in some form or other, the information contained therein. As we might expect, the structuring process is very intimately connected to understanding and tends to operate only on potentially "meaningful" information. Moreover, the process is actually "built-in" and so does not have to be learned, though it is modified by experience and may develop differently according to the individual. Some awareness of the process, despite its automatic character, may facilitate the formation and improve the quality of the result, as well as add greatly to our understanding of how the mind deals with information. Although the structures involved in the process may be extremely complex, those considered here are relatively simple and, up to a point, not very difficult to analyze.

All creative activity is highly structural in character, involving first of all the mental structuring processes of the originator. But it also involves the individuals to whom the fruit of this activity is directed. The work carries a message, and the originator must take into account, perhaps unconsciously, the manner in which it will be received. This amounts to an anticipation of how a prospective recipient may structure the information contained in the message.

In fact the product normally contains many features designed to influence this structuring process, and they are often surprisingly detailed. Techniques for exercising such control vary greatly in kind and complexity. A simple and familiar example is an artist's use of composition to influence the way in which a viewer's attention moves from one portion of a painting to another. A quite different example is the careful organization of a good piece of writing. Controls of this type, which usually operate very subtly, play an especially important role in Albers's art.

Albers's graphic constructions, which consist of highly structured arrangements of line segments in a plane, are by far the easiest of his works to analyze. Though *two*-dimensional, the line arrangements are such that they are perceived immediately, by most observers, as representations of *three*-dimensional objects in space made up of various plane sections. Yet the viewer quickly becomes aware that no such objects can exist in real space. It is this setup, with its apparently conflicting message, that gives rise to the illusion of motion. The objective of the present essay is to try to explain exactly how and why this happens. For simplicity's sake most of the detailed analysis that follows is confined to just one of the graphic constructions.

It is worth noting that there are individuals who are unable to experience this sense of motion. One possible explanation for this may be a limitation in their ability to visualize three-dimensional objects as represented by two-dimensional figures. In fact I have encountered a few students who, as far as I could tell, were unable to "see" three-dimensional objects represented by carefully rendered drawings on the chalkboard. Unfortunately such persons will be denied the unique experience that most of us enjoy in viewing the Albers constructions.

Now let us consider the two figures that follow, which are reproduced in Albers's delightful little book, *Despite Straight Lines*.[3]

They constitute the last in a group of four pairs that are accompanied by the following poetic comments by the artist:

4 Pairs of Structural Constellations

Within a formal limitation of equal contours as mutual silhouette, these pairs show different but related plastic movements of lines, planes, volumes.

*Thus, they change
in motion: from coming to going,
in extension: from inward to outward,
in grouping: from together to separated,
in volume: from full to empty,
or reversed.*

And all this, in order to show extended flexibility.

J.A.

It is clear from his remarks that Albers's primary objective in the drawings was to create a complex illusion of motion for the viewer. He accomplished this by arranging the lines in remarkably clever ways. I will next examine the actual process by which the impression of motion is produced. It will be sufficient to concentrate on the top member of the pair.

We observe first that although the complete figure cannot be read in any way as representing a spatial object, certain of its parts can be so interpreted, often in more than one way. Moreover, in each case the only ambiguity is in which interpretation the viewer fixes upon. For example when we consider the reproductions on the facing page of three over-lapping parts of the figure, we note that *b* and *c* may be obtained from *a* by adding symmetric portions of the complete figure.

Part *a* admits two three-dimensional interpretations: the first, in which the middle panels extending from top left to bottom right appear to slope away from us (*1*); and the second, in which they appear to slope toward us (*2*). We note that in *1* we are looking up at the panels and in *2* we are looking down on them. In the case of *b* there is only one possible reading, since the additions to *a* which yield *b* "force" an interpretation consistent with *1*. This occurs primarily because the U-shaped addition on the right admits a unique interpretation in which we are looking up at its base. This view is reinforced by plane segments such as the one labeled Q. Similarly, *c* admits only the interpretation consistent with *2*. Therefore the complete figure, because of the conflicting readings demanded by its parts *b* and *c*, cannot represent a three-dimensional object. In other words, as far as relevance to a "real" object is concerned, the information contained in the figure is definitely contradictory. It is interesting to recall that Albers called these constructions "illogical" and in conversation referred to them as "my nonsense."

Both the mind's persistent drive to extract meaning from information, and its tendency to interpret two-

a *b* *c*

dimensional, perhaps retinal data as if it originated in a three-dimensional object, are universal automatic responses essential for coping with the outside world. However if the given information contains an obvious contradiction, the natural response would seem to be to reject it as irrelevant. Therefore in the case that interests us, we might expect an observer to abandon any attempt to make a three-dimensional interpretation of the figure and simply accept a two-dimensional picture. That this does not normally occur suggests that the drive to interpret figures in three dimensions and to acquire useful meaning is more basic than the intellectual demand for logical consistency.

We must not conclude, however, that the mind blindly accepts contradictory information. In fact it appears to abhor a contradiction, and when one does arise in a presumably meaningful situation, the mind will attempt to resolve it at all costs. Resolving an obvious contradiction such as the one we are considering would seem to require a bit of magic. Indeed the result is rather magical, though the trick is actually quite simple—just change the rules of the game.

As already suggested the mind's initial impulse is to interpret two-dimensional information as coming from a *fixed* three-dimensional object. Since this is not possible, something has to yield. The trick is to allow a solution that is *not* fixed. This additional freedom allows the mind to create an illusion of a *variable* three-dimensional object, one that may change from a particular form to another, so that some part of it, in each state, will represent a valid portion of the given information. Thus, a shift of attention from one part of the given figure to another part, instead of resulting in frustration and confusion, actually provides the drive for transforming the illusory object from one state to another.

This analysis may be applied to the bottom element in the illustrated pair and, in fact, to any of Albers's graphic constructions that produce an illusion of motion. It even applies to parts *a*, *b* and *c* of the top figure in the pair. In the case of *a*, we observe that the ambiguity of two valid interpretations is itself a contradiction which may be resolved by a shift of attention from one interpretation to the other, giving the "flip-flop" motion common to many ordinary optical illusions. Part *b* produces an effect similar to that of the complete figure but much weaker. This arises because the one valid three-dimensional interpretation, though tending to dominate, is challenged locally in the left portion of the figure by the contradictory interpretation consistent with 2. The same effect occurs in the case of part *c*.

It should be noted that the above analysis addresses only a few basic features of the actual experience,

which is considerably more complex than might be expected. For example, in addition to the transformation of inside or outside corners into their opposite, so familiar in ordinary optical illusions, the middle planes appear to twist and turn as they change their directions. There are also subtle local effects, one of which is illustrated by the behavior of the three plane segments *P*, *Q* and *R* indicated in *b*. In what is usually the first interpretation of *b*, *Q* and *R* together constitute a plane segment that appears to lie behind *P*. However in the contradictory, local interpretation, obtained by starting at the upper left, *R* sits forward of *P* while *Q* joins the two and forms an angle with each. Thus, in the transitions, the plane formed initially by *Q* and *R* undergoes a flexing motion. We also discover that once we are caught up in this experience, we are virtually forced to take an active role in the process by orchestrating the transformations, exploring local effects and trying to recover or re-create effects after they have disappeared.

Finally, as Albers suggested in his comments on the "4 Pairs," the illusory objects associated with the two figures in a given pair also interact with one another—an effect somewhat more difficult to elicit—and this further enriches the total experience. The result has a dynamic quality wholly unique to Albers's art. All of the effects are carefully planned by the artist and are brought about by means of a very precise and subtle placement of line segments, sometimes appropriately emphasized, which direct and control the observer's attention. Needless to say, a full appreciation requires an extended period of relaxed and patient viewing. It is also helpful to read Albers's own comments on some of the individual constructions included in *Despite Straight Lines* and on his teaching methods described in *Search Versus Re-Search*.[4]

An analysis similar to the above may be applied to Albers's color constructions. Like the graphic constructions, they produce an illusion of motion by virtue of the contradictory messages they carry. In this case, however, the messages involve certain subtle characteristics of color perception which are not very familiar or obvious to the inexperienced observer. As far as motion is concerned, the property of interest is that in a collection of colors, some will be seen as advanced or receded in relation to the others. The perception will depend, of course, on the relative masses, intensities and arrangement of the various colors. Moreover, these effects can occur between different shades of the same color, even gray. Albers's well-known book *Interaction of Color* contains illustrations and discussions of these and many other remarkable properties of color perception.[5] Yet in contrast with the line drawings, an explanation of how and why the color constructions produce their effects is not so easily formed.

In these constructions the interaction between the colors of several regions produces messages concerning their relative fore and aft positions. Similar messages may also be conveyed geometrically or by the way the regions overlap. For example some areas may be depicted as semitransparent so that one field will seem as if it is seen through another. If such messages are contradictory, the stage is then set for an illusion of motion, just as in the previous case. The result, however, has a character somewhat different from that of the drawings. Here, perhaps because of a qualitative difference in the messages, the motion tends to be smoother and less cyclic. In fact all of the color effects, as compared to the graphics, are quite subtle and more difficult to analyze. This is especially true for certain of Albers's ubiquitous *Homages to the Square*.

An expert could no doubt cite many other examples of works of art, such as certain sculptures, which produce effects analogous to those we are discussing. Moreover, the phenomenon is not confined to visual perception. Settings for it are easy to identify in many fields, such as physics, mathematics, music, poetry and literature. Their common feature is that each

presents to the mind, in one form or another, a challenge to integrate into one meaningful whole two or more conflicting or perhaps competing sets of information. The product of the synthesis will generally have a character quite different from the separate components. And when the information is not visual, the results are usually more difficult to describe and therefore appear to be more subjective. But the present essay is not the place to attempt a detailed analysis of these examples.

One more comment should be made concerning abstract works such as those by Albers. As already indicated, although the mind will normally strive to make sense of presented information, that effort will be aborted without some evidence of its potential meaningfulness. In some cases the opinion of an authority on the subject or the simple fact that the work exists may suffice as evidence. For the Albers constructions, it is provided in part by the three-dimensional fragments contained in the figures. However another source is at least as important as any of these. It is a sense of the artist's competence and integrity, with the consequent assurance that the work does have content. Although with some artists such assurance may be rather elusive, this is not true of Albers—his superb technique and the resulting meticulous constructions leave little room for doubt. Few observers will have any trouble accepting the challenge to participate in the rewarding creative experience that Albers's graphic and color constructions offer.

NOTES

1 See Jacques Hadamard, *The Psychology of Invention in the Mathematical Field*, New York, Dover Publications, 1854; Marston Morse, "Mathematics and the Arts," *Bulletin of the Atomic Scientists,* vol. XV, February 1959, pp. 55-59 (reprinted from *The Yale Review,* vol. 40, Summer 1951, pp. 604-612); and Henri Poincre, *Foundations of Science,* G.H. Halstead, trans., New York, The Science Press, 1913.

2 Charles E. Rickart, *Structuralism and Structures: A Mathematical Perspective,* forthcoming.

3 Josef Albers and François Bucher, *Despite Straight Lines,* New Haven and London, Yale University Press, 1961, pp. 52, 55.

4 Josef Albers and François Bucher, *Despite Straight Lines*; Josef Albers, *Search Versus Re-Search,* Hartford, Trinity College Press, 1969.

5 Josef Albers, *Interaction of Color,* New Haven and London, Yale University Press, 1963; paperbound, 1971.

New Challenges Beyond the Studio:
The Murals and Sculpture of Josef Albers

NEAL BENEZRA

In October 1949 Walter Gropius invited his longtime friend and former Bauhaus colleague Josef Albers to design a large brick wall in a new graduate commons building that his firm, The Architects' Collaborative, had designed for Harvard University. Although Albers had never worked in brick, he had completed a number of art-in-architecture projects in the 1910s and 1920s, and he was pleased by the new challenge. The completed work, *America* (fig. 1), encapsulates Albers's views on the ideal interaction of art and architecture at that time. It is a brick mural consisting of no additive elements whatsoever; instead, the composition resides where the artist removed bricks from the Flemish bond structure that he selected for the wall. That is, the design is conveyed exclusively in the horizontal voids in the wall and the resulting vertical ranges that the aligned spaces create, a formal concept based in the "skyscraper" style which Albers evolved in the 1920s. He described *America* in 1952 as:

> *respect[ing] and preserv[ing the wall] to the last degree possible....instead of making a free arrangement of bricks,...by application of protruding and receding bricks, I decided to keep the flatness of the front intact...just as on the outside brick walls.[1]*

In its conception and even its design, *America* offers a model of Bauhaus-style collaboration, with art serving at the pleasure of architecture. In his program for the Graduate Center, Gropius sought to establish a rhythm of sequentially ordered and interlocking forms and spaces, in both plan and elevation. This formal theme was consistent with his early masterworks, the Werkbund Pavilion in Cologne (1914) and the Bauhaus complex at Dessau (1926), and it was communicated to Albers early in the planning stages of the Harvard project.[2] In deference to his architect, Albers produced a design of tightly interwoven and interpenetrating solids and voids, a composition which responds cleverly to the Gropius plan. Indeed, in his statement on the mural, Albers reaffirmed his strong belief in the responsibility of the artist to conform to the architect's prerogatives in such projects:

> *I believe that any design organically connected with an architectural structure should be related to that structure no matter whether this design is to emphasize or to complete, to change or to correct, the appearance or function of the building or space concerned.[3]*

Albers would complete twenty additional art-in-architecture projects after 1950, and these experiences would radically alter his deferential attitude. This largely unknown body of work includes a wide range of materials and formats, among them photosensitive glass windows, compositions in brick, formica and gold-leaf murals, reliefs in stainless steel and one extraordinary freestanding sculpture. Although the artist's reliance on architects in transforming the unforgiving geometry of his small-scale work to public sites was initially very strong, in time he would seek independence from their

dictates. The story of Josef Albers's art-in-architecture projects is that of a painter venturing outside the secure and established procedures of his studio, and confronting and eventually controlling the appearance of his work in public.[4]

Albers's respect for architects and architecture was longstanding, dating to the 1920s and his formative experience at the Bauhaus. Conceived by Gropius with the aim of regenerating the arts and crafts under the mantle of architecture, the philosophy of the Bauhaus was delineated by the architect in his often-quoted manifesto of 1919:

> *The ultimate aim of all visual arts is the complete building! To embellish buildings was once the noblest function of the fine arts; they were the indispensable components of great architecture. Today the arts exist in isolation, from which they can be rescued only through the conscious, cooperative effort of all craftsmen.... Together let us desire, conceive, and create the new structure of the future, which will embrace architecture and sculpture and painting in one unity....*[5]

In many ways Albers personified this Bauhaus ideal. A student from 1919 to 1922, he went on to teach at the Bauhaus until its forced closure in 1933. Promoted to the level of journeyman there in 1922, Albers did not paint, but rather involved himself in a number of constructive activities which predisposed him to his later art-in-architecture work. For example he was charged with the reorganization of the glass workshop and taught there; and he executed a number of stained- and single-pane glass compositions. In his later years at the Bauhaus, Albers directed the furniture workshop as well as the wallpaper design program. Indeed, two of his closest friends there were Gropius and Marcel Breuer, and it was through these architects and their students that Albers received many of his subsequent art-in-architecture commissions.

1 *America.* 1950
Masonry brick, 11′ x 8′8¼″
Swaine Room, Harkness Commons,
Graduate Center, Harvard University

2 Pyramid, Tenayuca, Mexico. ca. 1939
 Photograph by Josef Albers
 Collection The Josef Albers Foundation

3 Palace of the Columns, Mitla, Mexico. n.d.
 Photograph by Josef Albers
 Collection The Josef Albers Foundation

Following Albers's emigration to the United States in 1933, he found another crucial source which reinforced his profound respect for the primacy of architects and architecture. Beginning in 1935 Josef and Anni Albers visited Latin America on fourteen occasions.[6] They lectured, worked and traveled during these trips, and in the process they became passionate admirers of Pre-Columbian art and architecture. Albers was particularly enamored of the sculptural character of such monuments as the pyramid at Tenayuca, north of Mexico City, and the exquisite carved reliefs of the Palace of the Columns at Mitla, in Oaxaca, and he took numerous photographs at these and other sites (figs. 2, 3). For him these structures revealed an extraordinary conjunction of architecture and sculpture, a union largely unknown in Europe since the Middle Ages. As a product of the Bauhaus, Albers believed that western culture had emphasized—indeed abused—the notion of creative individuality at the expense of productive collaboration, and he found his idealism confirmed in these magnificent, sun-bleached walls.

While Albers's travels in Latin America intensified his belief in the collaborative ideal, the figure-ground equivalence that prevails in Pre-Columbian sculpture proved an important formal influence in works such as *America*. By the late 1930s Albers came to characterize sculpture as "active volume," a definition which ended the "separation of figure and background and the separation of high and low." Always a strong believer in the humanistic implications of form, the artist also felt that figure-ground equivalence implied a "very valuable social philosophy, namely real democracy: every part serves and at the same time is served."[7]

If *America* exemplified the collaborative process, it also functioned as a prototype for several future efforts in brick. During the 1950s and 1960s, Albers designed five additional brick reliefs, foremost among them a pair of domestic fireplaces in Connecticut homes and a large altar-wall triptych for a church in Oklahoma City. Both fireplaces were

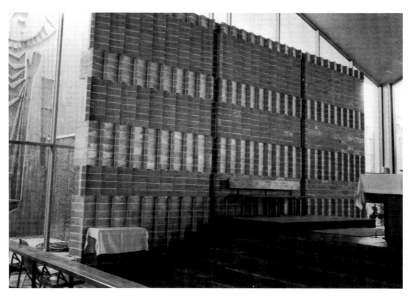

4 *Rouse Fireplace.* 1955
Masonry brick, 8 x 5′
Irving Rouse House, North Haven,
Connecticut

5 *St. Patrick's Altar Wall.* 1961
Masonry brick and gold leaf, 18 x 40′
St. Patrick's Church, Oklahoma City

designed for Albers's friend and colleague, the Yale architecture professor King Lui Wu. A graduate of Harvard's Graduate School of Design, Wu knew and admired *America*, and he commissioned the artist to contribute fireplace designs to two of his earliest projects, the Irving Rouse House in North Haven of 1955 (fig. 4), and the Benjamin DuPont House in Woodbridge of 1958-59.[8] In both instances Albers responded with more sculptural designs than he had produced previously. In them numerous courses of brick are set diagonally into the wall, thus increasing the number of light-reflecting surfaces and creating a strong and vibrant pattern of light and cast shadow.

Albers's largest and most compelling work in brick dating from this period is the *St. Patrick's Altar Wall* of 1961 (fig. 5).[9] Standing eighteen by forty feet and brilliantly colored with gold leaf, the altar wall represents an extraordinary step beyond its predecessors. In design it benefits from the artist's previous brick reliefs, with courses again projecting from the plane of the wall with mathematical regularity. The great size of the wall and its placement in a religious setting suggested the recess of two vertical courses of brick into shadow, thereby dividing the whole into triptych format. Adding to the power of the composition is the gold leaf, which is applied to the lengths but not the ends of the bricks. This enhances the shimmering interplay of light and deep shadow, an effect which heightens the visual intensity of Albers's first important sculpture.

Beyond these formal advances the *St. Patrick's Altar Wall* represents the first instance in which the artist's sculpture dominates an architectural space. The nave is a virtually unmediated horizontal expanse, with

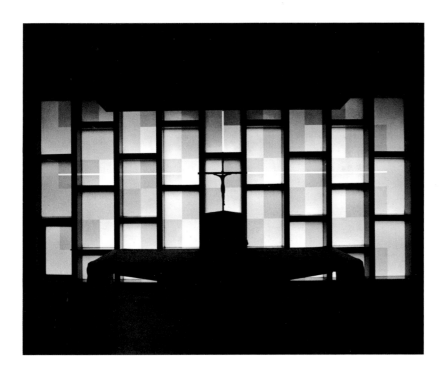

6 *White Cross Window.* 1955
Photosensitive glass, 5 x 11′
Abbot's Chapel, St. John's Abbey,
Collegeville, Minnesota

only a glass wall separating the congregation from an open ambulatory beyond. The altar wall is a compelling, radiant presence, and it rescues the nave from its complete lack of spatial focus. In its dominance of a religious space, the altar wall recalls the retables which Albers had seen in Bavaria in his youth, as well as those in the Colonial churches of Cuzco and Arequipa which he had photographed while in Peru in the 1950s.[10] Indeed, the breadth of the artist's field of aesthetic interest and reference was greater than is often supposed, and he found much inspiration in these retables, transforming them with all his admirable power of restraint into a monument of quiet but compelling spirituality.

The man responsible for the Oklahoma City commission was Frank Kacmarcik, consultant on art and liturgy at St. Patrick's. It was Kacmarcik who proposed Albers to the officials at St. Patrick's and

to the architects of the church, the Tulsa firm of Murray-Jones-Murray. Kacmarcik's knowledge of Albers's art-in-architecture projects was firsthand and longstanding, as he had also served for many years as consultant to the Benedictine community of St. John in Collegeville, Minnesota. In the mid-1950s this had been the site of Albers's work with Breuer, a collaboration which resulted in *White Cross Window* of 1955 (fig. 6).[11]

Installed in the small abbot's chapel of St. John's Abbey, *White Cross Window* is among Albers's most remarkable efforts in any medium. The window consists of thirty-one small panes of photosensitive glass joined by a framework of staggered wooden mullions. The composition—a complex, mathematically ordered arrangement in four shades of gray—is activated by the sensitivity of the glass to light. Such an idea became a realistic possibility only in the

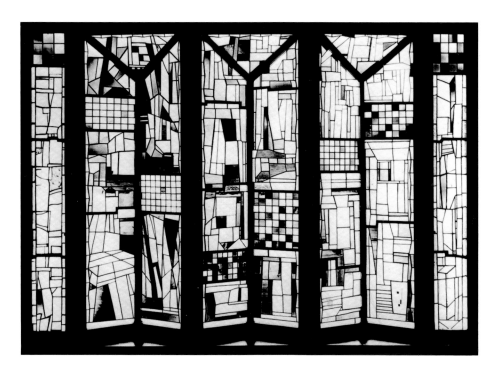

7　*Sommerfeld Window.* 1922 (destroyed)
Stained glass
Sommerfeld House, Berlin-Dahlem

1940s, when scientists discovered that when exposed photographically, a single pane of glass would yield a surprising range of tones within a single hue.[12] Thus Albers could place constrasting shades of gray beside one another without the leading of traditional stained glass. Beyond eliminating the need for leading, this discovery made possible the design of a monochrome window whose tones are not static but instead respond to light in a variety of ways. Because *White Cross Window* is made of photosensitive glass, its composition changes according to the direction and quality of the dominant light-source. As a result, at night, when artificial illumination replaces daylight, the tones of the glass reverse in value—dark areas become light and light areas become dark—an effect which completely transforms the composition of the window as a whole.

Albers's interest in glass can be traced to his child-

hood, as he was trained in the craft of stained glass at home by his father. In fact the artist's first art-in-architecture project dates to 1917-18, when he was asked to design a stained-glass window for a church in his native Bottrop, West Germany.[13] Glass was Albers's primary material throughout the Bauhaus years, and it was on the basis of a body of assemblages composed of discarded glass that he was promoted to the level of journeyman in 1922. In this position he was charged with the reorganization and direction of the glass workshop. While teaching he completed several commissions, the most important of which resulted in the now-destroyed *Sommerfeld Window*, part of the well-known architectural commission for a house in Berlin-Dahlem completed by Gropius in 1922 (fig. 7).[14]

It would be difficult to overstate the important role which glass held in the development of Albers's work.

Geometry only became a consistent element of his art in the mid-1920s, when he perfected a new process for sandblasting glass employing—as he would do with *White Cross Window* some thirty years later—a recently developed industrial technique to create a new form of expression in glass. As early as 1925 Albers had transformed the glazier's traditional craft into an expressly modern endeavor, with the hard-edged templates required for sandblasting yielding the geometry which would characterize his lifelong artistic style.

A postscript must be added to this account of the St. John's commission, since *White Cross Window* was to constitute only the first step of a much larger project. From their correspondence it is clear that both Albers and Breuer considered the window in the abbot's chapel to be experimental. If photosensitive glass could be designed successfully, it would also be employed much more extensively in the Abbey Church. This structure, which was completed in 1961, was to feature an enormous north window-wall consisting of 650 windows by Albers.

By 1958 the artist had finished his design and a now-lost model of the windows, which he presented at the abbey in 1959. Yet through a complex series of misunderstandings, Albers was not awarded the commission; it went instead to a lay member of the faculty at St. John's.[15] Whether the fault lay with Breuer or with the patrons, Albers felt badly betrayed. This was but the first instance in which the artist was victimized by circumstances in his art-in-architecture projects, and he would slowly come to reassess his former idealism regarding the value of collaborative endeavor. This realization would have extraordinary consequences in his later work.

By the late 1950s, Albers's art-in-architecture efforts had become well known among architects. Because of his reputation and that of Gropius and of Breuer, *America* and *White Cross Window* were published extensively, particularly in architectural journals. As a result, Albers, who celebrated his seventieth birthday in 1958, was now offered and accepted an increasing number of commissions. In the main these opportunities were of a much different order than the earlier ones. Although he would work again with Gropius in 1963, most of his new collaborators were not peers but protégés, architects who had been Albers's students at Black Mountain or Yale, or associates of Gropius or Breuer. These jobs often involved the design of murals for skyscraper lobbies, many of which are in New York, and they thus provided Albers with unparalleled opportunities to place his work in public settings. In most cases the artist responded by altering the materials and enhancing the scale of his small-scale work, an ambition which he had long held.

Two of these murals were particularly successful and influential. The first, commissioned and completed in 1959, is *Two Structural Constellations* (fig. 8), a pair of linear configurations incised in gold leaf on one wall of the Corning Glass Building lobby in midtown Manhattan. Composed of a striking black Carrara glass ceiling and crisp white Vermont marble walls, Harrison and Abramovitz's lobby showcases the racing lines of Albers's most refined and elegant mural.[16]

Albers was fascinated by his first urban mural commission, both because it allowed the public greater access to his work, and because he relished the challenge of expressing the pace of New York City. He was thrilled by the dynamism of New York, and he considered the *Structural Constellations*, a series he had begun around 1950 in which diagonal lines predominate, to be equal to the compelling urban rhythm. The *Structural Constellations* were conceived by plotting and then linking points on small sheets of graph paper. By maintaining the same coordinates but altering the lines that join them, the artist could achieve endless variations on a single compositional theme. The *Constellations* exist in drawings, engraved plastic and a variety of graphic media (see cat. nos. 171-176).

Beyond their elegance and effectiveness as mural decoration, when expanded greatly in size the

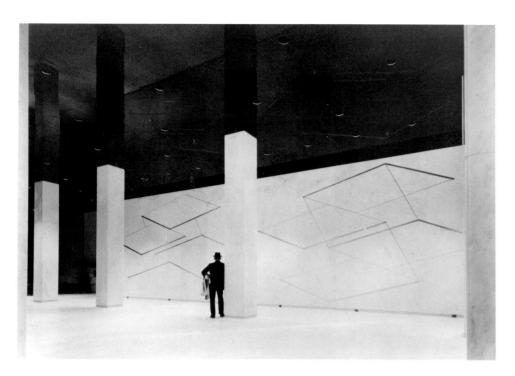

8 *Two Structural Constellations.* 1959
Vermont marble and gold leaf, 16 x 61'
Lobby, Corning Glass Building, New York

Constellations assumed enhanced formal value for the artist. At their original scale, these complex graphic configurations were like puzzles, offering the viewer a range of contrasting linear readings. When monumentalized the *Constellations* appeared more expansive and allusive; compositions which once seemed small and playful now suggested vast spatial enclosures or darting planes. This realization proved provocative for Albers, and he would soon employ the *Constellations* as the predominant motifs of his relief sculptures.

Albers's other major New York mural, *Manhattan* of 1963, is perhaps even more dynamic and successful than the first one (fig. 9).[17] Measuring twenty-eight by fifty-four feet and mounted above the bustling escalators linking the Pan Am Building and Grand Central Terminal, this is doubtless Albers's most frequently viewed work. Commissioned by

Gropius for Emery Roth's Pan Am Building, *Manhattan* is, like *Two Structural Constellations*, a compelling response to a vibrant urban environment. The Pan Am lobby is really a concourse, a well-lubricated architectural machine in which escalators funnel pedestrians at a rapid pace between Grand Central and the surrounding streets of New York.

The work evolved from a suggestion by Gropius, who proposed that Albers adapt *City* of 1928 (fig. 10)—one of the artist's finest sandblasted-glass pictures—to the scale and proportions of the Pan Am site. *City* had been acquired by the Kunsthaus Zürich in 1960 and was reproduced in the museum's journal that same year. Albers possessed numerous offprints of the publication and, in a fascinating reapplication of his own ideas, he used the published black and white photograph of the work as the basis for sketches for the mural (fig. 11).

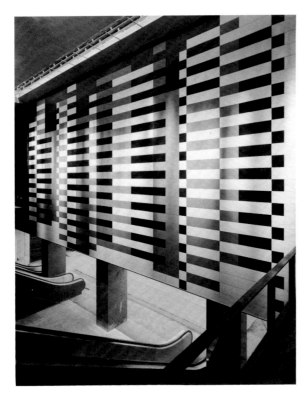

9 *Manhattan.* 1963
 Formica, 28 x 55′
 Lobby, Pan American Airlines Building, New York

11 *Untitled (Study for "Manhattan").* 1963
 Ink and tempera on paper, 4½ x 7½″
 Collection The Josef Albers Foundation

10 *City.* 1928
 Sandblasted glass, 11 x 21⅝″
 Collection Kunsthaus Zürich

In reworking the 1928 design, the artist retained the unit-measure system but expanded the number of red, white and black bars to great advantage. Whereas the "skyscraper" style of *City* and the other sandblasted-glass compositions of the twenties are carefully balanced but only moderately paced arrangements, *Manhattan* features, in Albers's words, "…constant change, overlapping and penetration which lead us up and down, over and back…."[18] In its scale and impact, *Manhattan* is a compelling image of constant flux, brilliantly capturing the unyielding pace of New York City.

Two Structural Constellations and *Manhattan* are among Josef Albers's finest large-scale works, and each had important implications for his future efforts. *Manhattan* would prove to be his last important indoor mural, as it was the final instance in which the site would enhance the artist's design. More often than not, Albers was invited to contribute to architecture which aspired to nothing more than functional clarity, with lobbies designed to move large quantities of people with minimum delay. The specific position of a mural would often be predetermined by the architect, and the artist often found his work obstructed by pillars, columns or other barriers. Although the design and impact of *Manhattan* would influence Albers's last work, for the Stanford University campus, throughout the remainder of his life he would focus primarily on sculpture, particularly the application of the *Constellations* in relief.

Within months after the completion of *Two Structural Constellations*, Albers described a new interest, which he termed "structural sculpture":

> *Following the history of sculpture, it is amazing to see for how long it has restricted itself to volume almost exclusively.... Centuries of predominantly voluminous sculpture are being confronted today by a strong trend toward linear sculpture, toward sculpture combined and constructed.... Finally a few independent*

> *[sculptors] were courageous enough to concentrate on the plane, the in-between of volume and line, as a broad sculptural concept and promise. It is a promise, truly new and exciting: Structural Sculpture. Because it traverses the separation of 2 and 3 dimensions.*[19]

On a formal level it was precisely this conjunction of two and three dimensions which Albers attempted in his late outdoor reliefs. *Two Structural Constellations* introduced this possibility, for it offered him the opportunity to visualize his purely linear work in planar and thus sculptural terms for the first time. The challenge he assumed lay in the possibility of creating three-dimensional illusion through strictly two-dimensional means. He achieved this by constructing *Constellations* of stainless steel and on a large scale, and affixing the reliefs to the facades of prominent buildings. Perhaps more important, these works also signaled a shift away from Albers's initial attitude of deference to his architect. In them the artist emphatically proclaimed the lines of his sculpture as possessing the strength to challenge the masses and materials of architecture.

The first occasion for such a project came with the completion of Paul Rudolph's Art and Architecture Building at Yale in 1963.[20] When Rudolph decided to add sculpture to the facade of his already distinctly sculptural building, he approached Albers who, although retired as chairman of the art school since 1958, had continued to teach until 1960. The artist agreed to contribute a work, and the result was *Repeat and Reverse* (1963), a stainless steel *Constellation* which was affixed directly above the principal entrance to the building (figs. 12, 13).

On most facades such placement would be ideal. However the entrance to Rudolph's building is set well back from the street and is not a prominent element in the overall design. In addition, the wall above the doorway is narrow. Due to these factors, *Repeat and Reverse* is extremely cramped in its chosen location. Further, it does not enjoy adequate

12　*Repeat and Reverse.* 1963
　　Stainless steel on concrete, 6′6″ x 3′
　　Entrance, Art and Architecture
　　Building, Yale University, New Haven

13　*Repeat and Reverse*

14　*Two Supraportas.* 1972
　　Stainless steel on granite, 59″ x 107′ (wall)
　　Entrance, Westfälisches Landesmuseum
　　für Kunst und Kulturgeschichte, Münster

lines of sight, an unfortunate circumstance for any sculpture, and all the more tragic in this case given Albers's long and influential tenure at Yale.

Yet, surprisingly, it was Albers himself who selected the setting. This occurred against the better judgment of Rudolph, who recalls: "Mr. Albers selected the precise location, although I must say that I never thought it well-placed."[21] As Albers was a frequent visitor to the school even after his retirement, it is inconceivable that he would not have realized the drawbacks of the site. Clearly his desire to see *Repeat and Reverse* above the entrance—as a contemporary portal or pediment sculpture—outweighed all other considerations.

Albers responded similarly when invited to design a sculpture for the facade of the Landesmuseum in Münster. The setting in this case was a newly expanded museum and, more specifically, the new entrance to the building, which fronted the city's central cathedral plaza. Albers, who had grown up in nearby Bottrop, who had made drawings in the nave of the Münster Cathedral as a young man, and who had been the subject of important exhibitions at the Landesmuseum in 1959 and 1968, knew exactly what to do with the opportunity. According to architect Bernd Kösters, during a visit to the museum to discuss the project: "Professor Albers went immediately to the side of the building with the main entrance and said he wanted to work there. In addition, he also made it clear that he was not thinking of a mural in color, but of a sculpture."[22]

Although not without certain problems, the work completed in 1972, *Two Supraportas*—meaning literally "two elements above the doors"—is a marked success (fig. 14). The two *Constellations* that Albers selected are attached to the facade, which projects directly over the entrance to the museum. They are affixed to a series of five charcoal-gray granite panels, which recede left to right in parallel stepped planes. Although the facade steps back approximately ten feet from side to side, Albers insisted—against the will of his architect, once

again—that the *Constellations* span these large spatial divisions. Unfazed by either architectural dictate or difficult structural problems, he moved boldly ahead and assumed control of the project himself.

Albers's determination had altogether happy consequences for the finished work, as Kösters proved a remarkable collaborator. He kept the artist abreast of the project throughout its many phases, and solicited Albers's advice on numerous issues pertaining to design and materials. For his part the artist immersed himself in these details, and his correspondence reveals surprising insight into obscure construction matters. This communication made it possible for Albers to expand his design very accurately, a difficult achievement given the precise geometry of the graphic work.

Albers was especially pleased with the finished sculpture and remarked that it appeared "unbelievably thin and light...so volumetric like three-dimensional sculpture."[23] *Two Supraportas* is also tremendously successful as an expressly modern public emblem, particularly when mounted above the entrance to a museum. Although far more successful than the Yale sculpture, both *Two Supraportas* and *Repeat and Reverse* evidence Albers's understanding of the traditional appearance and meaning of portal and pediment sculpture. With their dynamic shapes and sleek materials, these works are distinctly modern public forms, and their placement grants them extraordinary visibility and power.

When Josef Albers died in March 1976, two projects remained unfinished. The first, an enormous relief titled *Wrestling* (fig. 15), was all but complete and would be installed within a few weeks of the artist's death. Constructed of aluminum channel and mounted on a black anodized-aluminum wall, *Wrestling* measures over fifty feet high. It was commissioned by the architect Harry Seidler, a student of Albers at Black Mountain in 1947 and a longtime friend. As conceived and sited the relief

15 *Wrestling.* 1976
Aluminum channel on anodized
aluminum, 56 x 40′
Mutual Life Centre, Sydney, Australia

plays an integral role in Seidler's Mutual Life Centre, an extensive office and retail complex in Sydney, Australia. The main element of the center is an imposing seventy-story office tower, which was nearing completion at the time *Wrestling* was mounted.

In designing the complex, Seidler faced a number of challenging dilemmas.[24] The complex stands in the center of Sydney, and the large side-wall of an existing building faced disagreeably on his site. Beyond needing to sheathe this intrusive structure, Seidler also sought to add a form which might mediate the scale and visual power of his tower. At seventy stories the MLC Tower was the tallest building in the southern hemisphere at the time of its construction, and it was much taller than any of the buildings in the area.

Knowing of Albers's recent work in Münster, Seidler invited the artist to contribute a relief to the complex. He did so with the knowledge that Albers's graphic work could handle architectural scale, and he also believed that a very large relief would assist in solving his complicated problem. As the construction photograph demonstrates, when mounted on a black wall *Wrestling* sheathes the neighboring facade to great effect. Even more impressive, however, is the manner in which it graduates the scale of the tower.

In contrast to *Wrestling*, which lacked only installation at the time of Albers's death, the *Stanford Wall* would not be completed until 1980, nearly ten years after the project was conceived. Such a long gestation period was necessary because of the exceedingly complex nature of the work. The design required precise components, unusual materials, sensitive decisions regarding a site, and exacting construction standards. Not least of these complicating factors was Albers's death, as this was the artist's only large-scale project not commissioned by an architect.[25]

The *Stanford Wall* is a two-sided, freestanding planar-relief sculpture, completely independent of architecture except that it is a wall (figs. 16, 17). The

16 *Stanford Wall* (brick side). 1980

Arkansas brick, African granite, stainless
and gloss-plated steel, 8′8″ x 54′ x 1′

Lomita Mall, Stanford University, California

17 *Stanford Wall* (granite side). 1980

Arkansas brick, African granite, stainless
and gloss-plated steel, 8′8″ x 54′ x 1′

Lomita Mall, Stanford University, California

work is nearly nine feet high, fifty-four feet long and a very narrow one foot wide. One side is composed of black, gloss-plated steel rods affixed in rhythmic sequence to the mortar courses of a white brick wall; the other consists of sheets of black African granite to which Albers attached a series of four stainless-steel *Constellations*. It is immediately evident that the *Stanford Wall* encapsulates Albers's previous art-in-architecture projects: the brick murals, the "skyscraper" style and the stainless-steel *Constellations* are all present in this work.

But if the *Stanford Wall* serves as a summary statement of Albers's graphic art as translated to large scale, it marks several firsts in the artist's oeuvre which are ultimately more significant. Most obvious is the freestanding planar-relief format, which has no precedent in Albers's work and only a few in modern sculpture. It is this format which allows his designs to interact fully and sculpturally with natural light (the wall is seen to best advantage at noon, when the sunlight causes the horizontal bars to defy their form and cast long vertical shadows down the white brick face). This was also the first occasion on which Albers worked without a commission, as he donated the design to Stanford with the understanding that the university would fund, construct and maintain the sculpture. His drawings were, in fact, rendered by the architect Craig Ellwood, and following the artist's death, another architect, Robert Middlestadt, supervised the project for Stanford. In a very real sense, the architects were now working for the artist.

A word must be said as well about the design. Albers's art-in-architecture works were always site-specific — they were conceived and developed in response to the nature and proportions of the space and materials available to him. At Stanford Albers was free to design as he pleased, and the complex graphic language which he selected suggests a theme of constant evolution and flux within a carefully considered discipline. This is particularly true of the four *Constellations*, in which rigorously cir-

cumscribed spatial relations on the left give way to the most fleeting interaction, as the paired figures on the right are joined by only a single linear element. Although the *Constellations* had assumed emblematic character in Münster and Sydney on the basis of their public prominence and scale, the Stanford project was the first occasion on which Albers, at the very end of his life, was able to reflect on the relentless passage of time and the fragile existence of humanity in the universe.

Though not Albers's central achievement — the *Homage to the Square* series must be accorded its due — the art-in-architecture work is an essential element in the artist's portfolio. Indeed, it is significant that on only three occasions did he employ his *Homages* in architectural settings, perhaps in the belief that the graphic work was underappreciated by his public. More important were Albers's assumption of the new challenges which the art-in-architecture projects afforded him late in life, and his growth beyond the dictates and decisions of others into an artist possessing full confidence in his work at monumental scale.

NOTES

1　Quoted in Eleanor Bitterman, *Art in Modern Architecture*, New York, Reinhold Publishing Company, 1952, p. 148. The Harvard project is published in "Harvard Builds a Graduate Yard," *Architectural Forum*, vol. 93, December 1950, pp. 62-71. In addition to Albers, Jean Arp, Joan Miró, Herbert Bayer and Anni Albers contributed works of art to the complex.

2　Gropius described the process by which artists were commissioned as follows:
 The artists in the vicinity, such as Josef Albers...came to see us, the architects, and we discussed very thoroughly the kind of work possible for this particular group of buildings....All along I put definite stress on getting the proper space relationships, with the aim that the painter or sculptor supports the idea of the architecture and vice versa.
 Quoted in Bitterman, *Art in Modern Architecture*, p. 67.

3　Bitterman, *Art in Modern Architecture*, p. 148.

4　This essay derives from my doctoral dissertation, *The Murals and Sculpture of Josef Albers* (Stanford University, 1983), New York and London, Garland Publishing, Inc., Outstand-

ing Dissertations in the Fine Arts, 1985. Thanks are due Nicholas Fox Weber, Anni Albers, Maria Makela and, in particular, Albert E. Elsen, for his ongoing support.

5 Quoted in Hans M. Wingler, *The Bauhaus*, Wolfgang Jabs and Basil Gilbert, trans., Joseph Stein, ed., Cambridge, Massachusetts, and London, the MIT Press, 1969, p. 31.

6 In addition to a sabbatical year spent in Mexico in 1947, Albers taught on various occasions in Cuba, Chile, Peru and Mexico. Based on photographs the artist took which are today in the collection of The Josef Albers Foundation, we know he visited such Pre-Columbian sites as Chichen Itza, El Tajin, Mitla, Monte Alban, Palenque, Tenayuca, Teopanzolco, Teotihuacan, Xochicalco and Uxmal in Mexico, and Macchu Picchu, Ollantaytambo, Chan Chan and Huaca del Sol in Peru.

7 Quoted in "Truthfulness in Art," typescript of a lecture delivered at Black Mountain College in the late 1930s. The text is included in volume I of the Josef Albers Papers in the Library of The Museum of Modern Art. If Albers found a model in Pre-Columbian art-in-architecture, in contemporary Mexican art he studied another tradition which he rejected. For him the murals of Rivera, Siquieros and Orozco:

> *...merely present a story, illustration, or decorative nicety or the wall is treated as a landscape for private or political disclosures and extravagances. Too often they are enlarged easel paintings which can hang anywhere else and which add or subtract little to or from the structure or space....*

Quoted in Bitterman, *Art in Modern Architecture*, p. 148.

8 I am indebted to King Lui Wu for the time we spent together viewing these brick murals and discussing Albers's work in November 1980 and in October 1981. Both houses are published in King Lui Wu, "Notes on Architecture Today," *Perspecta*, 1959, pp. 29-36.

9 For St. Patrick's see "Medieval Forms Transformed," *Progressive Architecture*, vol. XLIV, November 1963, pp. 136-139.

10 While teaching at the Institute of Technology in Lima in 1953, Albers traveled extensively in Peru. He visited and photographed a number of Colonial churches, including San Blas in Cuzco and San Agostino in Arequipa.

11 Based on the author's conversation with Reverend Baldwin Dworschak, former abbot of St. John's Abbey, and Frank Kacmarcik, Collegeville, Minnesota, May 31, 1981. The most thorough history of Breuer's work at St. John's is Whitney Stoddard, *Adventure in Architecture: Building the New St. John's*, New York, Longmans, Green and Company, 1958.

12 This discovery was made by scientists at Corning Glass Works, where the glass for *White Cross Window* was manufactured. The invention of photosensitive glass is described in S. D. Stookey, "Photo-Sensitive Glass: A New Photographic Medium," *Industrial and Engineering Chemistry*, vol. 41, April 1949, pp. 856-861.

13 This work, *Rosa mystica ora pro nobis*, now destroyed, was installed in St. Michael's Church in Bottrop. The only known reproduction of the window is in the collection of the Busch-Reisinger Museum. The work is discussed in Irving Leonard Finkelstein, *The Life and Art of Josef Albers* (Ph.D. dissertation, New York University, 1968), microfilm, Ann Arbor, Michigan, University Microfilms International, 1979, pp. 38 ff.

14 The Sommerfeld commission is described in detail in Marcel Franciscono, *Walter Gropius and the Creation of the Bauhaus at Weimar*, Urbana, University of Illinois Press, 1971, pp. 40-44.

15 My reconstruction of these events, described in greater detail in *The Murals and Sculpture of Josef Albers*, pp. 48-52, is based on interviews with Anni Albers, Nicholas Fox Weber, Hamilton Smith of Marcel Breuer and Associates, Reverend Baldwin Dworschak and Frank Kacmarcik conducted in 1981.

16 See Jürgen Wissmann, *Josef Albers: Murals in New York*, Stuttgart, Philipp Reclam Verlag, 1971. The Corning Glass Building is published in "The Big Mirror," *Architectural Forum*, vol. 110, May 1959, pp. 116–121.

17 Publications on the Pan Am Building include Emerson Goble, "Pan Am Makes a Point," *Architectural Record*, vol. 131, May 1962, pp. 195-200; James T. Burns, Jr., "A Behemoth is Born," *Progressive Architecture*, vol. 44, April 1963, pp. 59-62; and "The Problem with Pan Am," *Architectural Record*, vol. 133, May 1963, pp. 151-158.

18 From an unpublished statement on *Manhattan* in the artist's files, The Josef Albers Foundation, Orange, Connecticut.

19 "Structural Sculpture" was originally published in the catalogue to the exhibition *Robert Engman: Recent Sculpture* held at the Stable Gallery, New York, in February-March 1960.

20 For Rudolph's Art and Architecture Building see Vincent Scully, "Art and Architecture Building, Yale University," *Architectural Review*, vol. 135, May 1964, pp. 324-332; and Walter McQuade and Sibyl Moholy-Nagy, "A Building That Is an Event," *Architectural Forum*, vol. 120, February 1964, pp. 62-85.

21 Correspondence with the author, January 4, 1980.

22 Correspondence with the author, September 3, 1981.

23 Josef Albers to Bernd Kösters, April 5, 1972. Courtesy of Bernd Kösters.

24 I am indebted to Harry Seidler for discussing *Wrestling* with me during my visit to Sydney in March 1981. In part this section of my essay also derives from a lecture Seidler delivered to the Sydney Institute of Architects on March 23, 1981, which I attended.

25 Publications on the *Stanford Wall* include Albert E. Elsen, "A 'Stunning Presence' at Stanford," *Art News*, vol. 80, January 1981, pp. 64-65; and Robert Middlestadt, "Homage to the Mall," *Archetype*, vol. II, Autumn 1980, pp. 7-8.

Catalogue

Unless otherwise noted, all works are Collection
The Josef Albers Foundation.

Titles are given in English, followed by the artist's
original German titles, if they exist, in parentheses.

*Indicates not illustrated.

1 *Farm Woman with Kerchief.* ca. 1914
Crayon and pencil on paper, 8⅝ x 10¾″
(22.1 x 27.3 cm.)

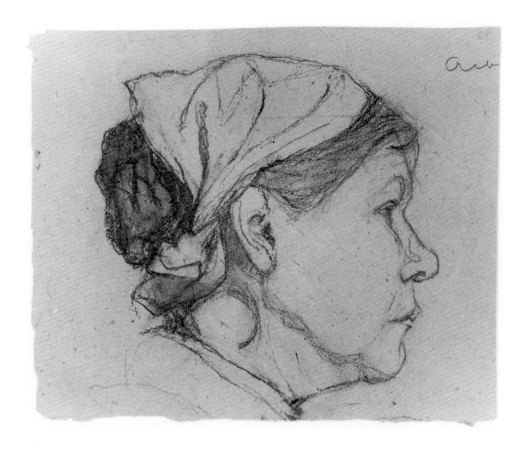

2 *Self-Portrait I.* ca. 1914-15
Pencil on paper, 17¹/₁₆ x 13⅛"
(43.3 x 33.3 cm.)

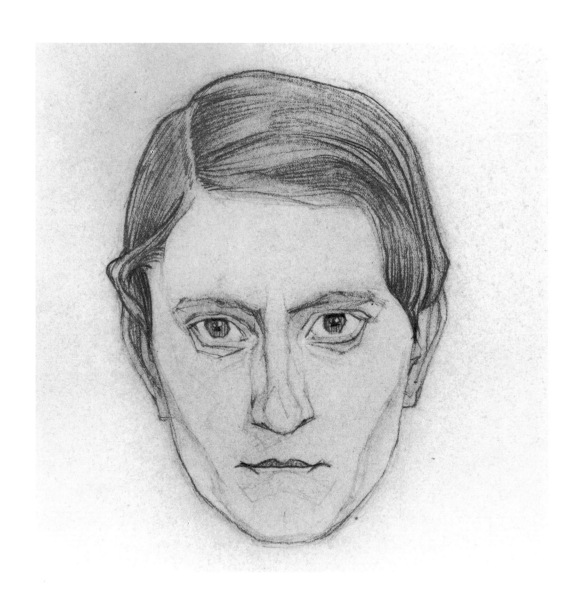

3 *Self-Portrait*. ca. 1915
 Oil on canvas, 11¼ x 9⅛″
 (28.5 x 23.2 cm.)

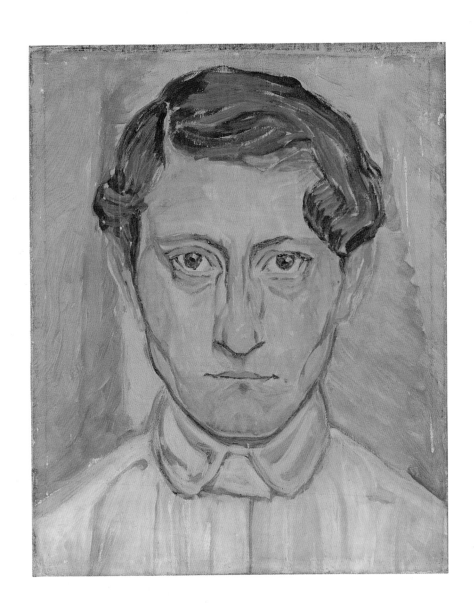

4 *Still Life with Russian Box (Stilleben
 mit russischer Dose).* ca. 1914

 Tempera on canvas, 15^{15}⁄$_{16}$ x 14^{3}⁄$_{8}$"
 (40.5 x 36.5 cm.)

 Private Collection

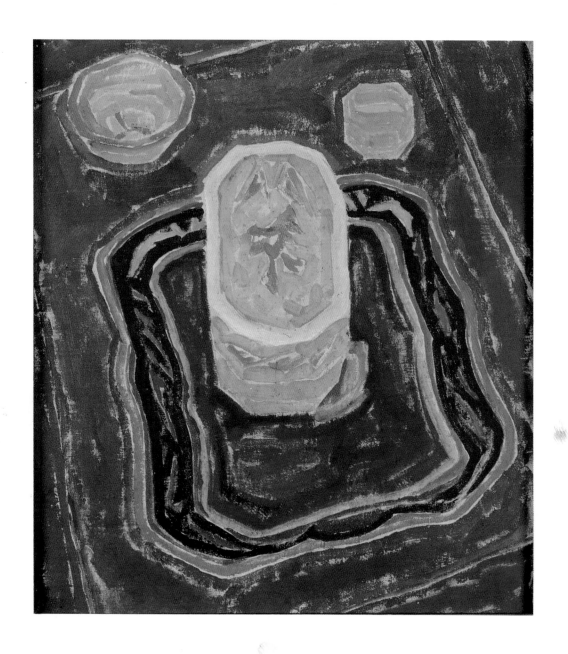

5 *Masks and Vase.* 1916
 Tempera on canvas, 19½ x 15″
 (49.5 x 38 cm.)
 Private Collection

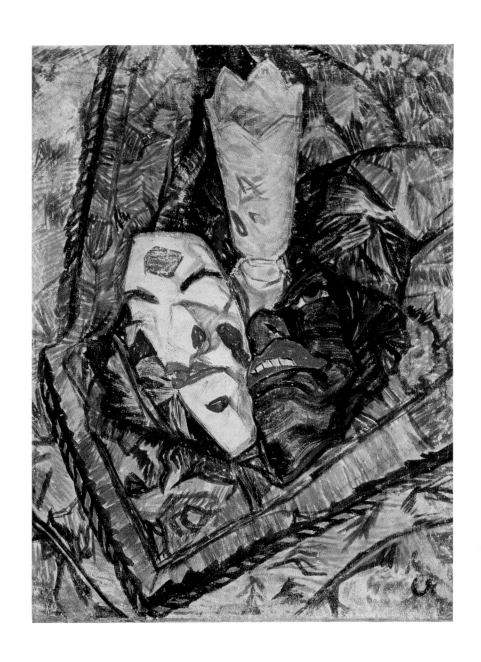

6 *Sandpits.* ca. 1916
 Ink on paper mounted on paper,
 8⅜ x 10¼″ (21.3 x 26.1 cm.)

7 *Rabbit I.* ca. 1916
 Lithographic crayon on paper,
 10¼ x 13⅝" (26.1 x 34.6 cm.)

8 *Rabbit II.* ca. 1916
 Lithographic crayon on paper,
 10¼ x 13⅜" (26.1 x 34 cm.)

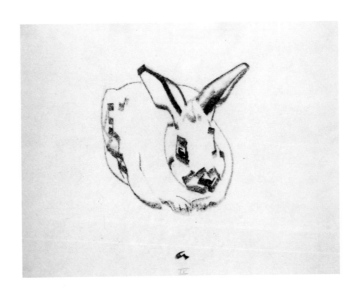

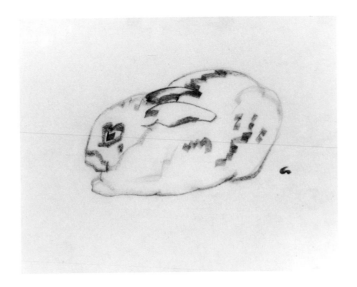

9 *Dorsten Town Hall.* ca. 1917
 Lithographic crayon on paper,
 $17^{3}/_{16}$ x $12^{3}/_{8}$″ (43.7 x 31.5 cm.)

10 *Church Interior.* ca. 1917
 Pencil and ink on paper, $18^{7}/_{8}$ x 12″
 (48 x 30.5 cm.)

11 *Study for "Ostring I" (Workers'
 Houses Series).* ca. 1917

 Lithographic crayon on paper,
 8¹/₁₆ x 12⁷/₈" (20.5 x 32.7 cm.)

12 *Study for "Ostring IV" (Workers'
 Houses Series).* ca. 1917

 Lithographic crayon on paper,
 7½ x 13¼" (19.1 x 33.6 cm.)

13 *Study for "Empty End" (Workers'*
 Houses Series). ca. 1917
 Lithographic crayon on paper,
 7⅞ x 13⅝" (20.1 x 34.7 cm.)

14 *Lamppost and Houses.* ca. 1917
 Lithographic crayon on paper,
 sight, 8 x 9¾" (20.3 x 24.8 cm.)

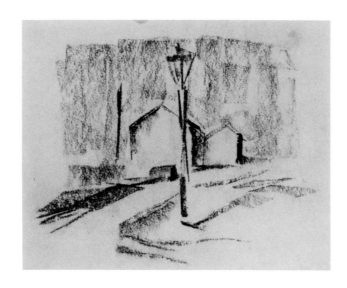

15 *Self-Portrait III.* ca. 1917
 Lithographic crayon on paper,
 19 x 15½" (48.3 x 39.4 cm.)

16 *Schoolgirl VII.* ca. 1917
 Ink on paper, 9 x 9½"
 (22.9 x 24.1 cm.)

17 *Schoolgirl VIII.* ca. 1917
 Ink on paper, 7 x 5"
 (17.7 x 12.7 cm.)

18 *Schoolgirl VI.* ca. 1917
 Ink on paper, 13¾ x 10¼"
 (34.9 x 26.1 cm.)

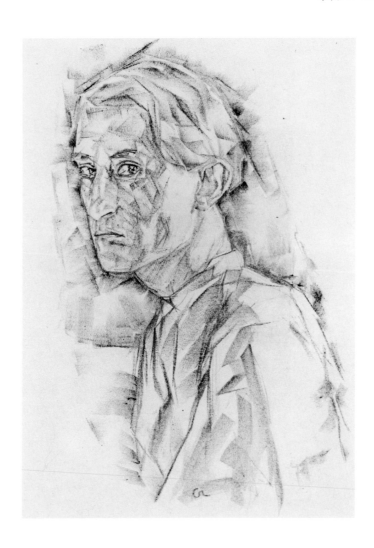

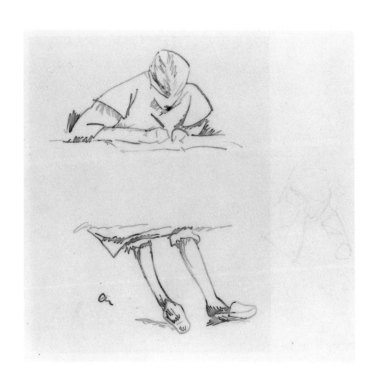

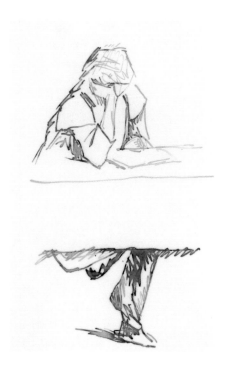

19 *Duck with Head Down.* ca. 1917
 Ink on paper, 10¼ x 14⁷/₁₆″
 (26.1 x 36.7 cm.)

20 *Standing Bird, Front View.* ca. 1917
 Ink on paper, 10⁵/₁₆ x 6⁵/₈″
 (26.2 x 16.8 cm.)

21 *Four Geese*. ca. 1917
 Ink on paper, 10⅛ x 12⅝"
 (25.7 x 32.1 cm.)

22 *Geese I*. ca. 1917
 Ink on paper, 10⅛ x 12⅝"
 (25.7 x 32.1 cm.)

23 *Two Geese*. ca. 1917
 Ink on paper, 10⅛ x 12⅝"
 (25.7 x 32.1 cm.)

24 *Two Roosters*. ca. 1917
 Ink on paper, 12⅝ x 10⅛"
 (32.1 x 25.7 cm.)

25 *Three Chickens*. ca. 1917
 Ink on paper, 12⅝ x 10"
 (32.1 x 25.5 cm.)

26 *Owl II*. ca. 1917
 Ink on reverse of wallpaper,
 19¾ x 14¾" (50.2 x 37.5 cm.)

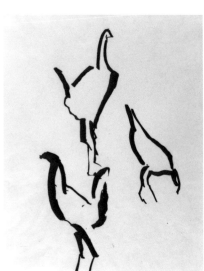

27 *The Procession (Green Flute Series).*
 ca. 1917
 Lithograph on paper, 12 x 21$^{15}/_{16}$"
 (30.5 x 55.7 cm.)

28 *Dancer.* ca. 1917
 Pencil on paper, 14⁷⁄₁₆ x 10³⁄₁₆″
 (36.7 x 25.9 cm.)

29 *Dancers.* ca. 1917
 Pencil on paper, 13³⁄₄ x 10³⁄₁₆″
 (34.9 x 25.9 cm.)

30 *Man Reading Newspaper.* ca. 1917-18
Pencil on paper, 12¹⁵/₁₆ x 9″
(32.9 x 22.9 cm.)

31 *Electrical Repairmen.* ca. 1918
Pencil on paper, 11⅛ x 8¼″
(28.2 x 21 cm.)

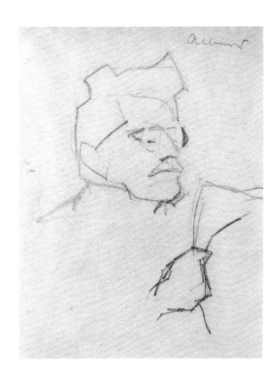

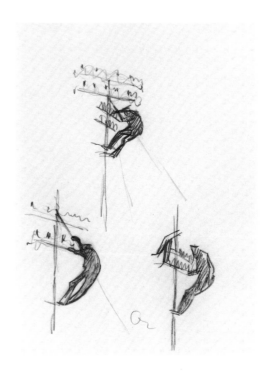

32 *House with Trees in Notteln.* ca. 1918
Pencil and ink on paper, 13¹³/₁₆ x 10¼″
(35.1 x 26.1 cm.)

33 *Pine Forest in Sauerland*
(Sauerländischer Tannenwald). ca. 1918
Ink on paper, 12⅝ x 9⅝″
(32.1 x 24.6 cm.)

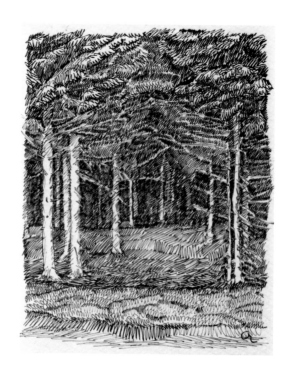

34 *Bavarian Mountain Scene I.* ca. 1919
 Ink on paper, 10⅛ x 12⅝″
 (25.7 x 32.1 cm.)

35 *Bavarian Mountain Scene II.* ca. 1919
 Ink on paper, 10 x 12⅝″
 (25.5 x 32.1 cm.)

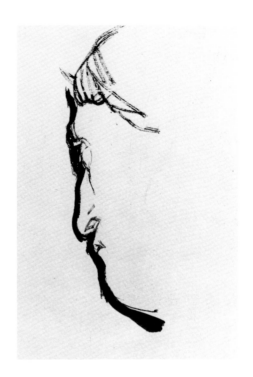

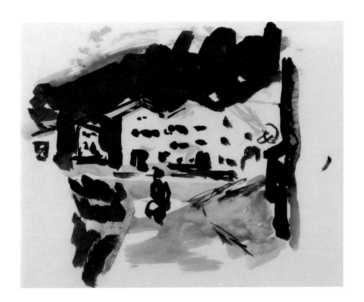

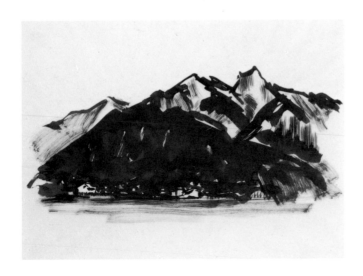

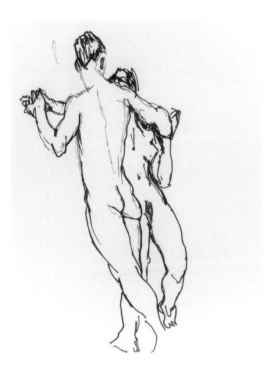

36 *Self-Portrait VI.* ca. 1919
 Ink on paper, 11½ x 7¾"
 (29.2 x 19.7 cm.)

37 *Dancing Pair.* ca. 1919
 Ink on paper, 12¹¹⁄₁₆ x 10⅛"
 (32.3 x 25.7 cm.)

38 *Standing Nude I.* ca. 1919
 Ink on paper, 12⅝ x 10¹⁄₁₆"
 (32.1 x 25.6 cm.)

39 *Standing Nude II.* ca. 1919
 Ink on paper, 12⅝ x 10¹⁄₁₆"
 (32.1 x 25.6 cm.)

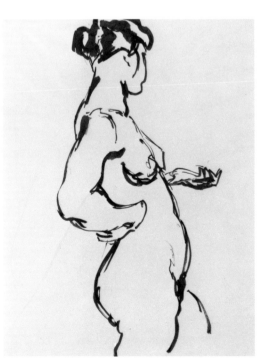

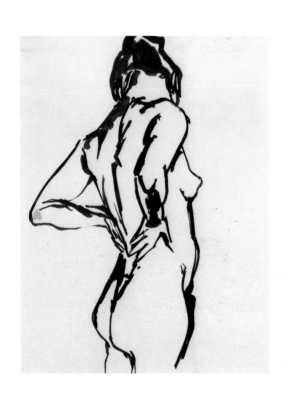

40 *Figure.* 1921

Glass assemblage, 21½ x 15½″
(54.6 x 39.4 cm.)

Collection The Metropolitan Museum
of Art, New York, Gift of the artist, 1972

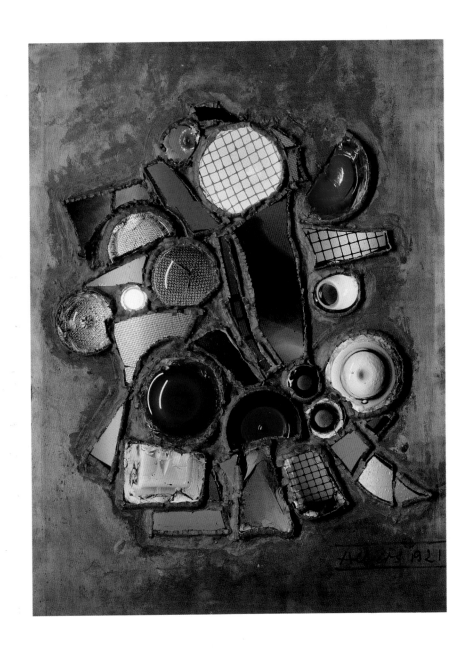

41 *Rhenish Legend (Rheinische Legende).*
1921
Glass assemblage, 19½ x 17½"
(49.5 x 44.4 cm.)
Collection The Metropolitan Museum
of Art, New York, Gift of the artist, 1972

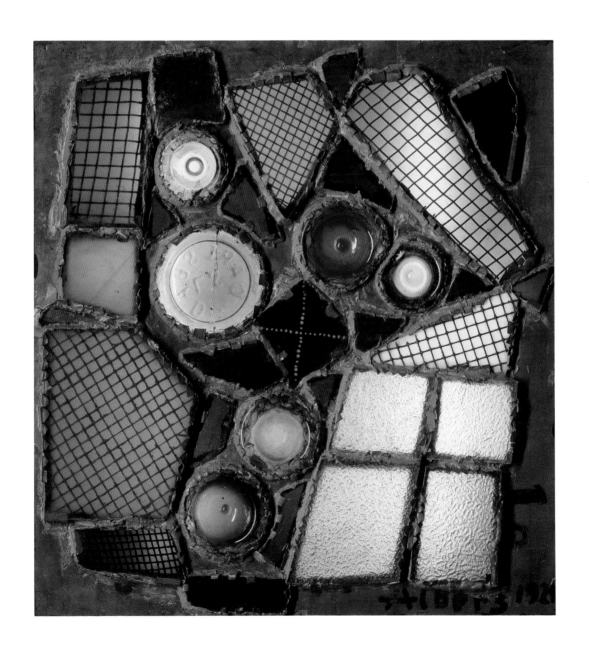

42 *Untitled (Window Picture
 [Fenster-Bild]).* 1921

Glass assemblage, 23 x 21¾ x 8⅜"
(58.9 x 55.3 x 21.3 cm.)

Collection Hirshhorn Museum and
Sculpture Garden, Smithsonian
Institution, Washington, D.C., Gift of
Joseph H. Hirshhorn, 1972

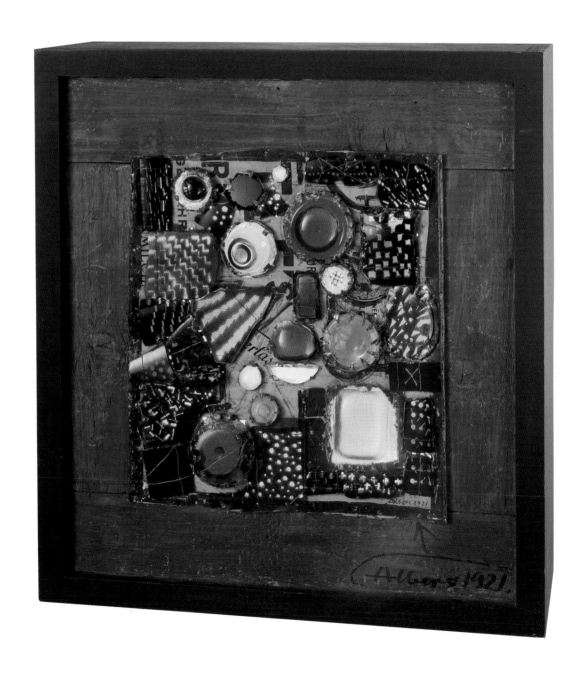

43 *Untitled.* ca. 1921
 Glass assemblage, 14¾ x 11¾″
 (37.5 x 29.8 cm.)

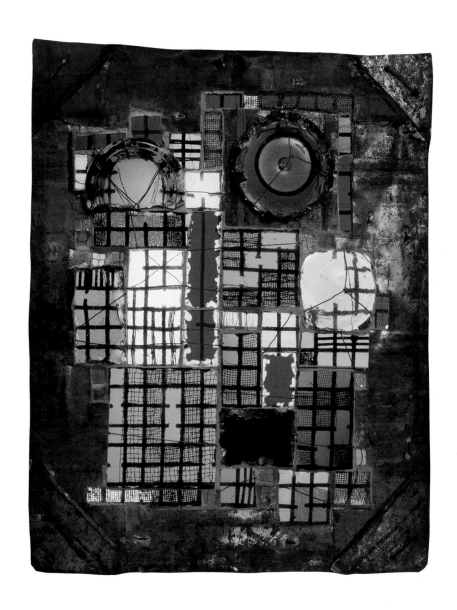

44 *Grid Mounted.* 1922
 Glass assemblage, 12¾ x 11⅜″
 (32.4 x 28.9 cm.)

45A,B Photographer Unknown

 *Two Views of Stair Hall, Grassi
 Museum, Leipzig (Destroyed 1944)
 Showing Stained-Glass Windows
 Designed by Albers in 1923-24.* n.d.

 2 photographs, each 6½ x 9″
 (16 x 22.9 cm.)

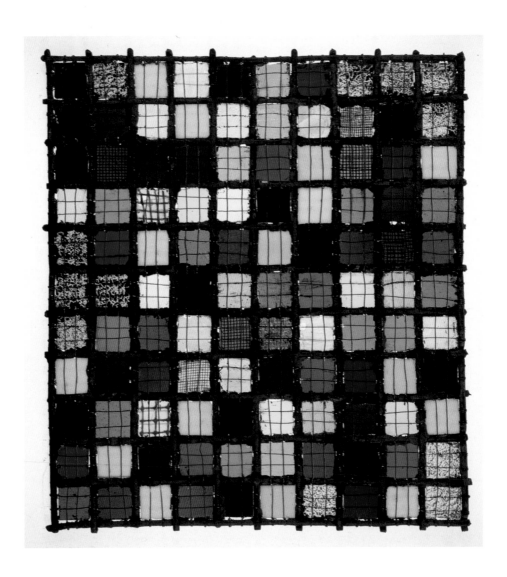

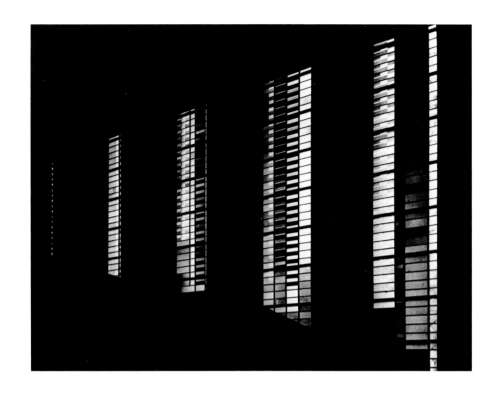

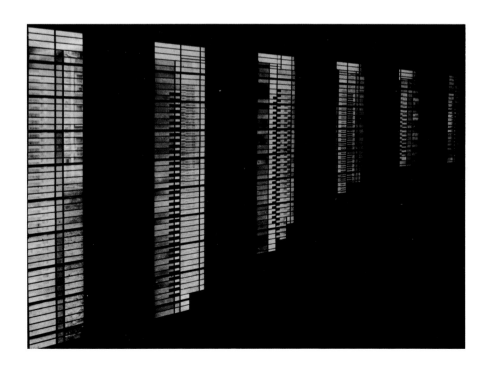

46 *Bauhaus Bookshelf.* 1923
 Photograph, 8¾ x 6½″ (22.3 x 16 cm.)
 Courtesy Prakapas Gallery, New York

47 *Bauhaus Table.* 1923
 Photograph, 6½ x 8¾″
 (16 x 22.3 cm.)
 Courtesy Prakapas Gallery, New York

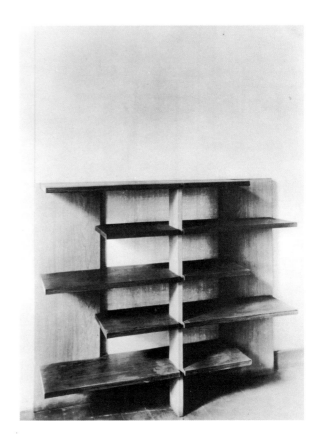

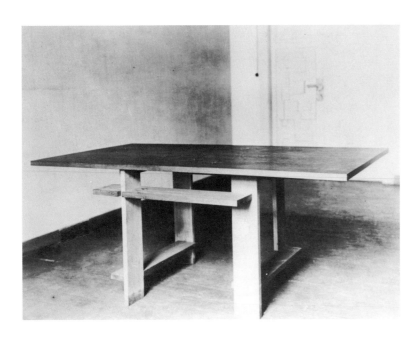

48 *Fruit Bowl.* 1923

Chrome-plated brass, painted wood and glass, 2⅞ x 14⅜″ (7.5 x 36.5 cm.) diameter

Collection Bauhaus-Archiv, W. Berlin, Gift of the artist, 1961

49A,B *Tea Glasses with Saucers.* 1926

A. Heat resistant glass, nickel-plated steel, Bakelite and porcelain (left), 2½ x 5⅜″ (5.7 x 13.7 cm.)
B. Heat resistant glass, stainless steel, ebony and porcelain (right), 2½ x 5⅜″ (5.7 x 13.7 cm.)

Collection Bauhaus-Archiv, W. Berlin, Gift of the artist

50 *Bauhaus Lettering Set (Kombinations-
 schrift)* ca. 1926

 Opaque glass mounted on wood,
 24 x 24″ (61 x 61 cm.)

 Collection The Museum of Modern
 Art, New York, Gift of the artist, 1957

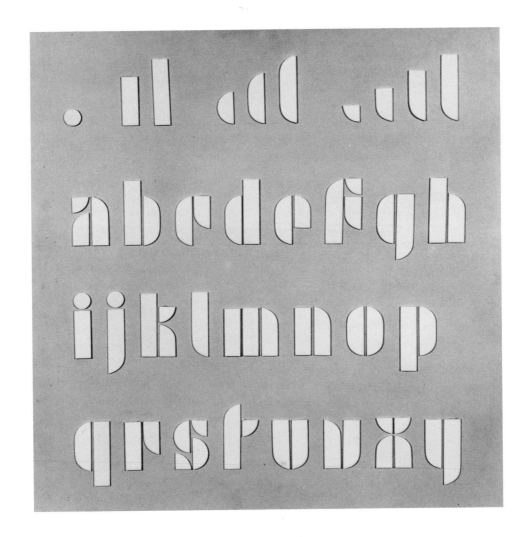

51 Illustration of *Design for Remodeled Storefront—Ullstein Publishing Co., Berlin (Entwurf für einen Ladenumbau)*

In *Offset: Buch und Werbekunst*, Leipzig, vol. 7, special Bauhaus issue, 1926, 12¹/₁₆ x 9³/₁₆″ (30.7 x 23.3 cm.)

52 Illustration of *Design for Remodeled Corner Store—Ullstein Publishing Co., Berlin (Entwurf für Eckladenumbau)*

In *Offset: Buch und Werbekunst*, Leipzig, vol. 7, special Bauhaus issue, 1926, 12¹/₁₆ x 9³/₁₆″ (30.7 x 23.3 cm.)

Collection Ex Libris, New York

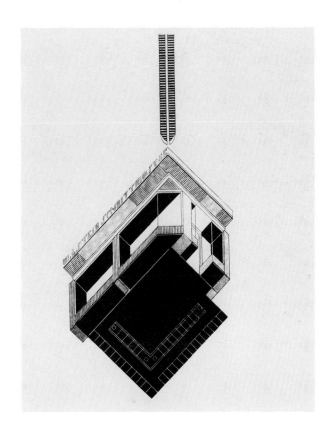

53 *Stacking Tables.* ca. 1926

Wood and painted glass, 15⅝ x 16½ x
15¾″ (39.2 x 41.9 x 40 cm.); 18⅝ x
18⅞ x 15¾″ (47.3 x 48 x 40 cm.); 21¾
x 21 x 15¾″ (55.4 x 53.3 x 40 cm.);
24⅝ x 23⅝ x 15⅞″ (62.6 x 60.1 x
40.3 cm.)

Collection Andrea and John Weil,
Saskatoon

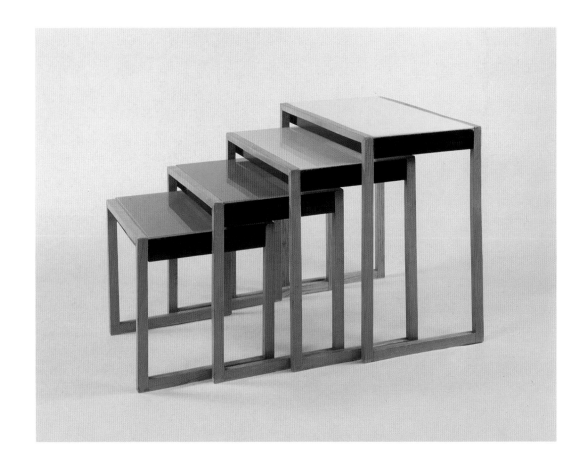

54 *Writing Desk.* ca. 1926

Wood and painted glass, 30 x 35⅜ x
23″ (76.2 x 89.8 x 58.9 cm.), with leaf
extended, 30 x 52¼ x 23″ (76.2 x 127.6
x 58.9 cm.)

Collection Esther M. Cole

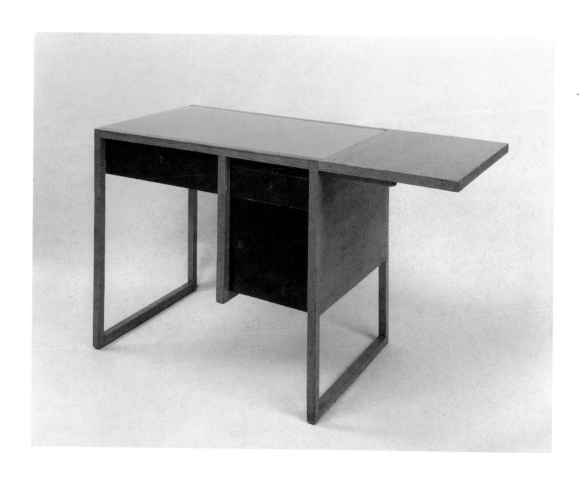

55 *Fugue.* ca. 1925
Sandblasted flashed glass, 9¾ x 25⅞″
(24.8 x 65.7 cm.)

56 *Fugue II.* 1925

Sandblasted flashed glass, irregular,
ca. 6¼ x 22⅞″ (15.8 x 58.1 cm.)

Collection Hirshhorn Museum and
Sculpture Garden, Smithsonian Institu-
tion, Washington, D.C., Gift of Joseph
H. Hirshhorn Foundation, 1972

57 *Factory.* ca. 1925
 Sandblasted flashed glass, 14⅛ x 18¹⁄₁₆″
 (35.8 x 45.8 cm.)
 Collection Yale University Art Gallery,
 New Haven, Gift of Anni Albers and
 The Josef Albers Foundation

58 *Latticework*. ca. 1926

Sandblasted flashed glass, 11¼ x 11⅞″
(28.5 x 30.1 cm.)

Collection Hirshhorn Museum and
Sculpture Garden, Smithsonian Institu-
tion, Washington, D.C., Gift of Joseph
H. Hirshhorn Foundation, 1974

59 *Upward.* ca. 1926
 Sandblasted flashed glass, 17 x 11¾″
 (43.2 x 29.8 cm.)

60 *Dominating White.* 1927
Sandblasted flashed glass, 8½ x 11½"
(21.5 x 29.2 cm.)

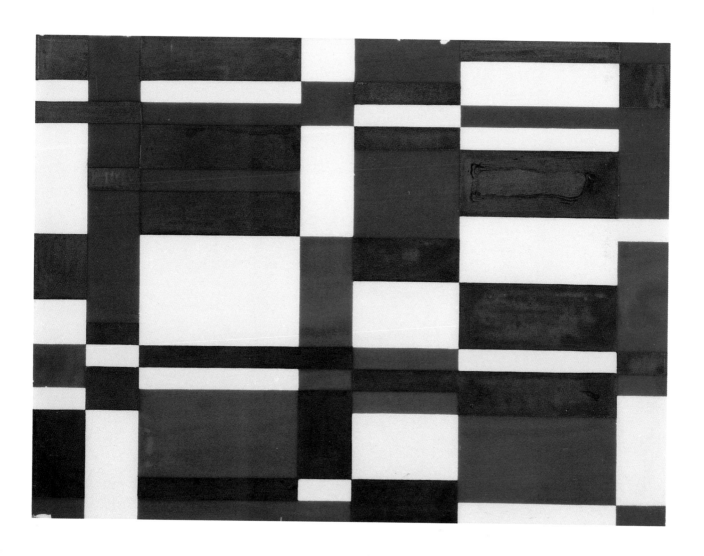

61 *Study for "Frontal." ca. 1927*
Pencil and ink on graph paper,
16⅛ x 23¼″ (41 x 59.1 cm.)

62 *Frontal.* 1927
 Sandblasted flashed glass,
 13³/₁₆ x 18³/₈″ (33.3 x 46.7 cm.)

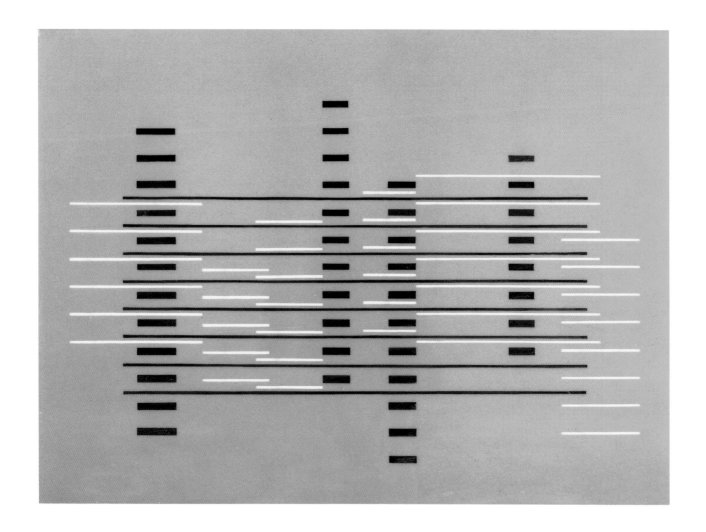

63 *Walls and Screens.* ca. 1928
Sandblasted flashed glass,
12 x 10⅛″ (30.5 x 26 cm.)

Collection Mr. and Mrs. James H.
Clark, Jr., Dallas

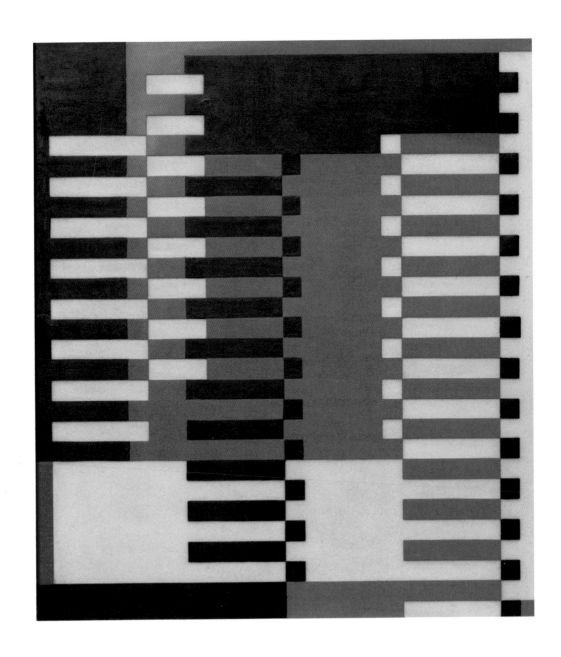

64 *Skyscrapers on Transparent Yellow.*
 ca. 1929
 Sandblasted flashed glass,
 13 3/8 x 13 3/16" (34 x 33.3 cm.)

65 *Skyscrapers A.* 1929
Sandblasted flashed glass,
13¾ x 13¾″ (34.9 x 34.9 cm.)
Collection Mr. and Mrs. James H.
Clark, Jr., Dallas

66 *Skyscrapers B.* 1925-29

Sandblasted flashed glass, 14¼ x 14¼″
(36.2 x 36.2 cm.)

Collection Hirshhorn Museum and
Sculpture Garden, Smithsonian Institu-
tion, Washington, D.C., Gift of Joseph
H. Hirshhorn Foundation, 1974

67 *Study for "Pergola."* 1929
Pencil and ink on graph paper,
12¼ x 20″ (31.1 x 50.8 cm.)

68 *Pergola.* 1929
 Sandblasted flashed glass,
 10½ x 17¾″ (26.7 x 45.1 cm.)

69 *Interior A.* 1929
 Sandblasted flashed glass,
 9¾ x 8⅛″ (24.8 x 20.7 cm.)

70 *Interior B.* 1929
 Sandblasted flashed glass,
 10⅝ x 9⅛″ (27 x 23.2 cm.)

71 *Interior A.* 1929
 Sandblasted flashed glass,
 13 x 10″ (33 x 25.4 cm.)
 Collection Josef Albers Museum,
 Bottrop, W. Germany

72 *Interior B.* 1929
 Sandblasted flashed glass,
 13 x 10″ (33 x 25.4 cm.)
 Collection Josef Albers Museum,
 Bottrop, W. Germany

73 *Windows.* 1929

Sandblasted flashed glass,
13¼ x 14¾″ (33.6 x 37.5 cm.)

Collection Mr. and Mrs. James H.
Clark, Jr., Dallas

74 *Glove Stretchers.* 1931
Sandblasted flashed glass,
15½ x 20¾″ (39.4 x 52.7 cm.)

75 *Armchair.* 1928
 Walnut and maple veneers on wood
 with canvas upholstery (replaced 1961),
 29⅛ x 24¼ x 26⁹⁄₁₆″ (74 x 61.5 x 67.4 cm.)

 Collection Bauhaus-Archiv, W. Berlin

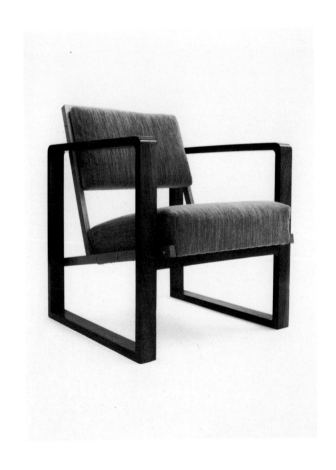

76 *Armchair.* 1929

Laminated beechwood, tubular steel
and canvas upholstery, 28½ x 23 x 28½″
(72.4 x 58.9 x 72.4 cm.)

Collection The Museum of Modern
Art, New York, Gift of the artist

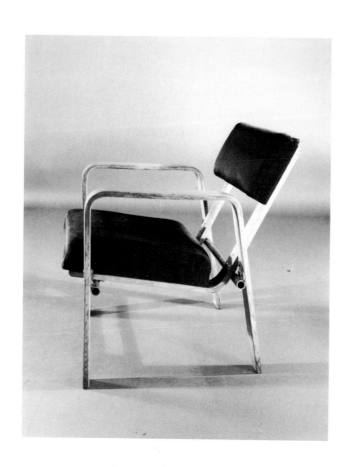

77 *Oskar Schlemmer, Tut Schlemmer,*
Ernst Kallai and Hans Wittner. 1927-30

Collage of 11 photographs mounted on
cardboard, 11⅝ x 16⅛″ (29.5 x 40.9 cm.)

78 *Paul Klee and Frau Klee, Guetary
 [Biarritz].* 1929
 Collage of 3 photographs mounted on
 cardboard, 11⅝ x 16⅛" (29.5 x 41 cm.)

79 *Anni, Summer 28 (Sommer 28).* 1928
Collage of 2 photographs mounted on
cardboard, 11⅝ x 16⁵⁄₁₆″
(29.5 x 41.5 cm.)

80　*Papal Palace, Avignon (Avignon am Päpste-Palast).* 1929

Collage of 2 photographs mounted on cardboard, 11⅝ x 16⅛″ (29.5 x 41 cm.)

81 *Sand, Biarritz.* ca. 1929
 Photograph, 7$\frac{1}{16}$ x 9$\frac{15}{16}$"
 (18 x 25.2 cm.)

82 *Small Beach, Biarritz (Kleiner Strand, Biarritz). ca. 1929*

Photograph, 9¼ x 5¹⁵/₁₆″ (23.5 x 15.1 cm.)

83 *Waves.* ca. 1929

Photograph mounted on cardboard, 8⅝ x 5⁹/₁₆″ (22.1 x 14.1 cm.)

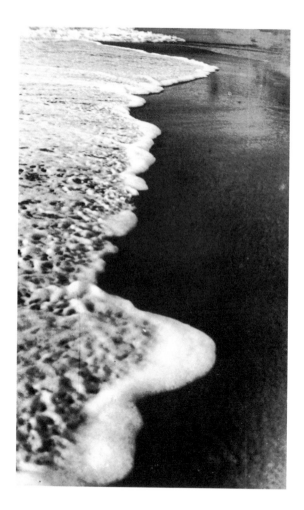

84 *Gropius, Ascona, Summer 30 (Sommer 30).*
1930
Photograph mounted on cardboard,
16⅛ x 11⅝″ (41 x 29.5 cm.)

85 *Philippo Haurer, Ascona.* 1930
Collage of 3 photographs mounted on
cardboard, 11⅝ x 16⅛″ (29.5 x 41 cm.)

86 *Herbert Bayer, Porto Ronco, Italy.*
 1930

 Collage of 2 photographs mounted on
 cardboard, 11⅝ x 16⅛" (29.5 x 41 cm.)

87 *Irene Bayer and Muzi, Porto Ronco, Italy.*
 1930
 Collage of 2 photographs mounted on
 cardboard, 11⅝ x 16⅛″ (29.5 x 41 cm.)

88 *Road in Paznauntal.* 1930
Photograph, 5^{15}/$_{16}$ x 9^{1}/$_{4}$″
(15.1 x 23.5 cm.)

89 *Garden Chairs at the Boulevard-Café*
 on the Kurfürstendamm [Berlin], Early
 Morning (Gartenstühle, das Boulevard-
 Kaffee, frühmorgens Kurfürstendamm).
 ca. 1931

 Photograph, 8¾ x 6⅜"
 (22.2 x 16.2 cm.)

90 *View of Maggia-Delta (including Ascona), Early Morning, on Lake Maggiore (Blick auf Maggia-Delta [darauf Ascona] früh am Lago Maggiore).* ca. 1930

Photograph, 6⁵/₁₆ x 9¹/₁₆″
(16 x 23 cm.)

91 *In Front of My Window*
 (Vor meinem Fenster). 1931-32

 Photograph, 9⅛ x 6″
 (23.2 x 15.2 cm.)

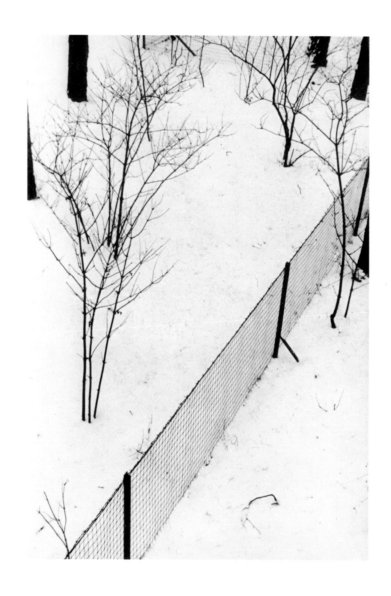

92 *Plan for Hotel Living Room in the
German Building Exhibition*, Berlin,
May 9-August 2, 1931

Pen and ink on paper, 8¼ x 11¾"
(21 x 29.8 cm.)

Collection Bauhaus-Archiv, W. Berlin,
Permanent loan from the Vogler family

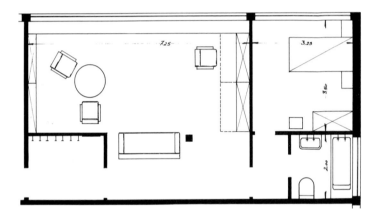

93 Illustration of *Hotel Living Room in the German Building Exhibition*, Berlin, May 9-August 2, 1931

In Henry Russell Hitchcock, *The International Style: Architecture Since 1922*, New York, W.W. Norton, 1932, 9½ x 7⅝″ (24.1 x 19.4 cm.)

Collection Mark Simon, Connecticut

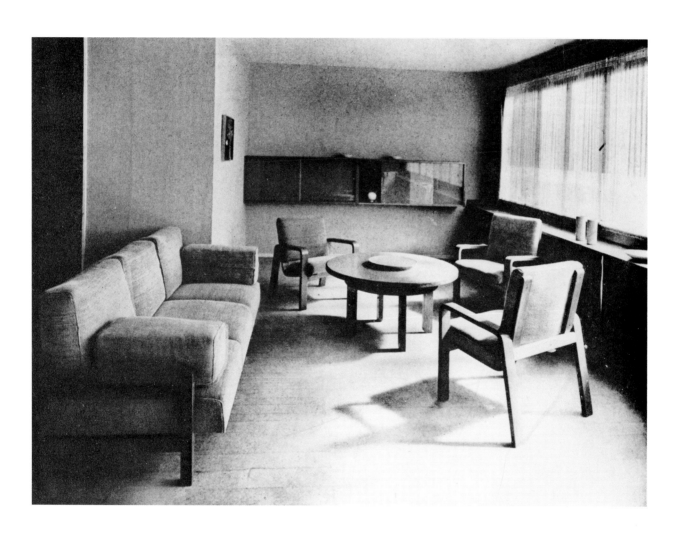

94 *Flying.* 1931
 Tempera on paper, 15¾ x 11¹³⁄₁₆″
 (40 x 30 cm.)
 Private Collection

95 *Steps (Stufen).* 1931
 Gouache and pencil on paper, 18¼ x
 23¼″ (46.1 x 59.1 cm.)
 Collection Hirshhorn Museum and
 Sculpture Garden, Smithsonian
 Institution, Washington, D.C., Gift of
 Joseph H. Hirshhorn, 1966

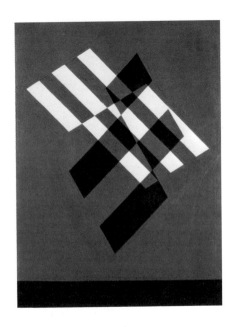

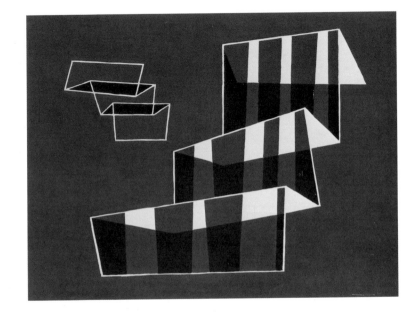

96 *Steps (Stufen)*. 1931
Sandblasted flashed glass,
15½ x 20½″ (39.4 x 52.1 cm.)

Collection Mr. and Mrs. Paul M.
Hirschland, New York

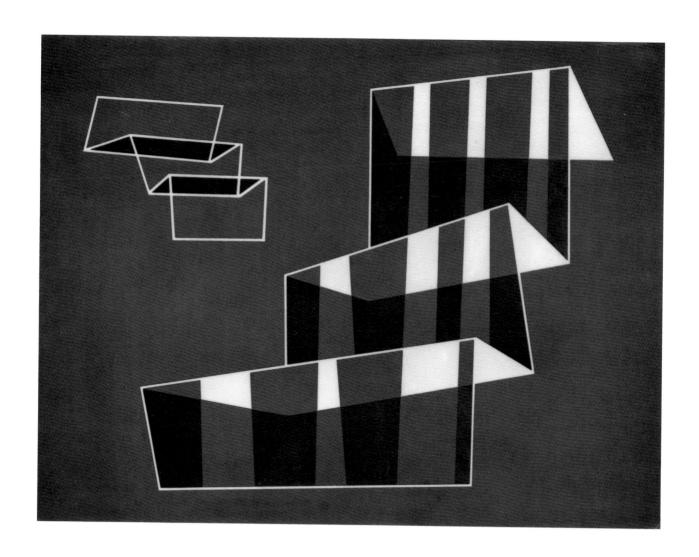

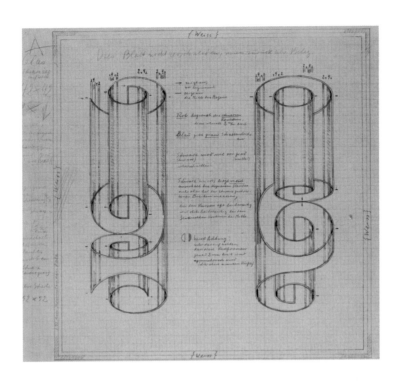

97 *Study for "Rolled Wrongly."* ca. 1931
Pencil and ink on blueprint paper,
17⅝ x 20½" (44.8 x 52.1 cm.)

98 *Rolled Wrongly.* 1931
Sandblasted flashed glass,
16¼ x 16¼" (41.3 x 41.3 cm.)

99 *Keyboard.* 1932
Sandblasted flashed glass, 14¾ x 25½"
(37.5 x 64.7 cm.)

100 *Treble Clef Ga.* 1932-35
Gouache on paper, 14¹⁵/₁₆ x 10″
(38 x 25.4 cm.)

101 *Treble Clef Gd.* 1932-35
Gouache on paper, sight, 14¼ x 8″
(36.2 x 20.3 cm.)
Collection Martina and Michael Yamin

102 *Treble Clef Ge.* 1932-35
Gouache on paper, sight, 14¼ x 8″
(36.2 x 20.3 cm.)
Collection Martina and Michael Yamin

103 *Treble Clef Gl.* 1932-35
Gouache on paper, 14¹⁵/₁₆ x 10¼″
(38 x 26.1 cm.)

104 *Treble Clef Gn.* 1932-35
Gouache on paper, 15 x 10³/₁₆″
(38 x 25.9 cm.)

105 *Treble Clef Go.* 1932-35
Gouache on paper, 14¾ x 10⅜″
(37.5 x 26.4 cm.)

106 *Together (Zusammen).* 1933
Linoleum cut on paper, 13¼ x 17"
(33.6 x 43.2 cm.)

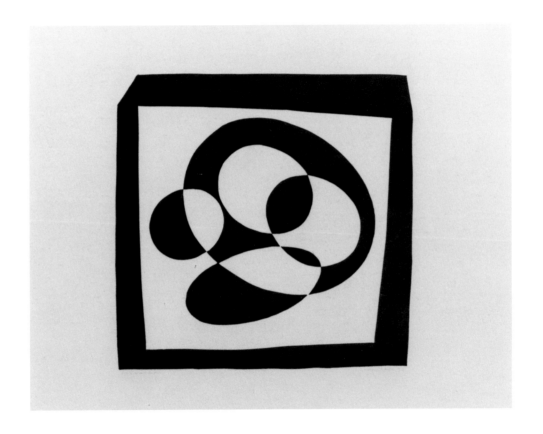

107 *Sea (Meer)*. 1933
 Linoleum/woodcut on paper, 14 x 17⅝"
 (35.6 x 44.8 cm.)

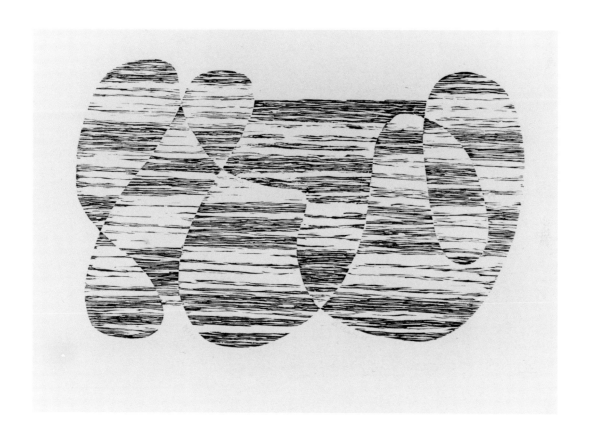

108 *Opera (Oper).* 1933
 Woodcut on paper, 12¾ x 17⅝″
 (32.4 x 44.8 cm.)

109 *Wings.* 1934
 Woodcut on paper, 10½ x 16⅜″
 (26.7 x 41.6 cm.)

110 *i.* 1934
 Linoleum cut on paper, 13⅞ x 15″
 (35.3 x 38 cm.)

111 *Showcase.* 1934
 Linoleum cut on paper, 14⅞ x 14″
 (37.8 x 35.6 cm.)

112 *Etude: Hot-Dry.* 1935
 Oil on Masonite, 12¾ x 15¾"
 (32.4 x 40 cm.)

113 *Etude: Red-Violet (Christmas Shopping)*. 1935
Oil on panel, 15⅜ x 14″
(39 x 35.6 cm.)

114 *Four Abstractions.* ca. 1935
 Pencil and oil on paper, 8⁷⁄₁₆ x 12″
 (21.4 x 30.5 cm.)

115 *Untitled Abstraction*. ca. 1940
Oil on Victor Talking Machine
"Victrola" cover, 14½ x 12½"
(36.8 x 31.7 cm.)

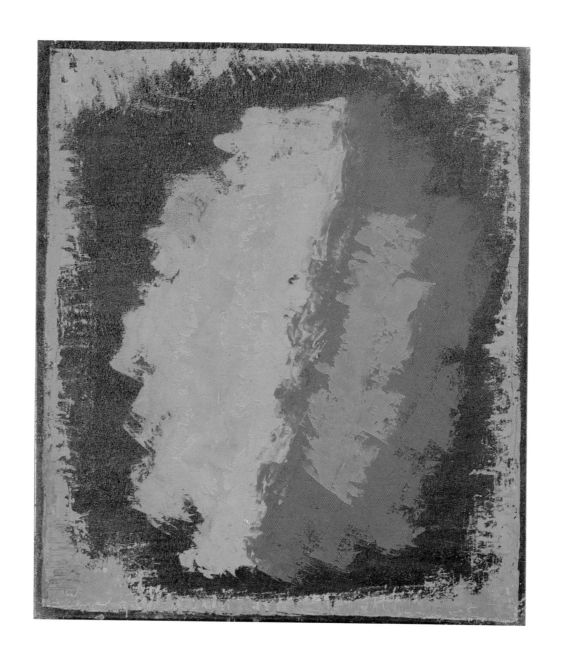

116 *Evening (an improvisation).* 1935
Oil on Masonite, 11 x 12⅜"
(28 x 31.5 cm.)

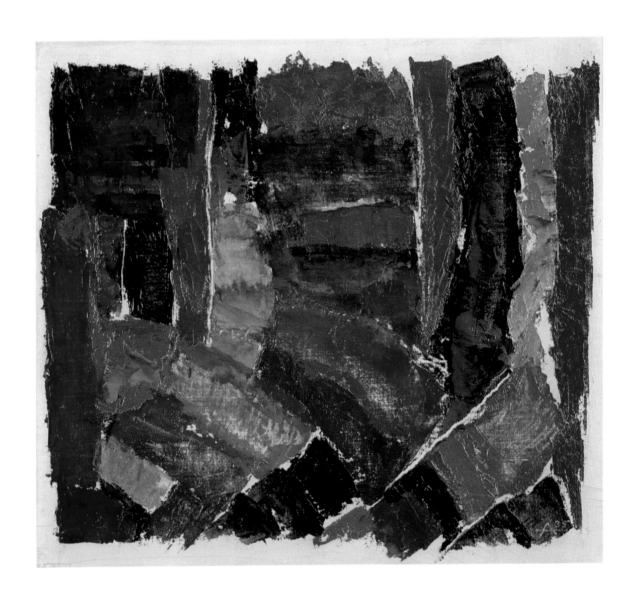

117 *Almost Four (color étude).* 1936
 Oil on Masonite, 13¾ x 15¼″
 (34.9 x 38.7 cm.)

118 *in open air.* 1936
Oil on Masonite, 19⅞ x 17¾″
(50.5 x 45.1 cm.)

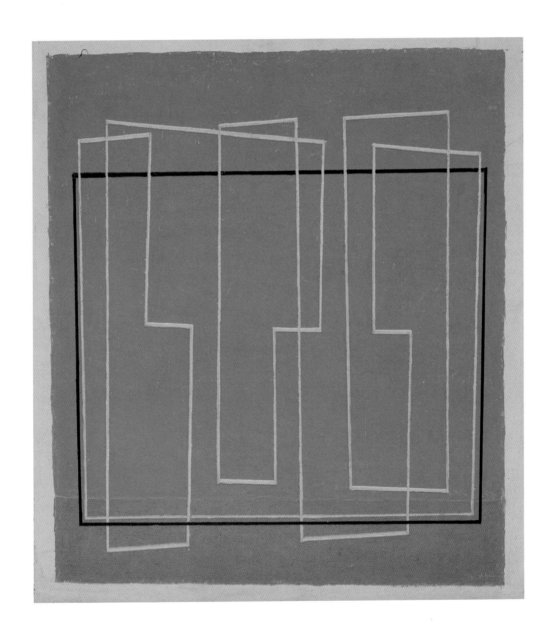

119 *Untitled I.* 1936
 Ink on paper, 14½ x 11″
 (36.8 x 28 cm.)

120 *Untitled IX.* 1936
 Ink on paper, 15¾ x 11¾″
 (40 x 29.8 cm.)

121 *Untitled X.* 1936
 Ink on paper, 15¹¹⁄₁₆ x 11½″
 (39.9 x 29.2 cm.)

122 *Untitled XI.* 1936
 Ink on paper, 15¾ x 11¾″
 (40 x 29.8 cm.)

123 *Mexican Stonework.* ca. 1936
Photograph, $9^{13}/_{16}$ x $6^{15}/_{16}''$
(24.9 x 17.7 cm.)

124 *Study for "Tenayuca."* ca. 1938
 Watercolor wash with ink and
 lithographic crayon on paper,
 9½ x 15½" (24.1 x 39.4 cm.)

125 *b and p.* 1937

Oil on Masonite, 23⅞ x 23¼″
(60.7 x 59.1 cm.)

Collection Solomon R. Guggenheim
Museum, New York
48.1172 x264

126 *"Related"* A. 1937
Oil on canvas, 23⅞ x 17¾"
(60.7 x 45.1 cm.)
Collection Bill Bass, Chicago

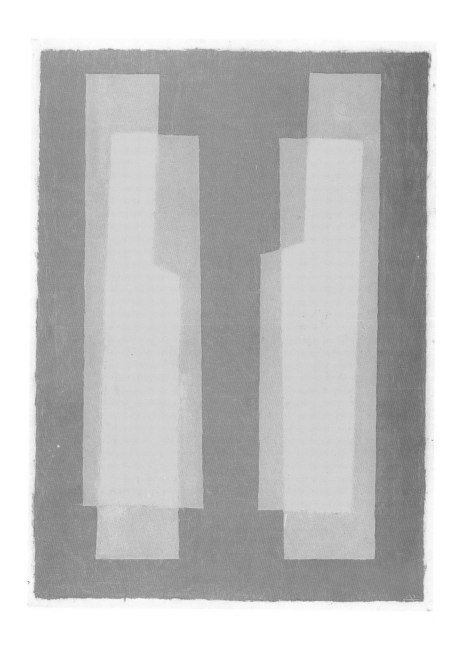

127 *Related I (red).* 1938-43
Oil on Masonite, 24½ x 18½″
(62.3 X 47 cm.)

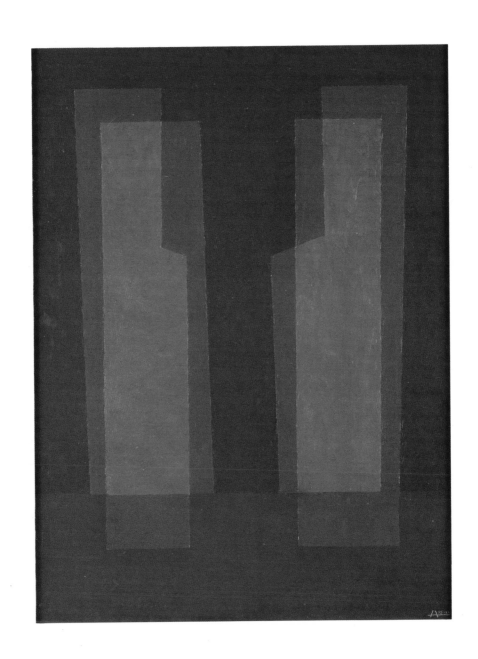

128 *Variant of "Related."* ca. 1940
Oil on Masonite, 16½ x 13⅛"
(41.9 x 33.3 cm.)

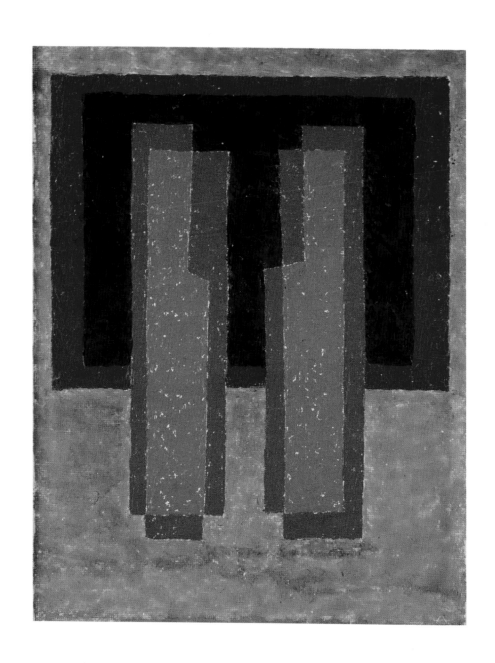

129A,B *Two Studies for "Airy Center."* ca. 1938

A. Oil and pencil on paper,
13 x 17⅜″ (33 x 44.1 cm.)

B. Oil and pencil on board,
5¼ x 8³⁄₁₆″ (13.4 x 20.7 cm.)

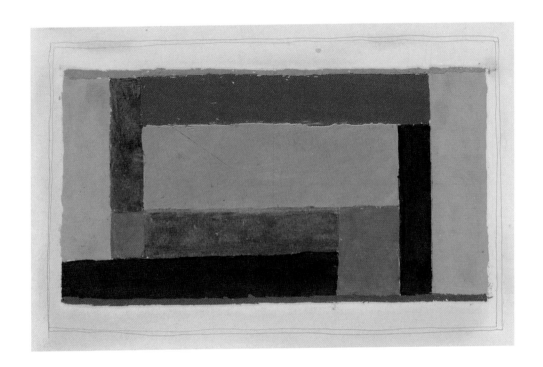

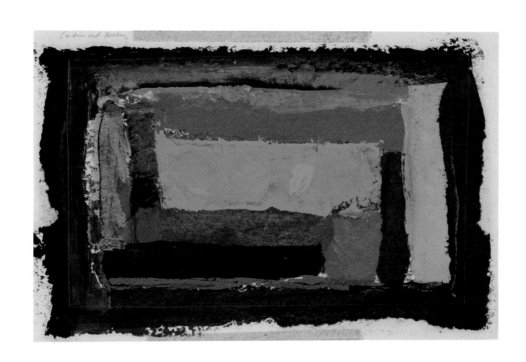

130 *Gate.* 1936

Oil on Masonite, 19³⁄₁₆ x 20¹⁄₁₆″
(48.7 x 50.9 cm.)

Collection Yale University Art Gallery,
New Haven, Gift of Collection of
Société Anonyme

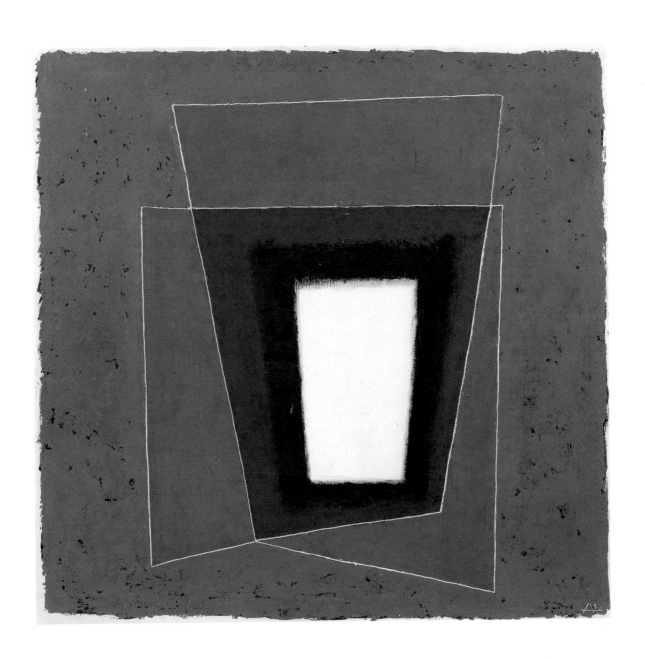

131 *Cadence.* 1940

Oil on Masonite, 28⁷⁄₁₆ x 28³⁄₁₆″
(72.3 x 71.6 cm.)

Collection Yale University Art Gallery,
New Haven, Gift of Anni Albers and
The Josef Albers Foundation

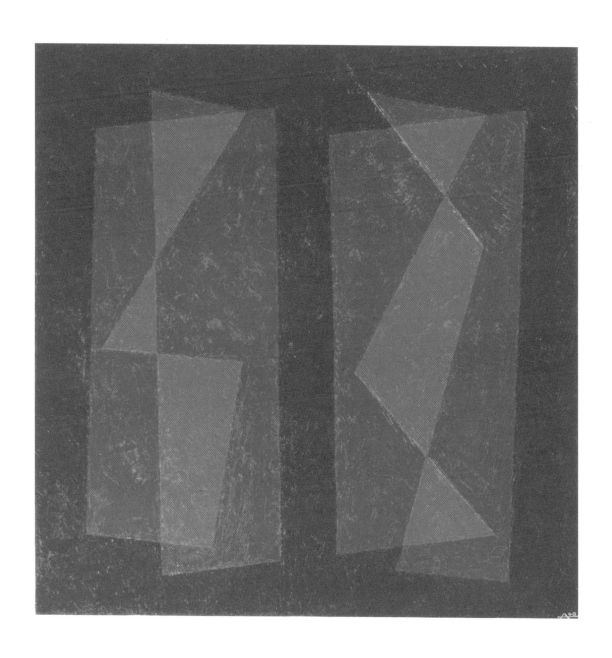

132A,B *Two Studies for "Movement in Gray."*
ca. 1939

 A. Pencil on paper, 5⅜ x 7¼"
(13.7 x 18.4 cm.)

 B. Pencil on paper, 5⅜ x 7¼"
(13.7 x 18.4 cm.)

133 *Movement in Gray.* 1939
Oil on Masonite, 36 x 35"
(91.4 x 88.9 cm.)

134 *Equal and Unequal.* 1939
Oil on Masonite, 19 x 40″
(48.3 x 101.6 cm.)
Collection Anni Albers

135 *Bent Black (A)*. 1940

Oil and casein on panel, 39¾ x 28"
(101 x 71.2 cm.)

Collection Addison Gallery of American Art,
Phillips Academy, Andover, Massachusetts,
Gift of Mrs. Frederick E. Donaldson

136 *Bent Black (B).* 1940

Oil on fiberboard, 26 x 19¼″
(66 x 48.9 cm.)

Collection Hirshhorn Museum and
Sculpture Garden, Smithsonian
Institution, Washington, D.C., Gift of
Joseph H. Hirshhorn, 1966

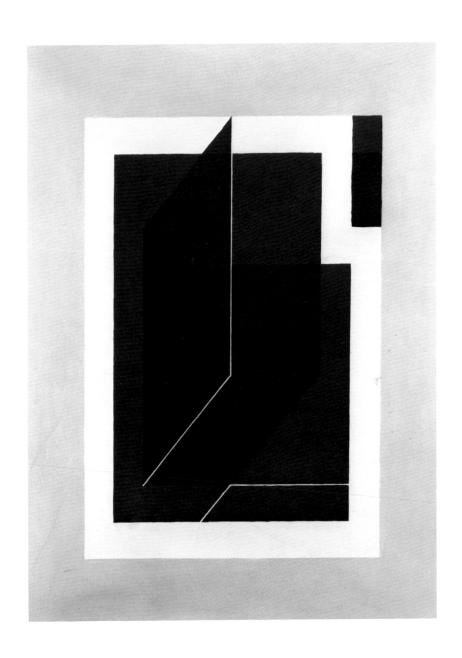

137 *Bent Dark Gray.* 1943
Oil on Masonite, 19 x 14″
(48.2 x 35.6 cm.)

Collection Solomon R. Guggenheim
Museum, New York
48.1172 x260

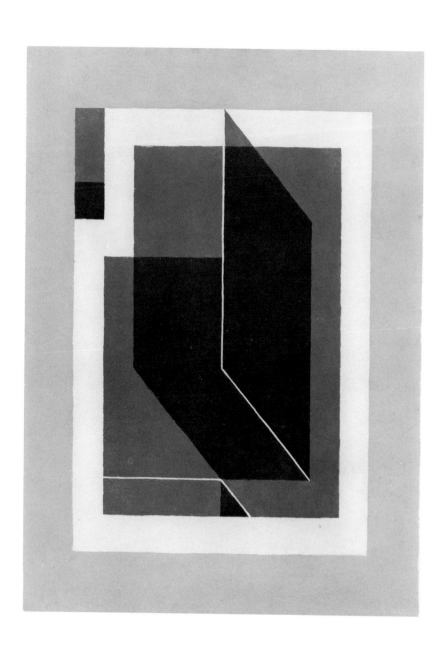

138 *Growing.* 1940
Oil on Masonite, 24 x 26¾"
(61 x 67.9 cm.)
Collection San Francisco Museum of
Modern Art, Gift of Charlotte Mack

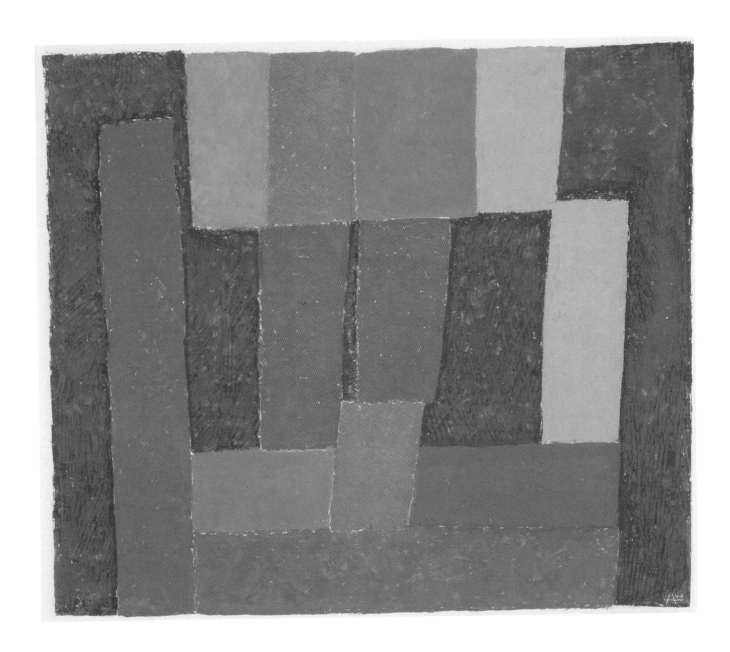

139 *Layered.* 1940
 Oil on Masonite, 23½ x 28"
 (59.7 x 71.2 cm.)

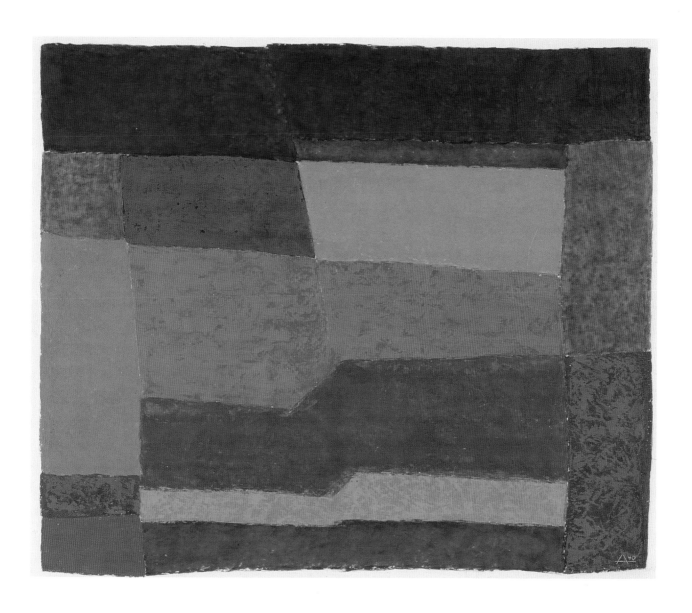

140 *Tierra Verde.* 1940
Oil on Masonite, 22¾ x 28″
(57.8 x 71.2 cm.)

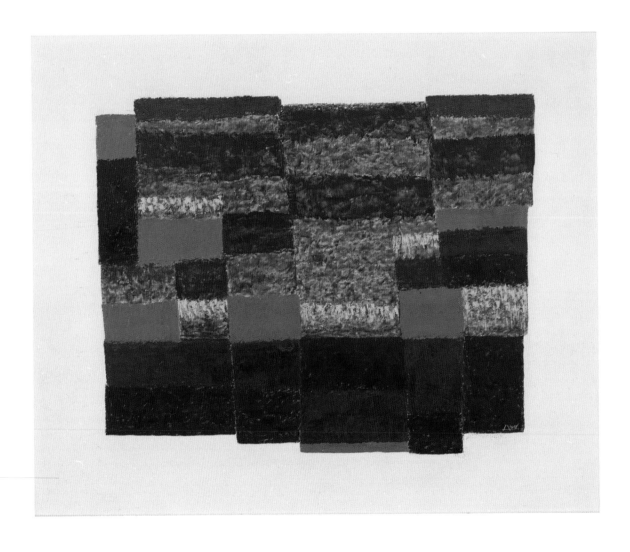

141 *To Mitla.* 1940
 Oil on Masonite, 21½ x 28⅛″
 (54.6 x 71.4 cm.)

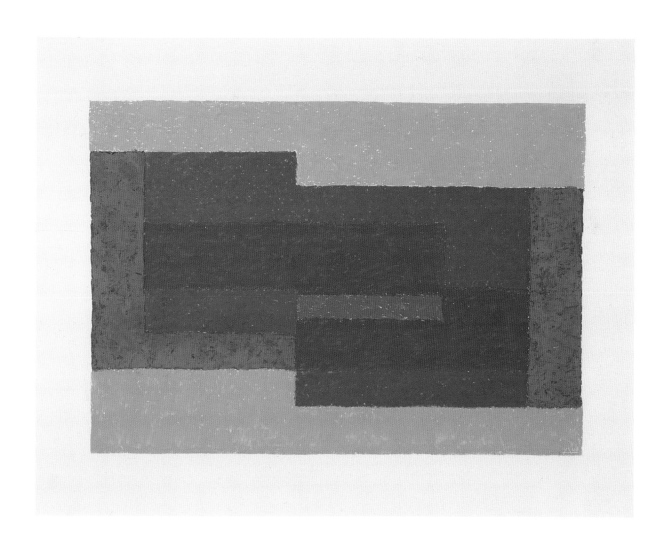

142 *Study for "Open."* 1940
Oil on paper, 18⅛ x 19¼″
(60 x 48.9 cm.)
Private Collection

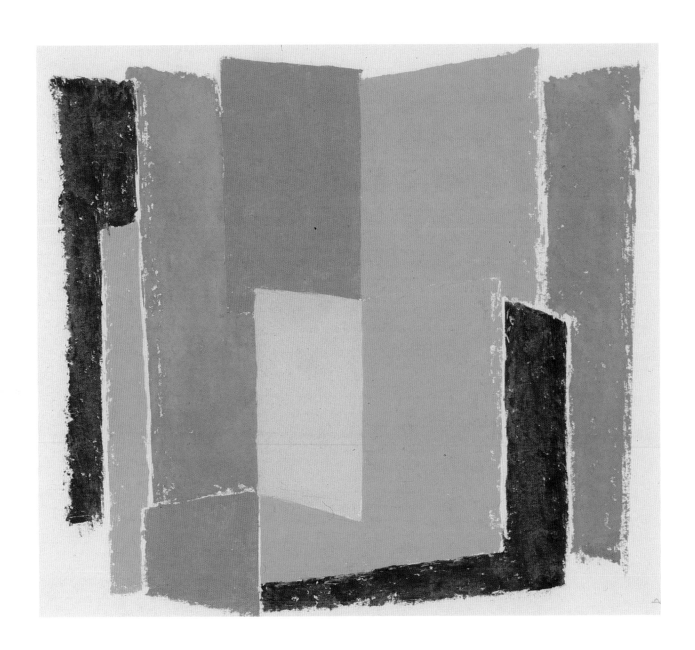

143 *Open.* ca. 1940
Oil on paper, 16 x 19″
(40.6 x 48.3 cm.)
Collection Hollins College, Roanoke,
Virginia

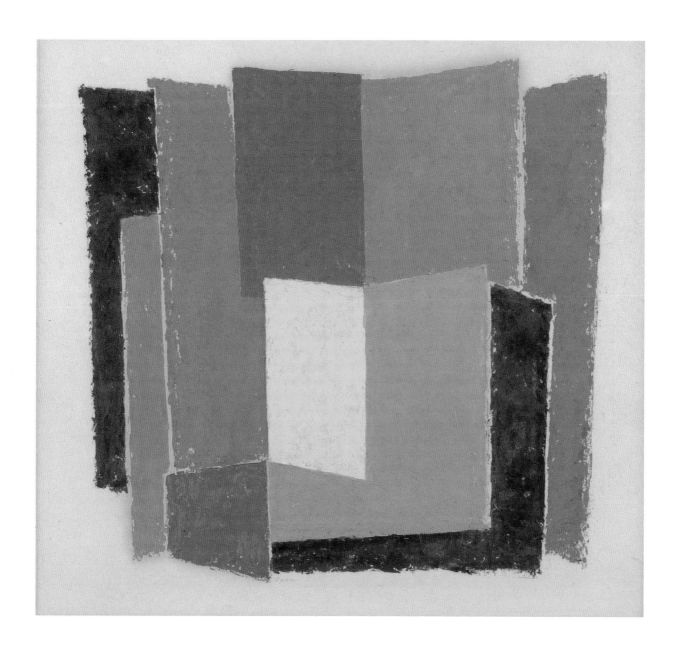

144 *Open (B)*. December 1940

Oil on Masonite, 19⁷⁄₈ x 19⁵⁄₈″
(50.7 x 49.8 cm.)

Collection Solomon R. Guggenheim
Museum, New York
48.1172 x263

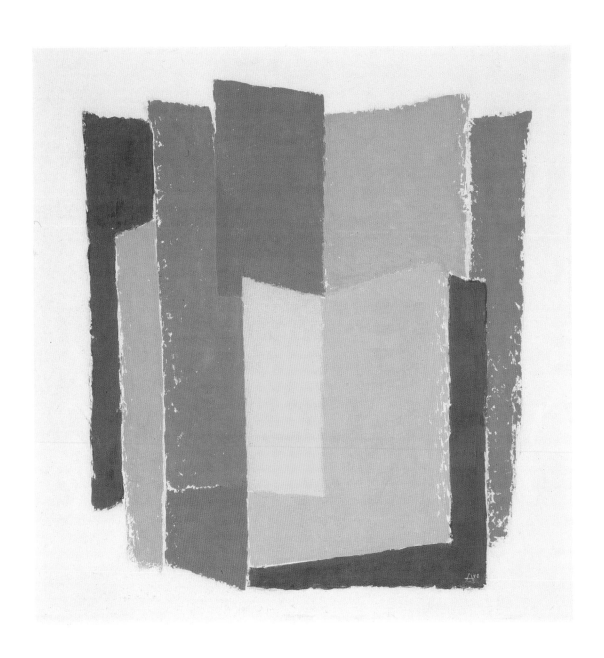

145 *Concealing.* December 1940

Oil on pressed wood, 27⅞ x 23¼″
(70.8 x 59.1 cm.)

Collection Solomon R. Guggenheim
Museum, New York
48.1172 x265

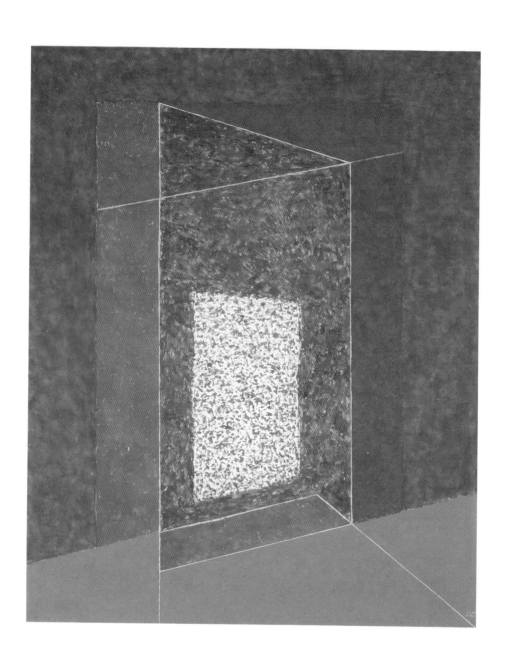

146 *Janus.* 1936-48
Oil on Masonite, 42½ x 37½"
(107.9 x 95.2 cm.)
Collection Josef Albers Museum,
Bottrop, W. Germany

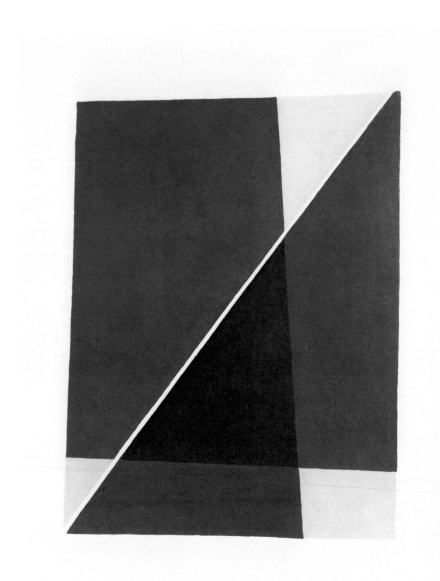

147 *Leaf Study I.* ca. 1940
Collage of leaves on paper, 9½ x 18″
(24.1 x 45.7 cm.)

148 *Leaf Study III.* ca. 1940
Collage of leaves on paper, 17¾ x 18⅝″
(45.1 x 47.3 cm.)

149 *Leaf Study VI.* 1942
Collage of leaves on paper, sight,
17¼ x 20″ (43.9 x 50.8 cm.)

150 *Leaf Study II.* ca. 1940
Collage of leaves on paper, 14½ x 18⅜″
(36.8 x 46.7 cm.)

151　*Leaf Study IV.* ca. 1940
　　Collage of leaves on paper, 18⁹/₁₆ x
　　22½″ (47.2 x 57.1 cm.)

152 *Three Postcards Framed Together*

top:
a good 39. 1938

Gouache on paper, 5⁷⁄₁₆ x 3½″
(13.7 x 8.8 cm.)

middle:
Merry Christmas and Happy New Year.
ca. 1940

Gouache on paper, 3½ x 5⁷⁄₁₆″
(8.8 x 13.7 cm.)

bottom:
with all best wishes for '43. 1942

Inscribed: *take this southern parkscape*
as a good symbol in spite of its baroque
curves—A

Gouache on paper, 3⁷⁄₁₆ x 5½″
(8.7 x 14 cm.)

153 *Birds.* ca. 1938
 Photograph, 9¾ x 7¾"
 (24.8 x 19.7 cm.)

154 *Study for "Proto-Form B" (no. 1).* 1938
Oil on fiberboard, 10½ x 9¾"
(26.7 x 24.8 cm.)

Collection Hirshhorn Museum and
Sculpture Garden, Smithsonian Institu-
tion, Washington, D.C., Gift of Joseph
H. Hirshhorn Foundation, 1974

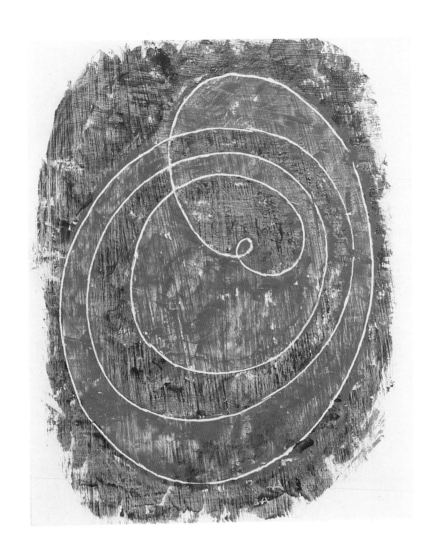

155 *Study for "Proto-Form B" (no. 2)*. 1938
Oil on fiberboard, 10½ x 9¾"
(26.7 x 24.8 cm.)

Collection Hirshhorn Museum and
Sculpture Garden, Smithsonian Institu-
tion, Washington, D.C., Gift of Joseph
H. Hirshhorn Foundation, 1974

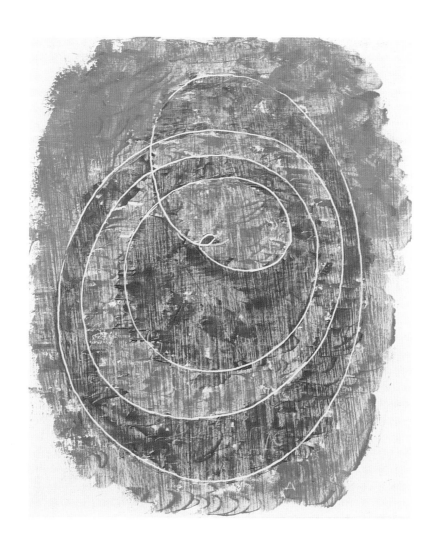

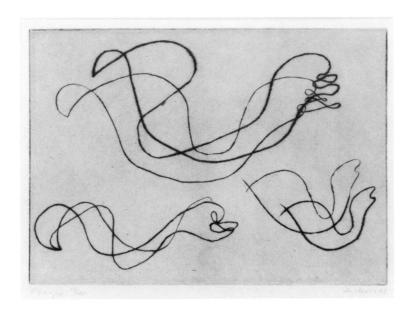

156 *Escape.* 1942

Drypoint on paper, 7⅞ x 10¼"
(20 x 26.1 cm.)

157 *Maternity.* 1942

Drypoint on paper, 12¹⁵/₁₆ x 9¹⁵/₁₆"
(32.9 x 25.2 cm.)

158 *Eh-De.* 1940

Drypoint on paper, 8⅞ x 10⅞"
(22.6 x 27.2 cm.)

159 *Eddie Dreier.* ca. 1938

Photograph, 6¼ x 9⁵/₁₆"
(15.8 x 23.7 cm.)

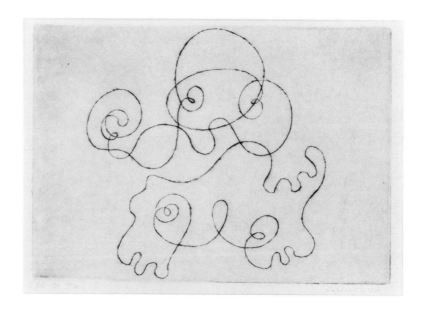

160 *Graphic Tectonic III.*
ca. 1941-42

Ink on paper, 23⅞ x 17⅞"
(60.7 x 45.4 cm.)

161 *Seclusion (Graphic Tectonic Series).* 1942
Zinc lithograph on paper, 19 x 23⅝"
(48.3 x 60.1 cm.)

162 *Study for "Memento" (I).* 1943
 Oil and pencil on paper, 16 x 12″
 (40.7 x 30.5 cm.)
 Private Collection

163 *Study for "Memento" (II).* 1943
 Oil and pencil on paper, 12½ x 17½″
 (31.7 x 44.4 cm.)
 Private Collection

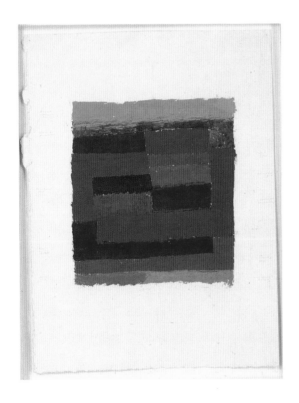

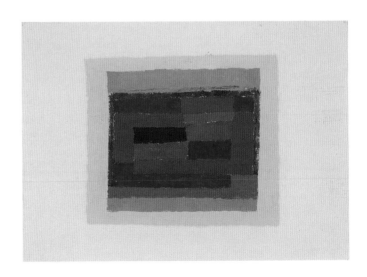

164 *Memento.* 1943
Oil on Masonite, 18½ x 20⅝″
(47 x 52.4 cm.)

Collection Solomon R. Guggenheim
Museum, New York
48.1172 x262

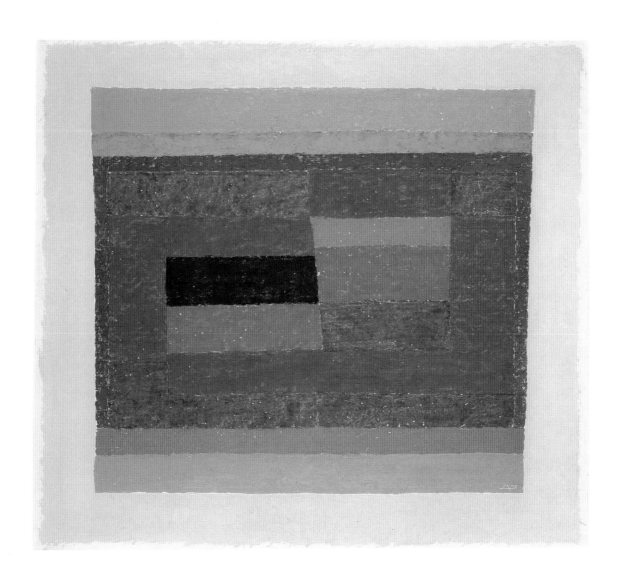

165 *Penetrating (B).* 1943

Oil, casein and tempera on Masonite,
21⅜ x 24⅞″ (54.3 x 63.2 cm.)

Collection Solomon R. Guggenheim
Museum, New York
48.1172 x261

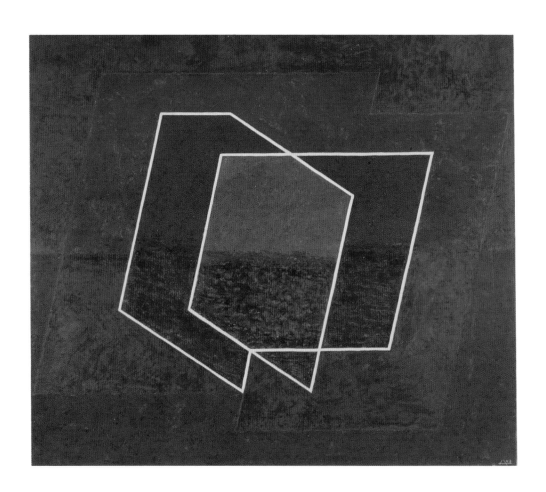

166 *Untitled Abstraction.* 1943
Oil on Masonite, 15¾ x 23¾″
(40 x 60.3 cm.)

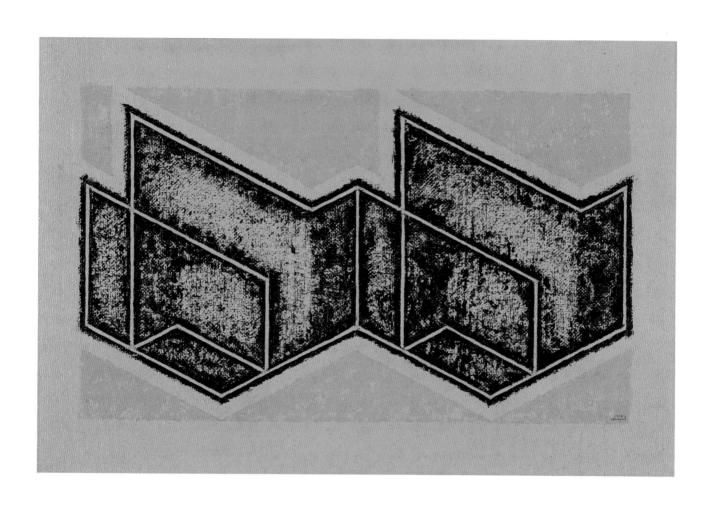

167 *Inscribed.* 1944
 Cork relief print, 12 x 15½″
 (30.5 x 39.4 cm.)

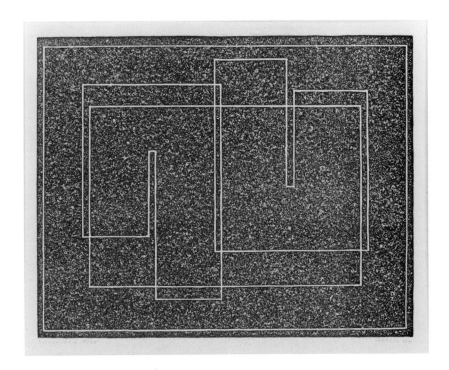

168 *Astatic.* 1944
Woodcut on paper, 17½ x 11⅛″
(44.4 x 28.2 cm.)
Collection Anni Albers

169 *Tlaloc.* 1944
 Woodcut on paper, 14½ x 15″
 (36.8 x 38 cm.)

170 *Light Construction.* 1945
Ink and oil on Masonite, 17 x 28¼″
(43.2 x 71.7 cm.)

171 *Structural Constellation II.* ca. 1950
Machine-engraved Vinylite mounted on
board, 17 x 22½″ (43.2 x 57.1 cm.)

172 *Structural Constellation III*. ca. 1950
Machine-engraved Vinylite mounted on
board, 17 x 22½" (43.2 x 57.1 cm.)

173 *Structural Constellation: Transformation
of a Scheme No. 12. 1950*
Machine-engraved Vinylite mounted on
board, 17 x 22½″ (43.2 x 57.1 cm.)

174 *Structural Constellation: Transformation of a Scheme No. 19.* 1950

Machine-engraved Vinylite mounted on board, 17 x 22½″ (43.2 x 57.1 cm.)

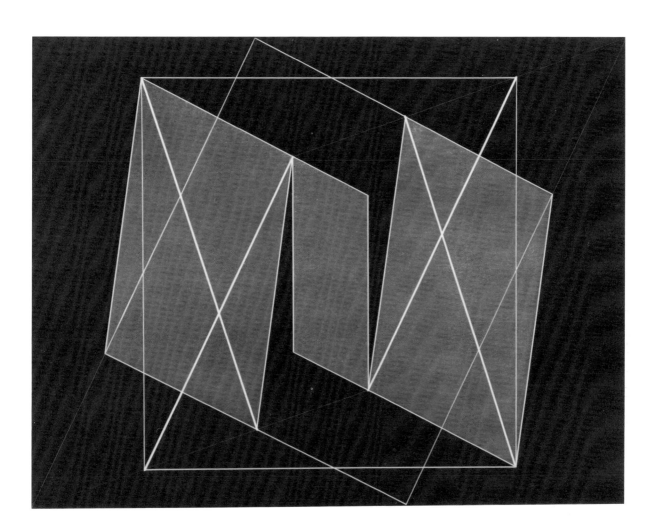

175 *Structural Constellation I.* ca. 1950
Machine-engraved Vinylite mounted on
board, 17 x 22½" (43.2 x 57.1 cm.)

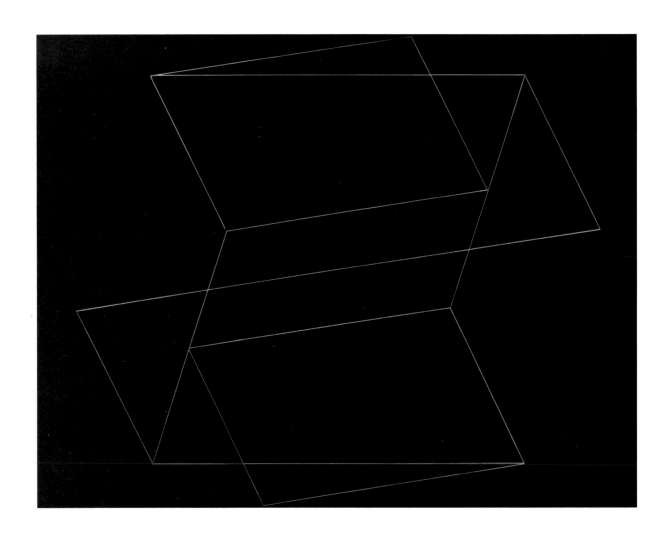

176 *Structural Constellation F-32.* 1954
Machine-engraved Vinylite mounted on
board, 17 x 22½″ (43.2 x 57.1 cm.)

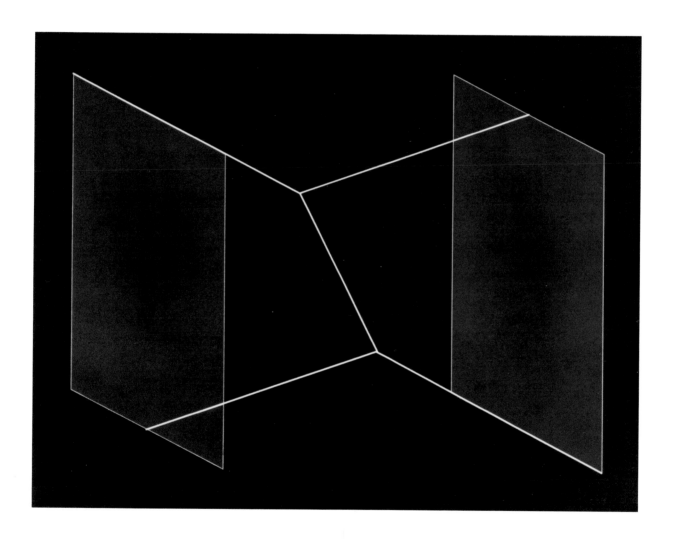

177 *Study for a Variant (I).* ca. 1947
Oil and pencil on paper, 9½ x 12¹/₁₆″
(24.1 x 30.7 cm.)

178 *Study for "Variant: Four Central Warm
Colors Surrounded by 2 Blues." ca. 1948*
Oil on paper, 19 x 23⅞" (48.3 x 60.7 cm.)

179 *Variant.* 1947-52
Oil on Masonite, 13½ x 26½"
(34.3 x 67.3 cm.)
Collection Theodore and Barbara Dreier

180 *Adobe (Variant): Luminous Day.*
1947-52
Oil on Masonite, 11 x 21½″
(28 x 54.6 cm.)
Collection Maximilian Schell

181 *Variant: Outer Gray/Repeated in*
 Center. 1948

 Oil on Masonite, 19½ x 29⅛"
 (49.5 x 74 cm.)

182 *Variant: Harboured.* 1947-52
Oil on Masonite, 25 x 32⅞″
(63.5 x 83.5 cm.)
Collection Don Page, New York

183 *Variant: Pink Orange Surrounded by*
 4 Grays. 1947-52
 Oil on Masonite, 15½ x 27¼″
 (39.4 x 69.2 cm.)

184 *Adobe (Variant): New Mexico*
Black-Pink. 1947

Oil on Masonite, 12⅛ x 24″
(30.8 x 61 cm.)

Collection Bill Bass, Chicago

185 *Variant: Brown, Ochre, Yellow.* 1948
Oil on Masonite, 18 x 25½″ (45.7 x
64.7 cm.)

186 *Variant: Southern Climate.* 1948-55
 Oil on Masonite, 12¼ x 22½″
 (31.1 x 57.1 cm.)

187 *Variant: Inside and Out.* 1948-53

Oil on composition board, 17⅝ x
26⁹/₁₆″ (44.8 x 67.4 cm.)

Collection Wadsworth Atheneum,
Hartford, The Ella Gallup Sumner and
Mary Catlin Sumner Collection

188 *Variant.* 1948-52

Oil on Masonite, 15¾ x 23¼″
(40 x 59.1 cm.)

Collection Josef Albers Museum,
Bottrop, W. Germany

189 *Variant.* 1948-55
Oil on Masonite, 16 x 31″
(40.6 x 78.7 cm.)

190 *Variant: Four Reds Around Blue.* 1948
Oil on Masonite, 21⅜ x 23" (54.3 x
58.9 cm.)
Private Collection

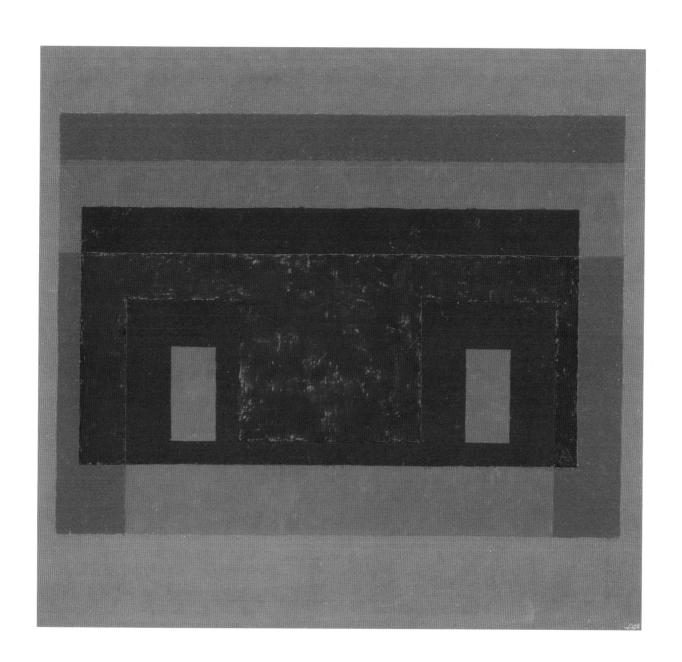

191 *Study for a Variant (II)*. ca. 1947
Oil and pencil on paper, 9½ x 12″
(24.1 x 30.5 cm.)

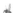

192 *Color Swatches*. n.d.
Oil and pencil on cardboard, 16½ x
25⅛″ (41.9 x 64.1 cm.)

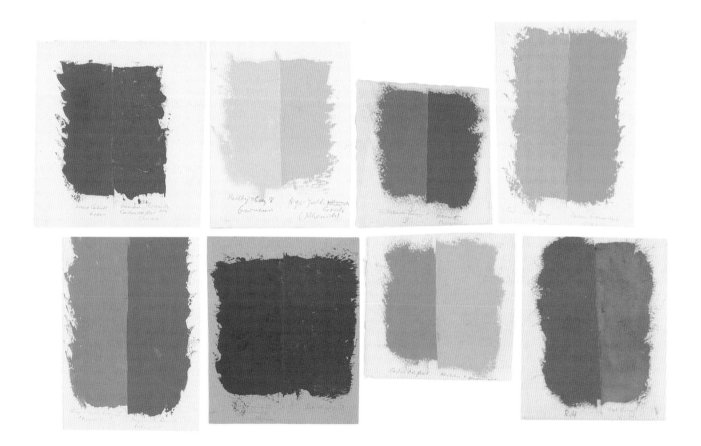

193 *Two Studies for "Interaction of Color."*
ca. 1961

Silk screen on paper mounted on paper,
20 x 19" (50.8 x 48.3 cm.)

194 *Two Studies (Homage to the Square
Series).* n.d.

Oil and pencil on paper, 12 x 5¼"
(30.5 x 13.4 cm.)

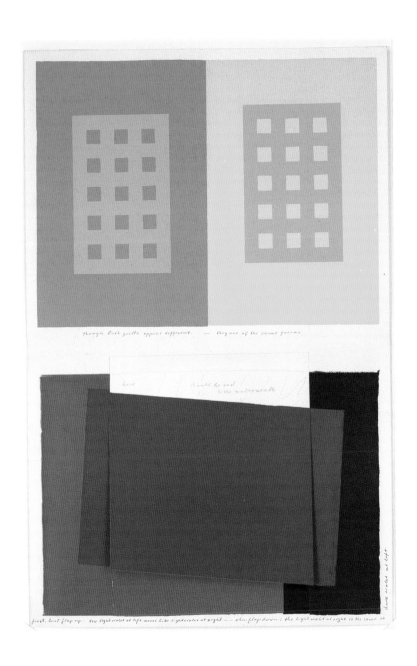

195 *Two Studies (Homage to the Square Series)*. n.d.

Oil and pencil on cardboard, 11 x 4¹⁵⁄₁₆″ (28 x 12.5 cm.)

196 *Two Studies (Homage to the Square Series)*. n.d.

Oil and pencil on cardboard, 11¼ x 4⅞″ (28.5 x 12.4 cm.)

197　*Study (Homage to the Square Series).* n.d.
Oil and pencil on paper, 12 x 12″
(30.5 x 30.5 cm.)

198　*Study (Homage to the Square Series).* n.d.
Oil and pencil on paper, 11¹⁵⁄₁₆ x 12¹⁄₁₆″
(30.4 x 30.7 cm.)

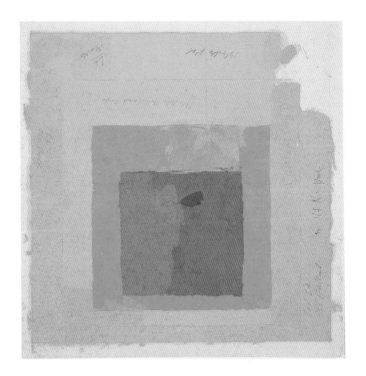

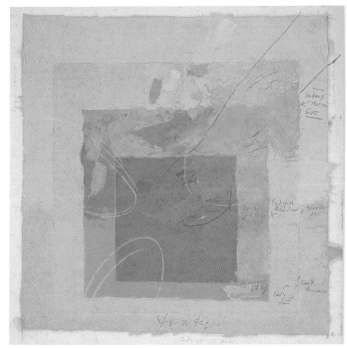

199 *Study (Homage to the Square Series)*. n.d.

Oil and pencil on paper, 13 1/16 x 12 1/16″
(33.2 x 30.7 cm.)

200 *Working Study (Homage to the Square
Series)*. n.d.

Oil on Masonite, 16 x 16″
(40.6 x 40.6 cm.)

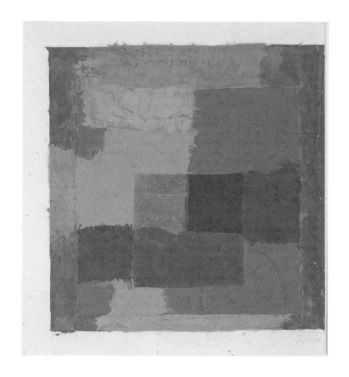

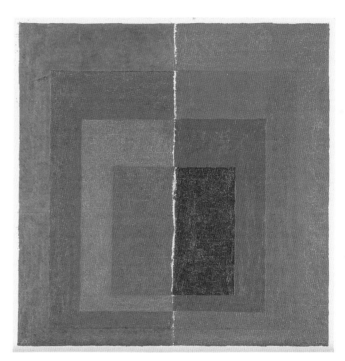

201 *Homage to the Square.* 1950
Oil on Masonite, 20⅝ x 20½"
(52.4 x 52.1 cm.)
Collection Yale University Art Gallery,
New Haven, Gift of Anni Albers and
The Josef Albers Foundation

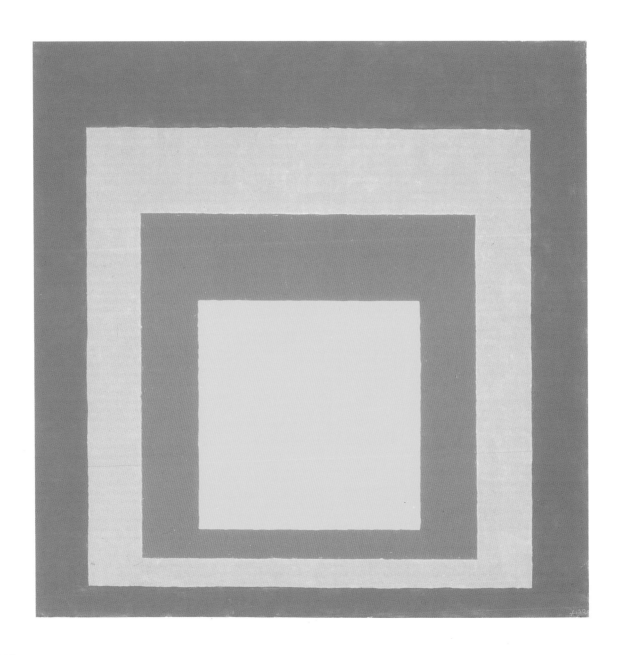

202 *Homage to the Square: Festive.* 1951
Oil on Masonite, 24 x 24″ (61 x 61 cm.)
Collection Yale University Art Gallery,
New Haven, Gift of Anni Albers and
The Josef Albers Foundation

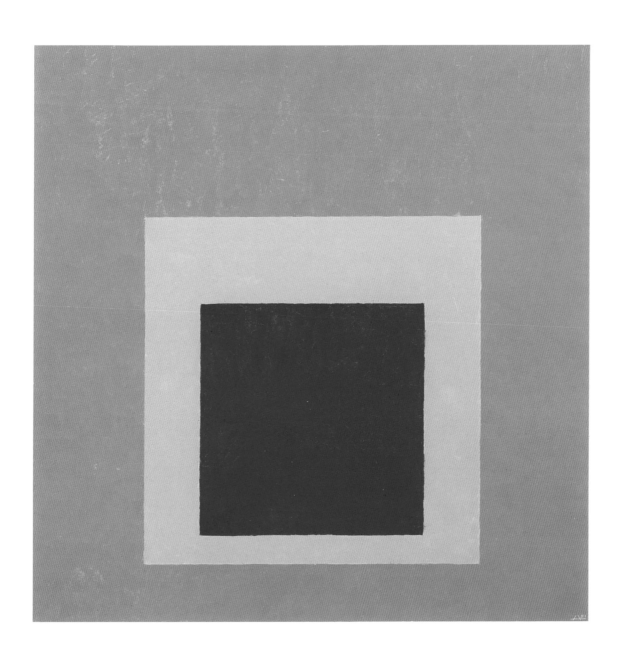

203 *Homage to the Square: Black Setting.* 1951
Oil on Masonite, 31¾ x 31¾″ (80.7 x 80.7 cm.)

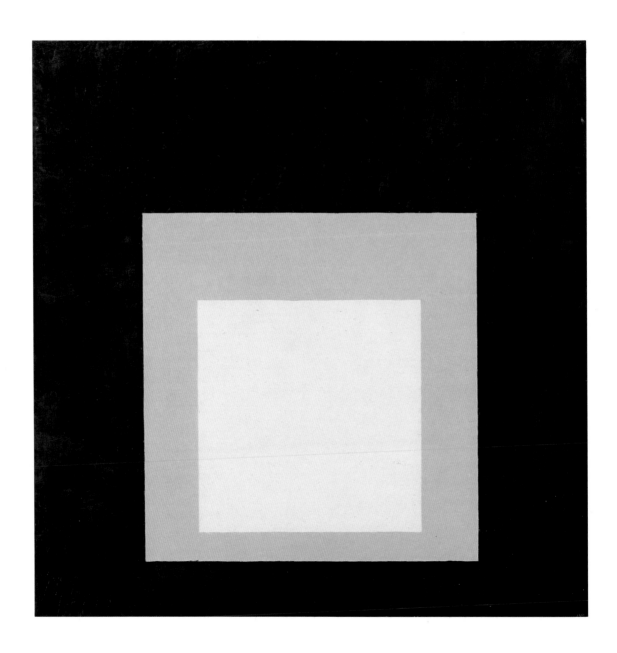

204 *Homage to the Square: Decided.* 1951
Oil on Masonite, 31¾ x 31¾"
(80.7 x 80.7 cm.)

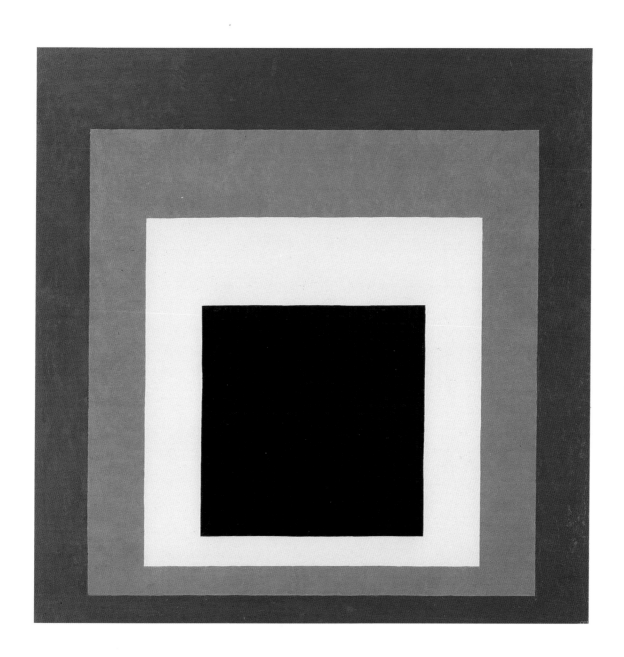

205 *Homage to the Square.* 1955
Oil on Masonite, 24 x 24"
(61 x 61 cm.)

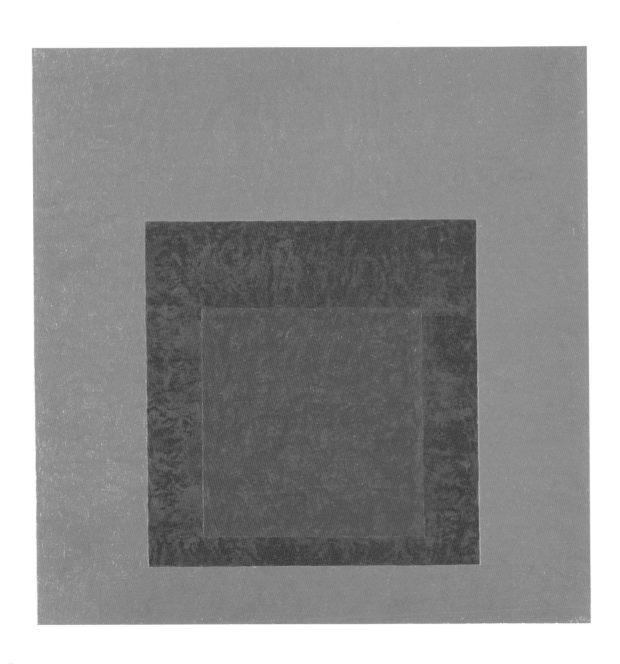

206 *Homage to the Square: Saturated.* 1951
Oil on Masonite, 23¼ x 23⅜" (59.1 x 59.4 cm.)
Collection Yale University Art Gallery, New Haven, The Katherine Ordway Collection

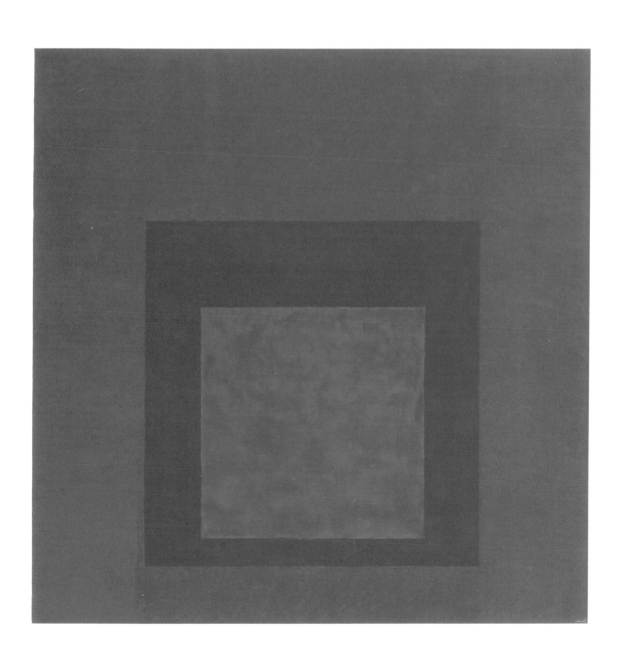

207 *Homage to the Square.* 1951
Oil on Masonite, 24 x 24″
(61 x 61 cm.)

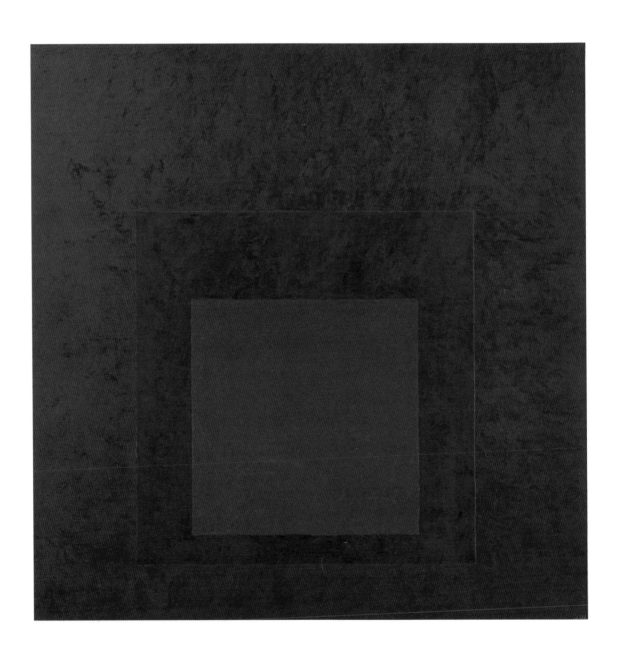

208 *Homage to the Square: Greek Island.*
1967
Oil on Masonite, 24 x 24″
(61 x 61 cm.)
Collection Ernst Beyeler, Basel

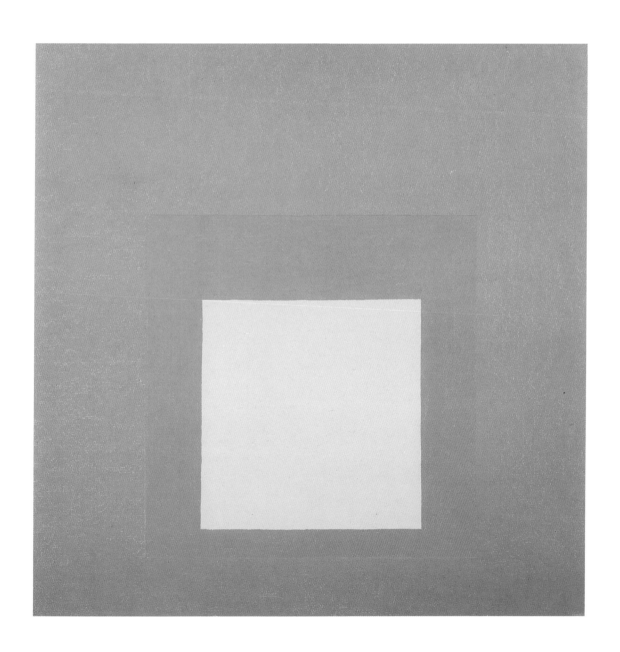

209 *Homage to the Square: A Rose Is a
Rose.* 1969
Oil on Masonite, 24 x 24"
(61 x 61 cm.)

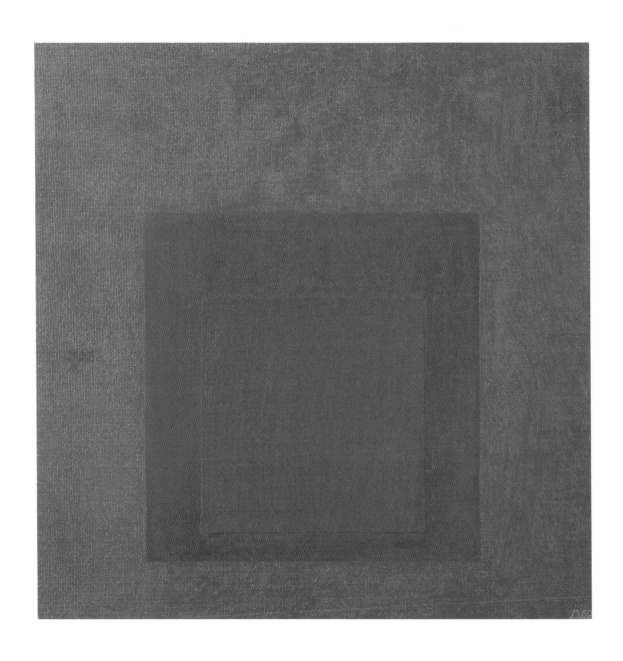

210 *Homage to the Square: R I c-1.*
1969
Oil on Masonite, 16 x 16″
(40.6 x 40.6 cm.)
Collection Maximilian Schell

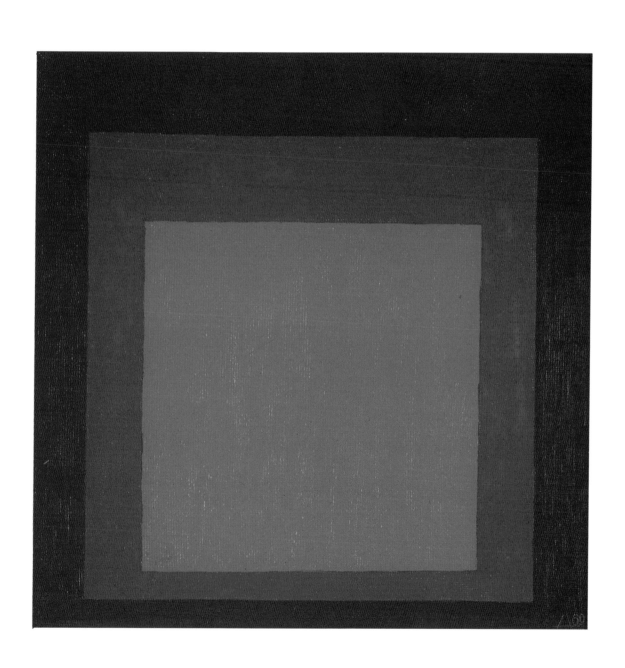

211 *Homage to the Square: Pompeian.* 1963
Oil on Masonite, 18 x 18″
(45.7 x 45.7 cm.)
Collection Maximilian Schell

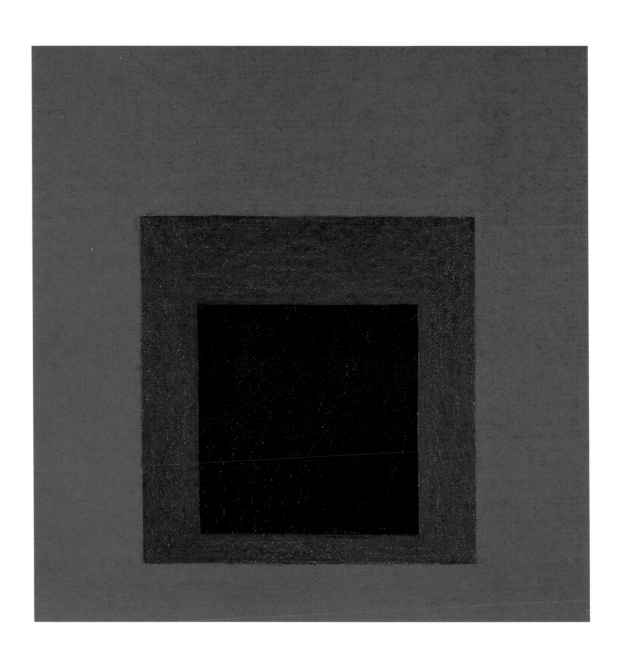

212 *Homage to the Square: Mitered.*
1962

Oil on Masonite, 48 x 48″
(122 x 122 cm.)

Collection Josef Albers Museum,
Bottrop, W. Germany

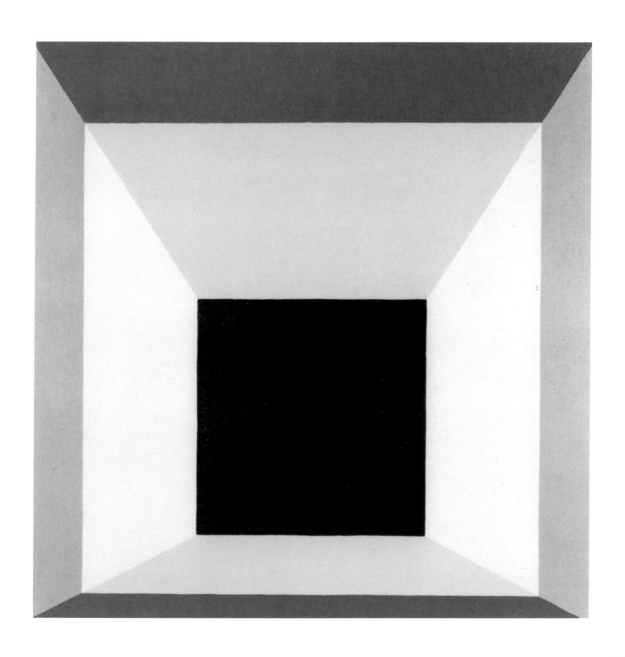

213 *Homage to the Square: Open Outwards.* 1967
Oil on Masonite, 48 x 48"
(122 x 122 cm.)

Collection Staatliche Museen Preussischer
Kulturbesitz, Nationalgalerie, Berlin

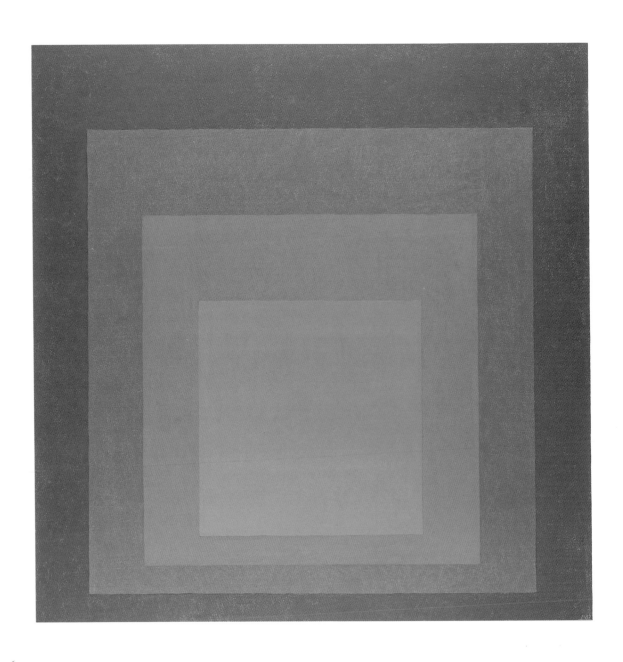

214 *Homage to the Square: Apparition.*
1959

Oil on Masonite, 47½ x 47½″
(120.6 x 120.6 cm.)

Collection Solomon R. Guggenheim
Museum, New York
61.1590

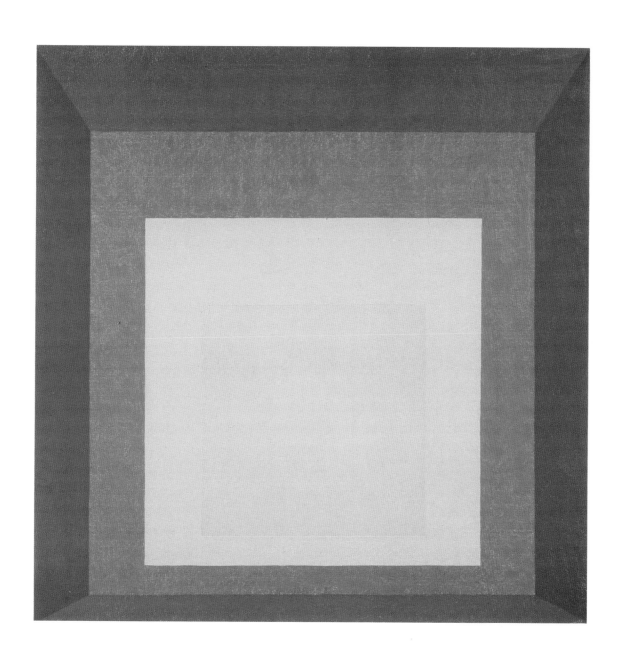

215 *Homage to the Square.* 1960
Oil on Masonite, 32 x 32″
(81.3 x 81.3 cm.)
Collection Mr. and Mrs. Lee V.
Eastman

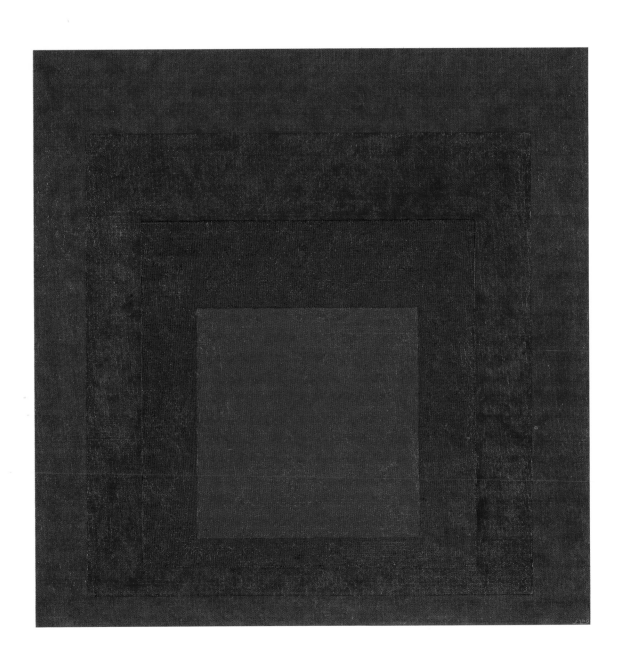

216 *Homage to the Square: On an Early Sky.* 1964

Oil on Masonite, 48 x 48″
(122 x 122 cm.)

Collection Australian National Gallery,
Canberra

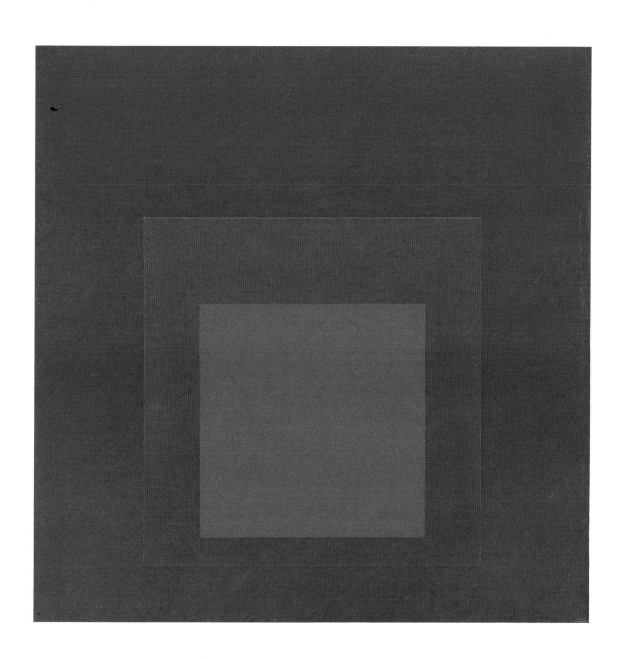

217 *Study for "Homage to the Square: Cooling."* 1961

Oil on panel, 24 x 24″ (61 x 61 cm.)

Collection Solomon R. Guggenheim Museum, New York, Gift, Anni Albers and The Josef Albers Foundation, 1977 77.2340

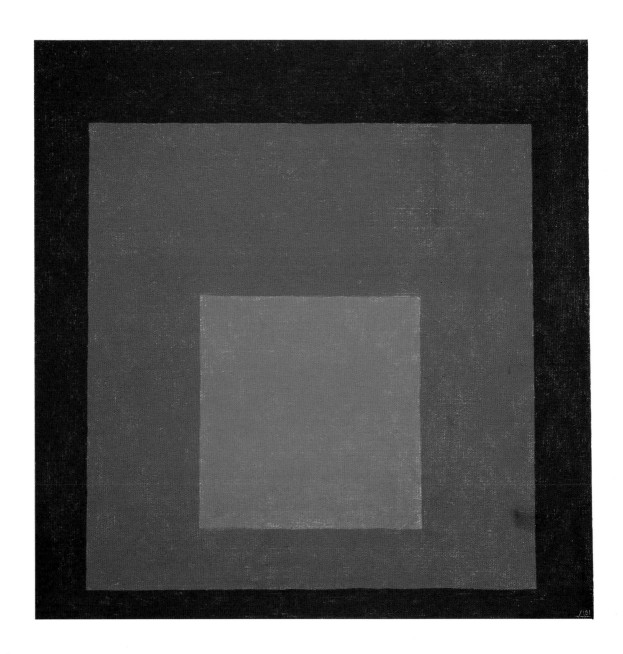

218 *Homage to the Square.* 1965

Oil on Masonite, 24 x 24″
(61 x 61 cm.)

Collection Musée National d'Art
Moderne, Centre Georges Pompidou,
Paris, Gift, Anni Albers and The Josef
Albers Foundation, 1978

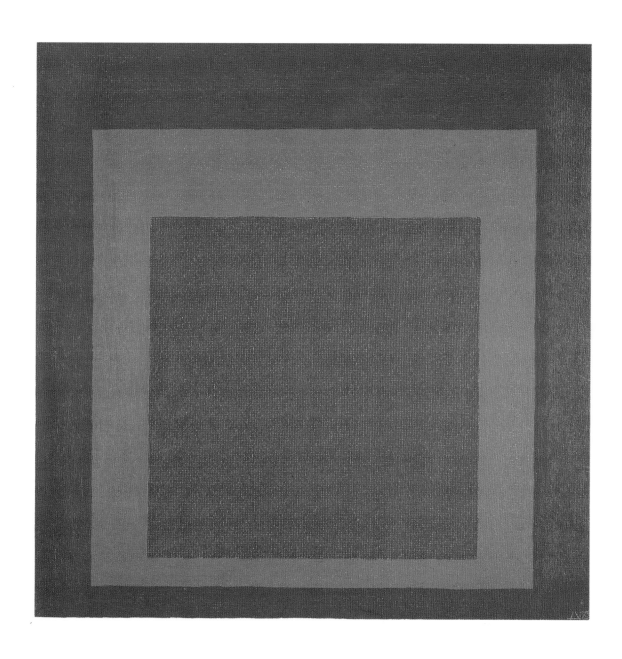

219 *Homage to the Square: Saturated II.*
1967
Oil on Masonite, 48 x 48″
(122 x 122 cm.)

Collection Maria and Conrad Janis,
Beverly Hills

220 *Homage to the Square: Potent.* 1968
Oil on Masonite, 40 x 40″
(101.6 x 101.6 cm.)
Collection Maximilian Schell

221 *Homage to the Square: Early Ode.*
1962

Oil on Masonite, 18 x 18″
(45.7 x 45.7 cm.)

Collection Maria and Conrad Janis,
Beverly Hills

222 *Homage to the Square: Arrival.* 1963

Oil on Masonite, 40 x 40″
(101.6 x 101.6 cm.)

Collection Maria and Conrad Janis,
Beverly Hills

223 *Homage to the Square: Light-Soft.*
1968

Oil on Masonite, 40½ x 40½"
(102.9 x 102.9 cm.)

Collection Yale University Art Gallery,
New Haven, Gift of Anni Albers and
The Josef Albers Foundation

224 *Homage to the Square: Dense-Soft.*
1969

Oil on Masonite, 40 x 40″
(101.6 x 101.6 cm.)

Collection Yale University Art Gallery,
New Haven, Gift of Anni Albers and
The Josef Albers Foundation

225 *Homage to the Square: Tenacious.* 1969

Oil on Masonite, 24 x 24"
(61 x 61 cm.)

Collection Mr. and Mrs. Lee V.
Eastman

226 *Homage to the Square: Warm Silence.*
1971

Oil on Masonite, 24 x 24″
(61 x 61 cm.)

Collection Mr. and Mrs. Lee V.
Eastman

227 *Homage to the Square: White Nimbus.* 1964
Oil on Masonite, 48 x 48"
(122 x 122 cm.)
Collection Hannelore B. Schulhof, New York

*228 *Study for "Homage to the Square:
Closing."* 1964
Oil on board, 15¹³⁄₁₆ x 15¹³⁄₁₆"
(40.2 x 40.2 cm.)
Collection Solomon R. Guggenheim
Museum, New York, Gift of the artist,
1969
69.1917

*229 *Study for "Homage to the Square: Starting."* 1969

Oil on board, 15¹³⁄₁₆ x 15¹³⁄₁₆″ (40.2 x 40.2 cm.)

Collection Solomon R. Guggenheim Museum, New York, Gift of the artist, 1969
69.1916

230 *Homage to the Square: Impact.* 1965

Oil on Masonite, 24 x 24″ (61 x 61 cm.)

Collection Josef Albers Museum, Bottrop, W. Germany

231 *Homage to the Square: Lone Whites.*
1963
Oil on Masonite, 24 x 24″
(61 x 61 cm.)

232 *Homage to the Square: Dimly Reflected.* 1963
Oil on Masonite, 24 x 24″
(61 x 61 cm.)

233 *Homage to the Square: Yellow Climate.*
1961

Oil on Masonite, 48 x 48″
(122 x 122 cm.)

Collection Louisiana Museum of
Modern Art, Humlebæk, Denmark

234 *Study for "Homage to the Square."* 1971
Oil on Masonite, 24 x 24″
(61 x 61 cm.)
Collection Josef Albers Museum,
Bottrop, W. Germany

236 *Homage to the Square.* 1972
 Oil on Masonite, 24 x 24"
 (61 x 61 cm.)

237 *Homage to the Square.* 1970
Oil on Masonite, 16 x 16"
(40.6 x 40.6 cm.)

238 *Homage to the Square: R III- a 6.*
 1968
 Oil on Masonite, 32 x 32″
 (81.3 x 81.3 cm.)
 Collection Maximilian Schell

239 *Homage to the Square.* 1970
Oil on Masonite, 32 x 32"
(81.3 x 81.3 cm.)
Collection Donald and Barbara Jonas

*240 *Homage to the Square: Contained.*
1969
Oil on Masonite, 16 x 16"
(40.6 x 40.6 cm.)

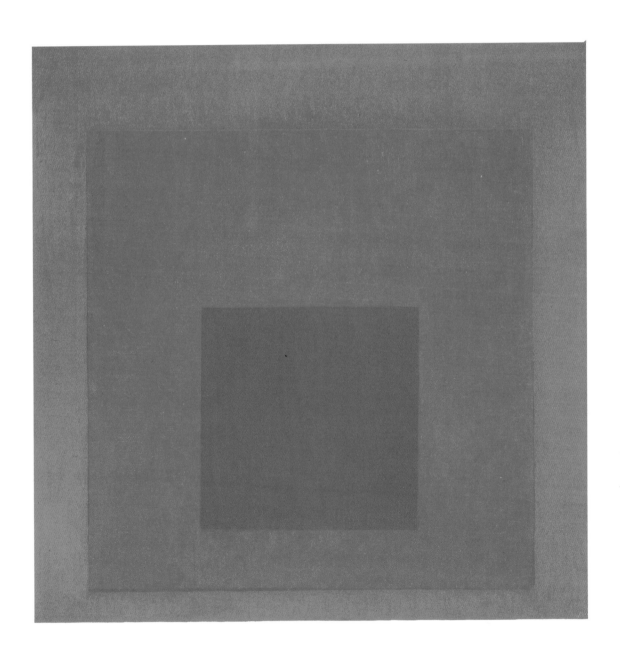

241 *Homage to the Square.* 1969
 Oil on Masonite, 16 x 16"
 (40.6 x 40.6 cm.)

*242 *Homage to the Square: Less and More.*
 1969
 Oil on Masonite, 24 x 24"
 (61 x 61 cm.)

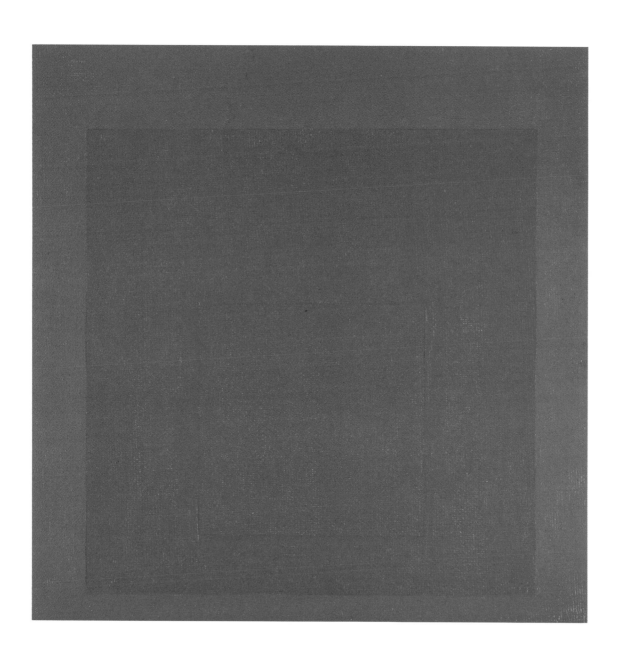

243 *Homage to the Square: Reticence.* 1965

Oil on Masonite, 31¾ x 31¾"
(80.7 x 80.7 cm.)

Collection Josef Albers Museum,
Bottrop, W. Germany

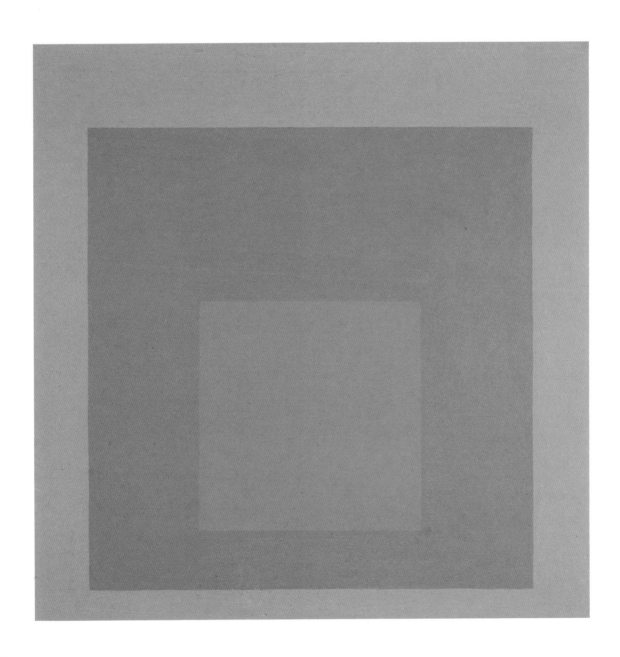

244 *Homage to the Square: Profundo.* 1965

Oil on Masonite, 31¾ x 31¾"
(80.7 x 80.7 cm.)

Collection Josef Albers Museum,
Bottrop, W. Germany

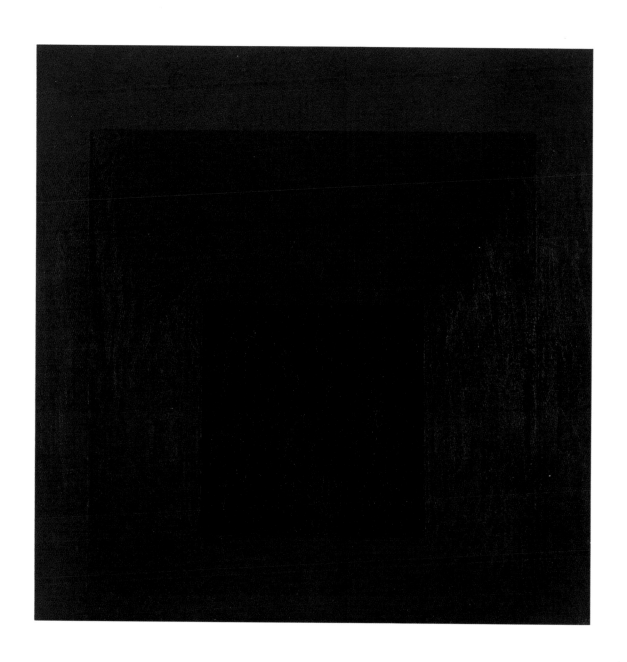

245 *Homage to the Square: Despite Mist.*
1967
Oil on Masonite, diptych, each panel
40 x 40″ (101.6 x 101.6 cm.)
Collection Maximilian Schell

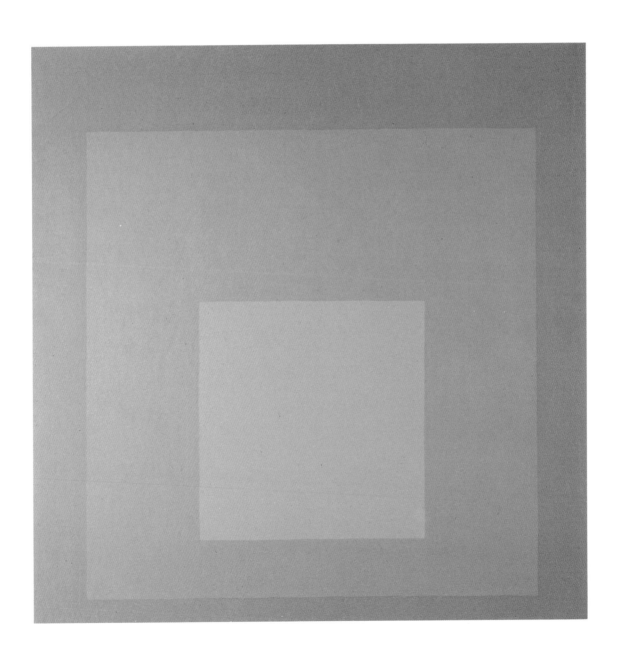

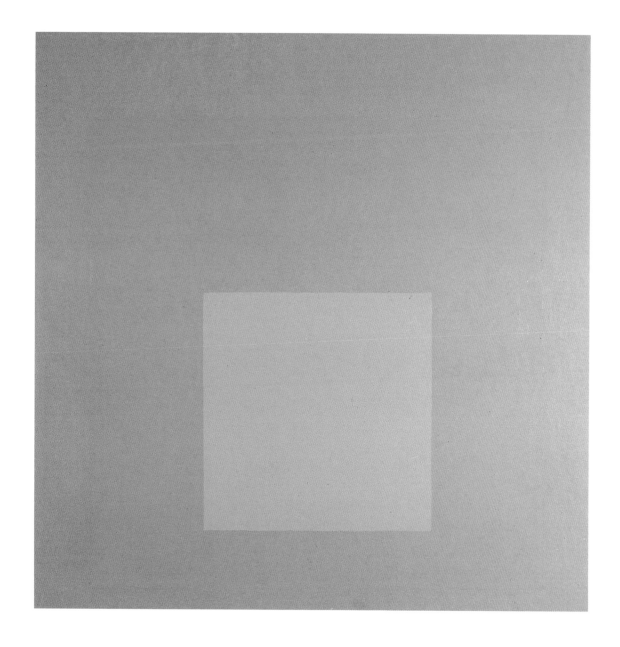

246 *Homage to the Square.* 1976
Oil on Masonite, 23⅞ x 23⅞″
(60.7 x 60.7 cm.)

*247 *Interaction of Color.* 1963/88
Electronic interactive videodisc of
1963 book
Presented by Pratt Institute and
Jerry Whiteley
see p. 296

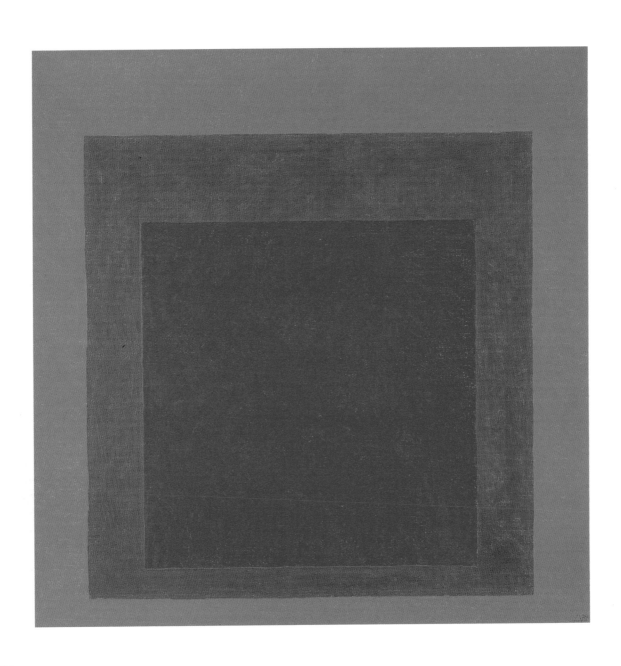

Chronology

1888 Born March 19 in Bottrop, a small industrial city in the Ruhr district, Germany; the oldest son of Lorenz Albers and Magdalena Schumacher Albers.

1902-05 Attends Präparanden-Schule, Langenhorst.

1905-08 Attends Lehrerseminar (Teacher's College), Büren; receives teacher's certificate.

1908 Visits museums in Munich and Folkwang Museum, Hagen, where he sees first paintings by Cézanne and Matisse.

1908-13 Teaches public school, primary grades, for Westfalian regional teaching system, in small towns and then in Bottrop.

1913-15 Attends Königliche Kunstschule, Berlin, where he studies teaching of art under Philipp Franck. Exempted from military service because of teaching affiliation. Visits state museums and galleries in Berlin. Executes first figurative oils, mostly boldly colored still lifes and drawings reminiscent of Dürer (see cat. nos. 1-5).

1915 Receives certificate as art teacher.

1916-19 Attends Kunstgewerbeschule, Essen, while still teaching in public schools in Bottrop. Studies with Jan Thorn-Prikker, a stained-glass artisan and drawing instructor. Begins independent work in stained glass. Executes first lithographs and blockprints, including *Workers' Houses* and *Rabbits* series (see cat. nos. 11-13; 7, 8); these are exhibited in 1918 at Galerie Goltz, Munich. Makes more figurative drawings, including portraits and self-portraits (see cat. nos. 15-18, 30); other subjects include farm animals and many aspects of local scenery (see cat. nos. 19-26). Albers's style, while reflecting his awareness of contemporary European artistic movements, begins to emerge, with an emphasis on precise articulation and visual spareness (see cat. nos. 6, 9, 10, 14, 32, 33).

1917-18 Executes *Rosa mystica ora pro nobis*, stained-glass window commissioned for St. Michael's Church, Bottrop (destroyed).

1919-20 At Königliche Bayerische Akademie der Bildenden Kunst, Munich, attends Franz von Stuck's drawing class and Max Doerner's course in painting technique. Makes many figurative drawings there, as well as series of brush and ink drawings of rural Bavarian town of Mittenwald (see cat. nos. 36-39; 34, 35).

BAUHAUS

1920 Attends Bauhaus in Weimar, where he takes preliminary course and begins independent study in glass assemblage. From this point on all of his art, with the exception of his photographs and designs for functional objects, will be abstract.

1921-22 Continues making glass assemblages, in which he uses detritus from dump in Weimar (see cat. nos. 40-43).

1922 Promoted to level of journeyman. Reorganizes glass workshop.

1922-23 Designs and executes stained-glass windows for houses in Berlin designed by Walter Gropius, founding director of the Bauhaus, and for reception room of Gropius's office in Weimar. These are complex abstract compositions juxtaposing multiple pieces of clear and colored single-pane glass. Also makes wooden furniture for Gropius's office.

1923 Invited by Gropius to conduct preliminary course in material and design. Designs fruit bowl of glass, metal and wood (cat. no. 48).

1923-24 Executes stained-glass window for Grassi Museum, Leipzig (destroyed 1944) (cat. no. 45A,B).

1924 First essay, "Historisch oder jetzig?," is published in special Bauhaus issue of Hamburg

Albers (third from right) and friends, Berlin, ca. 1914

periodical *Junge Menschen*. Executes stained-glass windows for Ullstein Publishing Co., Berlin-Tempelhof. These windows, installed in 1926, were later destroyed, probably at the time of the occupation of the building by the Red Army in 1945. Here, as in the Grassi Museum windows, the design is a more simplified geometric abstraction than in the earlier work.

1925 Moves with Bauhaus to Dessau. Appointed Bauhaus master. Marries Annelise Fleischmann, a weaving student at the Bauhaus. Travels to Italy. Develops sandblasted flashed-glass paintings with increasingly refined geometric compositions (see cat. nos. 55, 58-60, 62-66, 68-74). He will continue making these—in what becomes known as his "thermometer" style—for the next four years.

1926 Designs tea glasses of glass, metal, wood, plastic and porcelain (see cat. no. 49A, B) and begins working in typography (see cat. no. 50). Designs furniture, primarily in wood and glass, for Berlin apartment of Drs. Fritz and Anno Moellenhoff (see cat. nos. 46, 47, 53, 54).

1926-32 Takes numerous black and white photographs, including portraits of fellow Bauhäuslers, many of which he mounts as photo-collages (see cat. nos. 77-91).

1928 Gropius leaves Bauhaus; is replaced by Hannes Meyer. Albers takes charge of preliminary course and lectures at International Congress

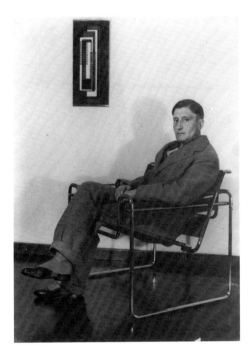

Albers in his Bauhaus studio, Dessau, 1928
Photo by Umbo

Albers with Herbert and Mutzi Bayer,
Ascona, 1929

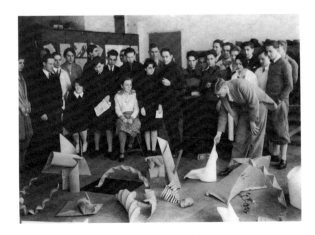

Albers teaching at the Bauhaus, Dessau, 1928
Photo by Umbo

for Art Education, Prague. Designs upholstered wood chair (cat. no. 75).

1928-30 Following Breuer's departure in 1928, Albers assumes directorship of furniture workshop, position Breuer had held since 1925. Heads wallpaper design program.

1929 Shows twenty glass-paintings in exhibition of Bauhaus masters in Zürich and Basel; others featured include Vasily Kandinsky and Paul Klee. Designs chair for mass production (cat. no. 76).

1929-32 Continues to make sandblasted glass constructions, now using illusionistic, volumetric forms, most of which combine straight lines and curves (see cat. nos. 96, 98, 99).

1930 Ludwig Mies van der Rohe replaces Meyer as director of Bauhaus; Albers becomes assistant director.

1932 Moves with Bauhaus to Berlin. Has first solo show at Bauhaus, a comprehensive exhibition of glass works from 1920 to 1932. In addition to basic design, teaches freehand drawing and lettering. Begins *Treble Clef* series of gouaches and glass constructions, his first major use of a single form repeated with very slight compositional variations in many different color schemes (see cat. nos. 100-105).

1933 With other remaining faculty members, closes Bauhaus. Executes series of woodcut and linoleum-cut prints in Berlin (see cat. nos. 106-108).

BLACK MOUNTAIN

1933 On recommendation of Philip Johnson at The Museum of Modern Art, New York, Josef and Anni Albers invited to teach at newly founded Black Mountain College, North Carolina, where they arrive November 28. Albers is based here for the next sixteen years.

1934 Gives lecture series at Lyceum Havana, Cuba. Executes woodcuts and linoleum cuts in Asheville, North Carolina, city nearest to Black Mountain (see cat. nos. 109-111).

1935 Makes first of fourteen visits to Mexico and Latin America. Paints first free-form abstractions (see cat. nos. 112, 113, 116).

1936 Executes series of spare geometric drawings (see cat. nos. 119-122).

Josef and Anni Albers aboard the S.S. Europa upon their arrival in the United States, New York, November 25, 1933
Associated Press photo

1936-40 At invitation of Gropius, holds seminars and lectures at Graduate School of Design, Harvard University, Cambridge, Massachusetts. Paints various small series of geometric abstractions of highly diverse imagery in gouache and oil (see cat. nos. 115, 117, 118, 124-131, 133-136, 138-146, 154, 155).

1936-41 Exhibits glass paintings from Bauhaus period, new oil paintings and other works in over twenty solo shows in American galleries.

1937 Included in first *American Abstract Artists* exhibition at Squibb Galleries, New York, April 3-17.

1939 Becomes a United States citizen.

1940-42 Makes autumn-leaf collages and small drypoint etchings of meandering linear compositions (see cat. nos. 147-151; 156-158).

1941 Takes sabbatical year, painting in New Mexico and teaching basic design and color at Harvard.

1941-42 Executes *Graphic Tectonic* series of drawings and zinc-plate lithographs featuring geometric

imagery that emphasizes the use of drafting tools in the creative process (see cat. nos. 160, 161).

1942-46 Plays increasingly active role in administration at Black Mountain, writing on educational theory and lecturing on behalf of the school.

1943 Begins *Biconjugate* and *Kinetic* (see cat. nos. 166, 170) series of two-figure geometric abstractions.

1944 Makes series of prints in Asheville, many of which superimpose geometric figures on grounds with wood grain and cork-relief patterns (see cat. nos. 167-169).

1947 Spends sabbatical year painting in Mexico. Begins *Variant* series, largest group of paintings to date, in which similar geometric compositions are executed in various color schemes (see cat. nos. 177-191). These paintings demonstrate many of the points about color effects and mutability with which Albers is becoming increasingly preoccupied.

1948 Serves as rector of Black Mountain. Makes *Multiples* woodcuts in Asheville.

1948-50 Elected member, Advisory Council of the Arts, Yale University, New Haven.

1949 Leaves Black Mountain. Travels to Mexico. Appointed visiting professor, Cincinnati Art

Albers teaching color course at Black Mountain College, August 1948
Photo by Rudolph Burckhardt

Academy and Pratt Institute, Brooklyn, New York, where he teaches color and leads faculty workshop. Begins *Structural Constellations*, also called *Transformations of a Scheme*, a series of linear, geometric drawings whose deliberately ambiguous imagery offers multiple readings (see cat. nos. 171-176). Over the next twenty-five years Albers will execute the *Constellations* as drawings, white line engravings on black Vinylite, prints made from engraved brass, inkless intaglio prints, printed embossings and large wall-reliefs made in various materials including stainless-steel tubes and incised marble with gold leaf.

YALE

1950 Begins *Homage to the Square* series (see cat. nos. 201-246), in which Albers uses four closely related formats of asymmetrical nested squares to present different color climates and color activity. Over the next twenty-five years he will render these as oil paintings on Masonite, lithographs, screenprints, Aubusson and other tapestries and large interior walls made in various media. Serves as visiting critic, Yale University School of Art, and visiting professor, Graduate School of Design, Harvard. Appointed chairman of Department of Design at Yale and establishes residence in New Haven. Executes *America*, rear wall of brick fireplace, for Swaine Room, Harkness Commons, Harvard University Graduate Center.

1952 Appointed Fellow of Saybrook College, Yale University.

1953-54 Lectures in Department of Architecture, Universidad Católica, Santiago, and at Escuela Nacional de Ingenieros del Perú, Lima. Takes position as visiting professor at Hochschule für Gestaltung, Ulm, West Germany.

1955 Returns as visting professor, Hochschule für Gestaltung, Ulm. Executes *White Cross Window*, photosensitive glass window, for Abbot's Chapel, St. John's Abbey, Collegeville, Minnesota.

1956 Has first retrospective exhibition at Yale University Art Gallery. Named Professor of Art Emeritus, Yale.

1957 Receives Officer's Cross, Order of Merit, First Class, of the German Federal Republic, and made Honorary Doctor of Fine Arts, University of Hartford.

Albers (detail), 1948
© Arnold Newman

1957-58 Teaches at Syracuse University, New York. Appointed visiting professor, Carnegie Institute, Pittsburgh.

1958 Retires as chairman of Department of Design at Yale; remains as visiting professor until 1960. Lectures at University of Minnesota, Kansas City Art Institute, Art Institute of Chicago and Department of Architecture, Princeton University. Awarded Conrad von Soest Prize for painting by Landesverband Westfalen-Lippe, West Germany.

LATE YEARS

1959 Awarded Ford Foundation Fellowship. Executes *Two Structural Constellations*, gold-leaf engraving in marble, for Corning Glass Building lobby, New York, and *Manuscript Wall*, recessed mortar composition, for Manuscript Society Building, New Haven.

1960 Attends Cultural Congress, Munich.

1961 Executes *Two Portals*, glass and bronze mural, for Time and Life Building lobby, New York, and *St. Patrick's Altar Wall*, brick wall, for St. Patrick's Church, Oklahoma City.

1962 Teaches at University of Oregon, Eugene. Awarded Graham Foundation Fellowship. Made Honorary Doctor of Fine Arts, Yale University, and receives Dean's Citation, Philadelphia Museum College of Art.

1963 Receives fellowship from Tamarind Lithography Workshop, Los Angeles. *Interaction of Color* published. Executes *Manhattan*, formica mural, for Pan Am Building lobby, New York, and *Repeat and Reverse*, steel sculpture, for Art and Architecture Building entrance, Yale.

1964 Lectures at Smith College, Northampton, Massachusetts, and University of Miami. Awarded second fellowship by Tamarind Lithography Workshop. Made Honorary Doctor of Fine Arts, California College of Arts and Crafts, Oakland, and receives medal for "Extraordinary work in the field of the graphic arts," American Institute of Graphic Arts, New York.

1965 Delivers lecture series at Trinity College, Hartford, published as *Search Versus Re-Search*. Featured in *The Responsive Eye*, an important traveling exhibition organized by William C. Seitz for The Museum of Modern Art, New York, as a result of which he comes to be regarded as the father of Op Art.

1966 Appointed visiting professor, University of South Florida, Tampa. Receives honorary LL.D., University of Bridgeport, Connecticut.

1967 Receives Carnegie Institute Award for painting, Pittsburgh International Exhibition. Executes *RIT Loggia Wall*, brick wall, for Science Building, and *Growth*, painted murals, for Administration Building lobby, Rochester Institute of Technology, New York. Made Honorary Doctor of Fine Arts, University of North Carolina, Chapel Hill, and Honorary Doctor of Philosophy, Ruhr-Universität, Bochum, West Germany.

1968 Wins Grand Prize, *La III Bienal Americana de Grabado*, Santiago, and Grand Prize for painting, State of Nordrhein-Westfalen, West Germany. Receives Commander's Cross, Order of Merit of the German Federal Republic. Elected member, National Institute of Arts and Letters, New York.

| 1969 | Made Honorary Doctor of Fine Arts, University of Illinois, Champaign-Urbana, Minneapolis School of Art and Kenyon College, Gambier, Ohio. |

| 1970 | Moves from New Haven to Orange, Connecticut. Elected Benjamin Franklin Fellow, Royal Society of the Arts, London. Made honorary citizen of Bottrop. |

| 1971 | Gives thirteen paintings and fifty-eight prints to The Metropolitan Museum of Art, New York, following his solo exhibition there, the first retrospective devoted by the museum to a major living artist. Wins First Medal for graphic arts, Skowhegan School of Painting and Sculpture, Maine. Made Honorary Doctor of Fine Arts, Washington University, St. Louis. |

| 1972 | Designs *Two Supraportas*, steel sculpture, for Westfälisches Landesmuseum für Kunst und Kulturgeschichte entrance, Münster; *Gemini*, stainless-steel relief mural, for Grand Avenue National Bank lobby, Crown Center, Kansas City, Missouri; and *Reclining Figure*, mosaic-tile mural, for Celanese Building lobby, New York. Made Honorary Doctor of Fine Arts, Maryland Institute and College of Art, Baltimore. Awarded Gold Medal, First Graphic Biennial, Norway. |

| 1973 | *Josef Albers, Formulation: Articulation* published. Designs *Stanford Wall*, two-sided, free-standing brick, granite and steel relief-wall, for Lomita Mall, Stanford University (installed posthumously in 1980). Receives Distinguished Teaching of Art Award, College Art Association, and Honorary LL.D., York University, Downsview, Ontario. Elected member, American Academy of Arts and Letters, Boston. |

| 1974 | Elected Extraordinary Member, Akademie der Künste, Berlin. |

| 1975 | Made Honorary Doctor of Fine Arts, Pratt Institute, Brooklyn, New York, and awarded Medal of Fine Arts, American Institute of Architects, New York Chapter. |

| 1976 | Designs *Wrestling*, aluminum relief-mural, for Mutual Life Centre, Sydney, Australia. Dies March 25 in New Haven; is buried in Orange. |

POSTHUMOUS

| 1976 | Made Honorary Doctor of Fine Arts, Philadelphia College of Art. |

| 1976-77 | Albers's figurative drawings and Bauhaus-period photographs rediscovered. |

| 1977-82 | Groups of Albers's paintings given by Anni Albers and The Josef Albers Foundation to Guggenheim Museum, New York; Tate Gallery, London; San Francisco Museum of Modern Art; Musée National d'Art Moderne, Centre Georges Pompidou, Paris; Detroit Institute of Arts; Museum of Fine Arts, Houston; Berlin Nationalgalerie; Milwaukee Art Center; Museo de Arte Contemporaneo, Caracas; Rijksmuseum Kröller-Müller, Otterlo, The Netherlands; Louisiana Museum of Modern Art; Humlebæk, Denmark; Los Angeles County Museum of Art; and Dallas Museum of Art. |

| 1978 | Permanent exhibition space devoted to Albers's work opens at Yale University Art Gallery, featuring gift from Anni Albers and The Josef Albers Foundation of sixty-four paintings and forty-nine prints. |

| 1980 | Commemorative postage-stamp issued bearing *Homage to the Square* design and U.S. Department of Education motto "Learning Never Ends." |

| 1983 | Josef Albers Museum opens in Bottrop, housing gift from Anni Albers and The Josef Albers Foundation of ninety-one paintings and 234 prints. |

Selected Bibliography

GENERAL

Herbert Bayer, Walter Gropius and Ise Gropius, eds., *Bauhaus 1919-1928*, New York, The Museum of Modern Art, 1938, pp. 41, 42, 47, 55, 114-118, 127, 135, 149, 194, 215

Ernest Harms, "Short-term Styles in Modern Art," *Studio*, vol. CLIV, 1957, pp. 132-133, 159

Marcel Brion, "Qu'est-ce que l'art abstrait?," *Jardin des Arts*, no. 30, 1958, pp. 348-358

Lee Nordness, ed., ART USA NOW, Lucerne, C. J. Bucher, Ltd., 1962, vol. I, pp. 38-41

George Rickey, *Constructivism: Origins and Evolution*, New York, George Braziller, 1967, pp. x, 7, 43, 45-47, 49, 51, 65, 81, 85-86, 90, 112, 136, 142-143, 151, 179-180, 209, 224

John Coplans, *Serial Imagery*, exh. cat., The New York Graphic Society and The Pasadena Art Museum, 1968, pp. 46-53

Jean Clay, *Visages de l'art moderne*, Lausanne and Paris, Editions Rencontre, 1969, pp. 63-78

Eberhard Roters, *Painters of the Bauhaus*, Anna Rose Cooper, trans., New York and Washington, Frederick A. Praeger, 1969, pp. 183-195

Hans M. Wingler, *The Bauhaus*, Wolfgang Jabs and Basil Gilbert, trans., Joseph Stein, ed., Cambridge, Massachusetts, and London, The MIT Press, 1969, passim

Anni Albers, *Pre-Columbian Mexican Miniatures: The Josef and Anni Albers Collection*, New York and Washington, Praeger Publishers, 1970

Martin Duberman, *Black Mountain College: An Exploration in Community*, New York, E.P. Dutton, Co., Inc., 1972, pp. 11, 15-16, 85, 90, 103, 128, 171, 231, 300-303, 323-324, 339, 370, 426-427, 465

Irving Leonard Finkelstein, *The Life and Art of Josef Albers* (Ph.D. dissertation, New York University, 1968), microfilm, Ann Arbor, Michigan, University Microfilms International, 1979

E. H. Gombrich, *The Sense of Order*, Oxford, Phaidon Press, Ltd., 1979, pp. 83, 124, 142n

Sammlungs-Katalog: Bauhaus-Archiv Museum, introduction by Hans M. Wingler, Berlin, Bauhaus-Archiv, 1981, pp. 13, 16, 18-20, 23, 49-58, 89, 91, 93, 104, 111, 115, 121-123, 152, 162, 210, 218-220, 225, 226, 231, 232, 287, 290, 296

Rudolf Arnheim, *The Power of the Center*, Berkeley, Los Angeles and London, University of California Press, 1982, p. 145

Mary Emma Harris, *The Arts at Black Mountain College*, Cambridge, Massachusetts, and London, The MIT Press, 1987, pp. x, xi, 4, 8-13, 29, 38, 53, 66, 72, 79-83, 85, 96, 108, 109, 114, 117, 120, 126-131, 140-141, 163-165, 183, 188

BY THE ARTIST

"Historisch oder jetzig?," *Junge Menschen* (Hamburg), no. 8, November 1924, p. 171. Special Bauhaus issue

"Zur Ökonomie der Schriftform," *Offset-Buch und Werbekunst* (Leipzig), no. 7, 1926. Revised edition, "Kombinationsschrift 3," *Bauhaus Zeitschrift für Gestaltung* (Dessau), no. 1, January 1931, pp. 3-4

"Gestaltungsunterricht," *Böttcherstrasse*, vol. 1, June 1928, pp. 26-27. Expanded edition, "Werklicher Formunterricht, *Bauhaus: Zeitschrift für Gestaltung* (Dessau), no. 2/3, 1928, pp. 3-7

"Produktive Erziehung zur Werkform," *Deutsche Goldschmiede Zeitung* (Leipzig), no. 25, 1929, pp. 259-262. Transcript of a lecture given by Albers to the Society of Goldsmiths, Leipzig, 1929

"Zu meinen Glas-wandbildern," *A bis Z: Organ der Gruppe progressiver Künstler* (Cologne), no. 3, February 1933, p. 117

"Concerning Art Instruction," *Black Mountain College Bulletin*, no. 2, June 1934, pp. 2-7

"Art as Experience," *Progressive Education*, vol. 12, October 1935, pp. 391-393

"A Note on the Arts in Education," *The American Magazine of Art*, vol. 29, April 1936, p. 233

"The Educational Value of Manual Work and Handicraft in Relation to Architecture," in Paul Zucker, ed., *New Architecture and City Planning*, New York, Philosophical Library, 1944, pp. 688-694

"Present and/or Past," *Design* (Columbus, Ohio), vol. 47, April 1946, pp. 16-17, 27

"Black Mountain College," *Junior Bazaar*, May 1946, pp. 130-133

"Abstract-Presentational," in *American Abstract Artists*, New York, Ram Press, 1946, pp. 63-64

"Letter to the Editor," *Art News*, May 1948, p. 6

"The Origin of Art," *Réalités Nouvelles*, no. 6, August 1952, pp. 64-69

"Modular Brick Wall Partition," in Eleanor Bitterman, *Art*

in *Modern Architecture*, New York, Rheinhold Publishing Company, 1952, pp. 148-149. Statement on the Harvard Graduate Center wall

"Josef Albers," *Spirale* (Bern and Zürich), no. 5, Fall 1955, pp. 1-12

"Josef Albers," *Nueva Visión* (Buenos Aires), no. 8, 1955, pp. 5-9

"The Teaching of Art," *The Carteret Digest*, vol. 2, April 1957, pp. 6-8

"Art and General Education," *Yale Alumni Magazine*, April 1958, pp. 6-7, 16

"Dimensions of Design," *Dimensions of Design*, New York, American Craftsmen's Council, 1958, pp. 13-18

Poems and Drawings, New Haven, The Readymade Press, 1958. Second edition, New York, George Wittenborn, Inc., 1961

"On Art and Expression," "On Articulation," "On Enunciation," "Seeing Art," *Yale Literary Magazine*, vol. CXXIX, May 1960, pp. 49-54

"When I Paint and Construct...," *Daedalus*, vol. 89, Winter 1960, p. 105. Special issue, "The Visual Arts Today"

"Structural Sculpture," *Robert Engman: Recent Sculpture*, exh. cat., New York, Stable Gallery, 1960, unpaginated

"In Behalf of Structured Sculpture, *Art in America*, vol. 49, March 1961, p. 75

with François Bucher, *Despite Straight Lines*, New Haven and London, Yale University Press, 1961, pp. 10-11. German edition, *Trotz der Geraden*, Bern, Benteli-Verlag, 1961. Revised edition, Cambridge, Massachusetts, and London, The MIT Press, 1977

"The Interaction of Color," *Art News*, vol. 62, March 1963, pp. 33-35, 56-59

Interaction of Color, New Haven, Yale University Press, 1963; pocket edition, 1971; revised pocket edition, 1975. (The 1963 publication was a boxed set with 80 color folios and a commentary. Subsequent editions, except for the complete German and Finnish volumes, were published either in paperback or pocket size with selected plates and an abridged text.) German paperback, *Grundlegung einer Didaktik des Sehens*, Cologne, Verlag M. DuMont Schauberg, 1970; complete German edition, Starnberg, Josef Keller Verlag, 1972. Japanese paperback, Tokyo, David Sha Ltd., 1972. French paperback, *L'Interaction des couleurs*, Paris, Librairie Hachette, 1974. Spanish paperback, *La interacción del color*, Madrid, Alianza Forma, 1975. Complete Finnish edition, *Värien vuorovaikutus*, Helsinki, Vapaa Taidekoulu, 1978; Finnish paperback,

1979. Swedish pocket edition, *Färglära om färgers inverkan på varandra*, Stockholm, Forum, 1982. Italian paperback, Parma, Pratiche Editrice, forthcoming in 1988

"Fugue," *The Structurist* (Saskatoon, Canada), no. 4, November 1964, p. 22

"Op Art and/or Perceptual Effects," *Yale Scientific Magazine*, November 1965, pp. 1-6

with Henry Hopkins and Kenneth E. Tyler, *Josef Albers: White Line Squares*, exh. cat., Los Angeles County Museum of Art and Gemini G.E.L., 1966

"My Courses at the Hochschule für Gestaltung at Ulm" (1954), *Form* (Cambridge, England), no. 4, April 1967, pp. 8-10

"Selected Writings," *Origin* (Kyoto), no. 8, January 1968, pp. 21-32

Search Versus Re-Search: Three Lectures by Josef Albers at Trinity College, April 1965, Hartford, Trinity College Press, 1969

"Thirteen Years at the Bauhaus," in Eckhard Neumann, *Bauhaus and Bauhaus People*, New York, Van Rostand and Reinhold, 1970, pp. 169-172. German edition, 1971

Josef Albers, Formulation: Articulation, New York, Harry N. Abrams, Inc., and New Haven, Ives-Sillman, Inc., 1972

ON THE ARTIST

"Das Drei-S-Werk auf der Leipziger Schaufensterschau," *Musik-Instrumenten Zeitung* (Leipzig), November 20, 1928, p. 1348

"Jubiläumsvorträge des Bauhauses: Vortrag Josef Albers, 'Werklehre des Bauhauses,' " *Volksblatt Dessau*, January 29, 1930

Arthur Korn, *Glas im Bau und als Gebrauchsgegenstand*, Berlin-Charlottenburg, Ernst Pollak Verlag, 1930

L. Sandusky, "The Bauhaus Tradition and the New Typography," *PM*, vol. 4, June/July 1938, pp. 1-34. (For Albers's response see "Letter to the Editor," *PM*, vol. 4, August/September 1938, p. 49.)

Maude Riley, "The Digest Interviews Josef Albers," *Art Digest*, vol. 19, January 15, 1945, pp. 15, 30

Mickey Fechheimer, "Albers Outlines Plans for Yale Department of Design," *The Summer Crimson* (Cambridge, Massachusetts), July 27, 1950, p. 4

Elaine de Kooning, "Albers Paints a Picture," *Art News*, vol. 49, November 1950, pp. 40-43, 57-58

Erhard Göpel, "Der Bauhaus-Meister Josef Albers," *Süddeutsche Zeitung* (Munich), no. 12, January 1954

"Optical Tricks Train Yale Artists," *Life Magazine,* vol. 40, March 26, 1956, pp. 71-76

Jean Charlot, "Nature and the Art of Josef Albers," *College Art Journal* (New York), vol. 15, Spring 1956, pp. 190-196

Eugen Gomringer, "Josef Albers, zum 70. Geburtstag," *Neue Zürcher-Zeitung,* March 19, 1958

Will Grohmann, "Zum 70. Geburtstag von Josef Albers," *Frankfurter Allgemeine Zeitung,* March 19, 1958

Max Bill, "Josef Albers," *Werk,* vol. 45, April 1958, pp. 135-138

Neil Welliver, "The Albers Critique" [letter to the editor], *Arts,* May 1958, p. 7

Eugen Gomringer, "Abstrakte Kompositionen auf opakem Glas: Die Glasbilder von Josef Albers," *Glaswelt* (Stuttgart), vol. 17, November 1958, pp. 14-15

Richard B. Lohse, "Josef Albers 'City' 1928," *Zürcher Kunstgesellschaft Jahresbericht,* 1960, pp. 53-56

Katharine Kuh, "Josef Albers," *The Artist's Voice: Talks with Seventeen Artists,* New York, Harper and Row, 1962, pp. 11-21

M. Shutaro, I. Koji and K. Akio, "The World of Josef Albers," *Graphic Design* (Tokyo), no. 11, April 1963, pp. 7-17 (in Japanese with English summary)

Dore Ashton, "Albers and the Indispensable Precision," *Studio,* June 1963, p. 253

Hannes Beckmann, "Josef Albers' 'Interaction of Color,' " *Inter-Society Color Council Newsletter,* no. 173, September-December 1963, pp. 17-19

Donald Judd, " 'Interaction of Color' " [review], *Arts Magazine,* November 1963, pp. 67, 73-75

Daniel and Eugenia Robbins, "Josef Albers: Art Is Looking at Us," *Studio International,* vol. 167, no. 850, 1964, pp. 54-57

Sidney Tillim, "Optical Art, Pending or Ending?" *Arts Magazine,* January 1965, pp. 16-23

John Canaday, "Art That Pulses, Quivers and Fascinates," *The New York Times Magazine,* February 21, 1965, pp. 12-13

Margit Staber, "Farbe und Linie—Kunst und Erziehung: Zum Werk von Josef Albers," *Neue Grafik,* no. 17/18, February 1965, pp. 54-69, 140-142 (in English, French and German)

Karl Gerstner, "Josef Albers' 'Interaction of Color,' " *Forum, Internationale Revue* (Opladen), vol. 29, March 1965

George Rickey, "Scandale de succès," *Art International,* vol. 9, May 1965, pp. 16-23

Irving Finkelstein, "Albers' Graphic Tectonics, from a Doctoral Dissertation on 'The Life and Art of Josef Albers,' " *Form* (Cambridge, England), no. 4, April 1967

Hans Hildebrandt, "Josef Albers," *Das Kunstwerk,* August-September 1967

Paul Overy, " 'Calm Down, What Happens, Happens Mainly Without You'—Josef Albers," *Art and Artists* (London), October 1967, pp. 32-35

Jean Clay, "Albers: Josef's Coats of Many Colours," *Réalités,* March 1968, pp. 64-69. English edition, August 1968

Jean Clay, "Albers, Trois Étapes d'une logique," *RHOBO* (Paris), Spring 1968, pp. 10-14

Eugen Gomringer, *Josef Albers,* Joyce Wittenborn, trans., New York, George Wittenborn, Inc., 1968. German edition, Starnberg, Josef Keller Verlag, 1971, with additional texts by Clara Diament de Sujo, Will Grohmann, Norbert Lynton, Michel Seuphor and the artist

Wieland Schmied, *Josef Albers zu seinem 80. Geburtstag: Lithografien, Seriegrafien,* exh. cat., Hannover, Kestnergesellschaft, 1968

Margit Staber, ed., *Josef Albers: Graphic Tectonic,* Cologne, Galerie der Spiegel, 1968, with statements by Max Bill, Buckminster Fuller, Karl Gerstner, Max Imdahl, Dietrich Mahlow, Margit Staber and the artist

Sam Hunter, "Josef Albers: Prophet and Presiding Genius of American Op Art," *Vogue,* October 15, 1970, pp. 70-73, 126-127

John H. Holloway and John A. Weil, "A Conversation with Josef Albers," *Leonardo* (Oxford), vol. 3, October 1970, pp. 459-464

Werner Spies, *Albers,* New York, Harry N. Abrams, Inc., Meridian Modern Artists, 1970

David Shapiro, "Homage to Albers," *Art News,* November 1971, pp. 30-34

Jürgen Wissmann, *Josef Albers,* Recklinghausen, Bongers Verlag, 1971

Jürgen Wissmann, *Josef Albers: Murals in New York,* Stuttgart, Phillip Reclam Verlag, 1971

Margit Rowell, "On Albers' Color," *Artforum,* vol. 10, January 1972, pp. 26-37

Jo Miller, *Josef Albers: Prints 1915-1970,* New York, The Brooklyn Museum, American Graphic Artists of the Twentieth Century, no. 8, 1973

Jürgen Wissmann, *Josef Albers im Westfälischen Landesmuseum Münster,* Landschaftsverband Westfalen-Lippe, 1977

Nicholas Fox Weber, *The Drawings of Josef Albers,* New Haven and London, Yale University Press, 1984

Neal D. Benezra, *The Murals and Sculpture of Josef Albers,* New York and London, Garland Publishing, Inc., Outstanding Dissertations in the Fine Arts, 1985

Films and Videos

Distinguished Living Artists: Josef Albers, interview conducted by Brian O'Doherty, Museum of Fine Arts, Boston, for the television series *Invitation to Art,* produced by WGBH-TV, Boston, 1960

To Open Eyes, film produced and directed by Carl Howard, SUNY-Albany, and distributed by The Josef Albers Foundation, Inc., 1969

Josef Albers: Homage to the Square, film produced by University-at-Large Programs, Inc., Chelsea House Publishers, New York, and directed by Paul Falkenberg and Hans Namuth, 1969

Man at the Center, film produced by Terry Filgate and the Canadian Broadcasting Corporation and directed by Lister Sinclair, 1972

Interaction of Color, electronic interactive videodisc presented by Pratt Institute and Jerry Whiteley, New York, 1988. Executive coproducers, Jerry Whiteley and Andrew Phelan; art direction, Sonya Haferkorn; color palette, Jodi Slater; Pratt faculty leader, Isaac Kerlow; voice narration, Mark Strand, Kelly Feeney and Natalie Charkow; original music, Robert Fair; computer graphic facilities, New York Institute of Technology and Pratt Institute; computer programmers, John Pane and Jim Ryan; project manager, Apple Computer, Inc., Barbara Bowen; technical manager, Apple Computer, Inc., Tony Masterson. Additional support and assistance provided by The Josef Albers Foundation, Apple Computer, Inc., Center for Art and Technology at Carnegie Mellon University, Yale University, Yale University Press, New York Institute of Technology and Phillips and DuPont Optical Co.

Selected Exhibitions and Reviews

This list consists of solo exhibitions or shows with one or two other artists. Group exhibitions are not included. Most of the shows listed featured paintings or paintings and prints; the hundreds of shows of *Interaction of Color, Formulation: Articulation* and other print groups have not been included.

Galerie Goltz, Munich [lithographs and woodcuts], 1918

Bauhaus, Berlin, *Josef Albers, Glasbilder*, May 1-12, 1932. Brochure with statements by the artist

Kunstverein Leipzig [glass paintings] (with Maria Salvona), January 1933

Albers's studio, Berlin [glass paintings], July 1933

> Brattislava and Bruhn [review], "Berliner Ausstellungen," *Forum, Zeitschrift für Kunst-Bau-und Einrichtung*, vol. 3, 1933, p. 355

Galleria del Milione, Milan, *Silographie recenti di Josef Albers e di Luigi Veronesi*, December 23, 1934-January 10, 1935. Catalogue with texts by Hans Hildebrandt, Vasily Kandinsky, Alberto Sartoris and Xanti Schawinsky

Lyceum Club, Havana, December 29, 1934-January 4, 1935

> José M. Valdes-Rodriguez, "Josef Albers y la nueva arquitectura," *Ahora* (Havana), January 2, 1935, pp. 1-2

Asheville Art Guild, North Carolina, *Works by Josef Albers*, October-November 1935

New Art Circle, J.B. Neumann, New York, *Work by Josef Albers*, March 9-30, 1936

> Carlyle Burrows, "Decorations," *New York Herald Tribune*, March 15, 1936
>
> Edward Alden Jewell, "The Realm of Art: Academism of the Left," *The New York Times*, March 15, 1936
>
> James W. Lane, *Parnassus*, April 1936, p. 28

Periódico El Nacional, Mexico City, August 15-25, 1936

Black Mountain College, North Carolina, *Exhibition of Glass and Oils by Josef Albers*, October 1936

Germanic Museum, Harvard University, Cambridge, Massachusetts, *Josef Albers and Hubert Landau*, November 9-30, 1936

Katharine Kuh Gallery, Chicago, *Albers and De Monda and the Katharine Kuh Gallery*, September 20-October 30, 1937

> [Review], *Magazine of Art*, vol. 30, November 1937, p. 683

New Art Circle, J.B. Neumann, New York, *Josef Albers*, March 9-30, 1938

Artists' Gallery, New York, *Josef Albers*, December 6-31, 1938. Catalogue with statements by Balcomb Greene, George L.K. Morris et al.

> Robert M. Coates [review], *The New Yorker*, December 24, 1938, p. 31
>
> J[ames] L[ane], *Art News*, December 24, 1938, p. 56

Philadelphia Art Alliance, *Prints and Watercolors by Josef Albers*, January 24-February 12, 1939. Traveled to J.B. Speed Memorial Museum, Louisville, February 28-March 19

San Francisco Museum of Art, *Oils and Woodcuts by Josef Albers*, February 16-March 15, 1940

Mint Museum of Art, Charlotte, North Carolina, *Art and the Artist: Paintings by Josef Albers, Lyonel Feininger and Frank London*, February 27-March 11, 1940

Newcomb College School of Art, New Orleans, *Josef Albers*, June 1-30, 1940

Nierendorf Gallery, New York, *Josef Albers*, February 10-March 1, 1941

> J[ames] L[ane], *Art News*, February 15-28, 1941, p. 11
>
> Edward Alden Jewell [review], *The New York Times*, February 16, 1941, p. 9x
>
> E.S. [review], *PM's Weekly*, February 16, 1941, p. 56

Stendahl Art Galleries, Los Angeles, *Josef Albers*, March 17-29, 1941

Museum of Fine Arts School, Boston, *Abstract Paintings by Josef Albers*, June 1-30, 1941

University Art Museum, University of New Mexico, Albuquerque, *Paintings by Josef Albers*, April 2-30, 1942

Museum of New Mexico, Santa Fe, *Paintings by Francesco de Cocco and Josef Albers*, May 15-June 1, 1942

Baltimore Museum of Art, *Abstractions by Josef Albers*, December 1, 1942-January 3, 1943

Pierson Hall Art Gallery, University of North Carolina, Chapel Hill, *Paintings and Watercolors by Josef Albers*, November 1943

New Art Circle, J.B. Neumann, New York, *Josef Albers*, January 2-17, 1945

Hollins College, Roanoke, Virginia, *Oils by Josef Albers*, February 1946

Memphis Academy of Arts, Tennessee, *Twenty-five Paintings by Josef Albers*, January 15-28, 1947

California Palace of the Legion of Honor, San Francisco, *Josef Albers: Oils, Lithography, Woodcuts,* August 24-September 24, 1947

Cranbrook Academy, Bloomfield Hills, Michigan, *Josef Albers: Paintings,* February 1948

Galerie Herbert Herrmann, Stuttgart, *Josef Albers, Hans Arp, Max Bill,* July-August 1948. Catalogue with texts by Max Bill and Hans Hildebrandt

Egan Gallery, New York, *Albers: Paintings in Black, Grey, White,* and Sidney Janis Gallery, New York, *Albers: Paintings Titled 'Variants,'* January 24-February 12, 1949

> [Review], *Time,* January 31, 1949, p. 37
>
> Margaret Lowengrund, "Variations on Albers," *Art Digest,* February 1, 1949
>
> Clement Greenberg, "Albers Exhibition...," *The Nation,* February 19, 1949, pp. 221-222
>
> E[laine de] K[ooning], "Albers," *Art News,* vol. 47, February 1949, pp. 18-19

Galerie Rosen, Berlin, *Josef Albers und Max Bill,* March 1949

Cincinnati Art Museum, *Josef Albers,* October 27-November 22, 1949

The Northeon, Easton, Pennsylvania, *Josef Albers,* November 1-30, 1949

> R. McGiffert [review], *Easton Express,* November 29, 1949, p. 16

Yale University Art Gallery, New Haven, *Paintings by Josef Albers,* December 7, 1949-January 30, 1950

Allen R. Hite Art Institute, University of Louisville, *Josef Albers: 1931-1948,* April 17-May 27, 1950. Catalogue with text by Creighton Gilbert

Contemporary Art Society, Sydney, Australia, 1951

Sidney Janis Gallery, New York, *Albers: Homage to the Square-Transformation of a Scheme,* January 7-26, 1952

Arts Club of Chicago, *Albers and Gabo,* January 29-February 28, 1952

University Fine Arts Gallery, Albuquerque, *Josef Albers,* February 1953

Essex Art Association, Connecticut, *Josef Albers,* June 12-28, 1953

Wadsworth Atheneum, Hartford, *Josef and Anni Albers: Paintings, Tapestries and Woven Textiles,* July 8-August 2, 1953. Catalogue with text by Charles Buckley

> Stuart Preston [review], *The New York Times,* July 9, 1953, p. II-7

San Francisco Museum of Art, *Paintings by Josef Albers,* November 4-22, 1953

> Alfred Frankenstein, "Josef Albers Shows What Thinking and Planning Will Do for Art," *San Francisco Chronicle,* November 22, 1953

Academy of Art, Honolulu, *Josef and Anni Albers: Painting and Weaving,* July 1-August 2, 1954

> Jean Charlot, "Albers' Selfless Explicit Paintings Grip Viewers," *Honolulu Advertiser,* July 6, 1954

Sidney Janis Gallery, New York, *Acting Colors: Albers,* January 31-February 26, 1955

Hayden Gallery, Massachusetts Institute of Technology, Cambridge, *Josef Albers,* March 6-27, 1955

Yale University Art Gallery, New Haven, *Josef Albers—Paintings, Prints, Projects,* April 25-June 18, 1956. Catalogue with text by George Heard Hamilton

> Michael Loew, "Albers: Impersonalization in Perfect Form," *Art News,* vol. 55, April 1956, pp. 27-29
>
> "Think," *Time,* June 18, 1956, pp. 80-83
>
> J. McHale, "Josef Albers," *Architectural Design,* June 1956, p. 205

Karl-Ernst-Osthaus-Museum, Hagen, West Germany, *Josef Albers,* January 20-February 17, 1957

> [Review], *Ruhr Nachrichten,* January 25 and February 16, 1957
>
> [Review], *Das Kunstwerk,* January-February 1957, p. 54
>
> [Review], *Werk und Zeit,* no. 2, 1957, pp. 2-3

Staatliche Werkkunstschule/Kunstsammlung Kassel, *Josef Albers,* May 28-June 8, 1957

Museum der Stadt, Ulm, West Germany, *Josef Albers,* September 8-October 6, 1957

> "Zeichnungen," *Werk,* vol. 44, September 1957, p. 171

Galerie Denise René, Paris, *Albers,* October-November 1957. Catalogue with texts by Jean Arp, Will Grohmann, Franz Roh and the artist

Kunstverein Freiburg im Breisgau, *Josef Albers,* March 16-April 13, 1958

> Ursula Binder-Hagelstange, "Farben machen Räume," *Frankfurter Allgemeine Zeitung,* March 25, 1958, p. 7

Sidney Janis Gallery, New York, *Albers, 70th Anniversary,* March 24-April 19, 1958

> Hilton Kramer, "Recent Paintings at the Sidney Janis Gallery," *Arts,* vol. 32, April 1958, pp. 52-53
>
> Bernard Chaet, "Color Is Magic: Interview with Josef Albers," *Arts,* vol. 32, May 1958, pp. 66-67

"Seventieth Birthday Celebrated with Show at Janis Gallery," *Art News*, vol. 57, May 1958, p. 12

Verkehrsverein, Bottrop, West Germany, *Albers*, May 19-27, 1958

Kunstverein Münster-Westfalen, 1958

Westfälisches Landesmuseum für Kunst und Kulturge-schichte Münster, *Josef Albers: Zur Verleihung des Conrad von Soest Preises*, January 10-February 7, 1959. Catalogue with texts by Anton Henze and the artist

Klaus Gruna, "Josef Albers erhielt den Conrad-von-Soest-Preis," *Westfälische Nachrichten*, January 18, 1959

[Review], *Westfalenspiegel*, vol. 8, February 1959, pp. 16-17

Museum am Ostwall, Dortmund, West Germany, *Josef Albers*, May 12-June 21, 1959

"Locarnese Albers-Ausstellung," *Werk*, vol. 46, October 1959, p. 219

Sidney Janis Gallery, New York, *Homage to the Square*, November 30-December 26, 1959

J[ames] S[chuyler] "Exhibition at the Janis Gallery," *Art News*, vol. 58, December 1959, p. 16

"Exhibition at the Janis Gallery," *Arts*, vol. 34, December 1959, p. 56

Galerie Suzanne Bollag, Zürich, *Josef Albers*, January 6-30, 1960

Margit Staber, "Josef Albers," *Schwabische Donau-Zeitung* (Ulm), January 14, 1960

G. Schmidt [review], *Werk*, vol. 47, March 1960, p. 50

Stedelijk Museum, Amsterdam, *Albers*, June-July 1961. Traveled to Gimpel Fils, London, July-August; Toninelli Arte Moderna, Milan, October-November; Galerie Charles Lienhard, Zürich, January 1962

Lief Sjöberg, "Fragen an Josef Albers," *Kunstwerk*, vol. 14, April 1961, pp. 55-59

Sidney Janis Gallery, New York, *Recent Paintings by Josef Albers*, October 2-28, 1961

Brian O'Doherty, "Dialectic of the Eye," *The New York Times*, October 3, 1961, p. 44

T[homas], B. H[ess], "Homage to the Square, the Nude," *Art News*, vol. 60, October 1961, pp. 26-27

North Carolina Museum of Art, Raleigh, *Josef Albers*, February 3-March 11, 1962. Catalogue with texts by Will Grohmann, Ben Williams and the artist

Pace Gallery, Boston, *Josef Albers at the Pace Gallery*, November 5-24, 1962

Edgar J. Driscoll, Jr., "This Week in the Art World," *The Boston Sunday Globe*, November 18, 1962, p. 60

Museum Folkwang, Essen, *Josef Albers*, February 6-March 3, 1963. Catalogue with statements by François Bucher, Jürgen Morschel, Margit Staber and the artist

Sidney Janis Gallery, New York, *Albers*, March 4-30, 1963

Dallas Museum of Fine Arts, *The Interaction of Color and Paintings by Josef Albers*, April 30-May 26, 1963. Traveled to San Francisco Museum of Art, June 3-30

Galerie Hybler, Copenhagen, 1963

Galerie Buren, Stockholm, *Josef Albers*, January-February 1964

Folke Edwards, "Det Elementära," *Stockholms-Tidningen*, February 1, 1964

Wilhelm-Morgner-Haus, Soest-Westfalen, West Germany, *Albers*, February 15-March 5, 1964

International Council, The Museum of Modern Art, New York (organizer), *Josef Albers: Homage to the Square*, Galleria Mendoza, Caracas, March 8-29, 1964; Centro de Artes y Letras, Montevideo, April 20-May 17; Instituto Torcuato di Tella, Buenos Aires, June 9-July 5; Instituto de Arte Contemporánea, Lima, September 14-October 11; Instituto Brasil-Estados Unidos, November 5-30; Museo de Arte Contemporánea, São Paulo, December 7-23; Casa de Cultura Ecuadoreana, Guayaquil, January 23-28, 1965; Ecuadorean-American Cultural Center, Quito, February 2-14; Bi-National Center, Bogota, February 23-March 18; Museo de Arte Contemporáneo, Santiago, April 4-20; Museo Universitario de Ciencias y Arte, Universidad Nacional Autónoma de Mexico, Mexico City, July 8-August 1; Dulin Gallery of Art, Knoxville, Tennessee, October 15-November 7; Huntington Galleries, West Virginia, November 19-December 12; The Rochester Memorial Art Gallery, New York, January 7-February 4, 1966; State University College, Oswego, New York, February 21-March 14; Atlanta Art Association, The High Museum, March 25-April 24; Marion Koogler McNay Art Institute, San Antonio, May 9-June 6; George Thomas Hunter Gallery of Art, Chattanooga, June 24-July 17; Walker Art Center, Minneapolis, August 14-September 18; Madison Art Center, Wisconsin, October 3-24; Virginia Museum of Fine Arts, Richmond, November 7-December 4; Wichita Art Museum, January 2-22, 1967. Catalogue with texts by Kynaston L. McShine and the artist

A. Otero, "Josef Albers en la Sala Mendoza," *Cal* (Caracas), vol. 29, April 18, 1964

Juan Acha "'El Homenaje al cuadrado' de Josef Albers," *Cultura Peruana*, October-December 1964, unpaginated

M. Neto, "Josef Albers or Homage to Purity," *Journal de Commercio* (Rio de Janeiro), November 8, 1964

Sidney Janis Gallery, New York, *Albers: Homage to the Square*, September 28-October 24, 1964

Emily Genauer, "'Cleansed Perceptions' of Hopper and Albers," *New York Herald Tribune*, October 4, 1964, p. 27

Stuart Preston, "A Square World," *The New York Times*, October 4, 1964, p. X-21

Galerie Gimpel & Hannover, Zürich, *Josef Albers: Homage to the Square*, June 23-August 7, 1965. Catalogue with texts by Margit Staber and the artist. Traveled to Gimpel Fils Gallery, London, September 1-October 2, 1965

The Washington Gallery of Modern Art, Washington, D.C., *Josef Albers: The American Years*, October 30-December 31, 1965. Catalogue with text by Gerald Nordland. Traveled to Isaac Delgado Museum of Art, New Orleans, January 23-February 27, 1966; San Francisco Museum of Art, June 2-26; Art Gallery, University of California, Santa Barbara, July 8-September 7; Rose Art Museum, Brandeis Univeristy, Waltham, Massachusetts, September 23-October 29

"Washington: Albers and the Current Generation," *Arts*, December 1965, pp. 34-35

Neil Welliver, "Albers on Albers" (interview), *Art News*, vol. 64, January 1966, pp. 48-51, 68-69

Alfred Frankenstein, "Homage to the Square," *San Francisco Chronicle*, May 31, 1966, p. 53

Galeria de Arte Mexicano, Mexico City, *Homenaje a Josef Albers*, August 9-September 7, 1966

Galerie Wilbrand, Münster, *Albers at Galerie Wilbrand*, March-April 1967

Galerie Denise René, Paris, *Albers*, March-April 1968. Catalogue with texts by Jean Clay and Max Imdahl

Guy Selz, "Deux Galeries rendent hommage au 'carré,'" *Elle*, April 4, 1968, p. 25

Sidney Janis Gallery, New York, *New Paintings by Josef Albers*, April 10-May 4, 1968

Westfälisches Landesmuseum für Kunst und Kulturgeschichte Münster, *Albers*, April 28-June 2, 1968. Catalogue with texts by Will Grohmann, Jürgen Wissmann and the artist. Traveled to Kunsthalle Basel, June 22-July 28; Overbeck Gesellschaft, Lübeck, West Germany, August 18-September 15; Badischer Kunstverein, Karlsruhe, September 29-October 25; Rheinisches Landesmuseum, Bonn, November 5-December 3; Villa Stuck, Munich; Kunstverein Berlin, January 15-February 5, 1969; *I Biennale*, Nürnberg; Sonja Henie-Niels Onstad

Foundation, Oslo; Kunsthalle Hamburg, January 29-March 1, 1970 (catalogue with texts by Kurd Asleben, Dietrich Helms, Werner Hofmann and Jürgen Wissmann); Kunstverein Munich

Hannes Peuckert, "Vergeistigtes Spiel mit Form und Farbe," *Westfalen-Blatt*, April 4, 1968

Hermann Lober, "Null Punkt für neue Ordnungen," *Münstersche Zeitung*, April 27, 1968

Ulrich Seelmann-Eggebert, "Der Alte Mann und das Quadrat," *Stuttgarter Nachrichten*, July 26, 1968, p. 8

Karl Strube, "Ein endloses meditatives Spiel," *Lübecker Nachrichten*, August 22, 1968

A.M., "Huldungen an ein Quadrat," *Münchner Kulturberichte*, December 16, 1968, p. 11

Galerie Thomas, Munich, *Look at Albers*, October 1969

Artestudio Macerata, Milan, *Albers*, March 1970

Städtische Kunsthalle Düsseldorf, *Josef Albers*, September 4-October 4, 1970. Catalogue with texts by Max Bill, Buckminster Fuller, Eugen Gomringer, Max Imdahl, Robert le Ricolais, Werner Spies and Jürgen Wissmann

Barbara Catoir, "Josef Albers' Works of Colour and Vexation Shown at Düsseldorf," *The German Tribune*, October 1, 1970

Sidney Janis Gallery, New York, *Paintings by Josef Albers*, October 5-31, 1970

Hilton Kramer, "Taeuber-Arp and Albers: Loyal Only to Art," *The New York Times*, October 18, 1970, p. D23

Princeton University Art Museum, *Josef Albers Paintings and Graphics, 1915-1970*, January 5-26, 1971. Catalogue with texts by Neil A. Chassman, Hugh M. Davies, Mary Laura Gibbs and Sam Hunter

Douglas Davis, "Man of a Thousand Squares," *Newsweek*, January 18, 1971, pp. 77-78

The Metropolitan Museum of Art, New York, *Josef Albers at The Metropolitan Museum of Art*, November 1971-January 11, 1972. Catalogue with text by Henry Geldzahler

Werner Spies, "Nach einem Wimpernschlag: Neues, fremdes," *Frankfurter Allgemeine Zeitung*, December 31, 1971, p. 22

Barbara Rose, "The Return of the Image," *Vogue*, January 17, 1972

Mark Strand, "Principles of Paradox, Josef Albers: Master Illusionist at the Metropolitan," *Saturday Review*, January 29, 1972, pp. 52-53

Pollock Gallery, Toronto, *Josef Albers*, September 28-October 20, 1972

Kestner-Gesellschaft, Hannover, *Josef Albers*, January 12-February 11, 1973. Catalogue with statements by Wieland Schmied and the artist

Rathaus der Stadt Bottrop, West Germany, *Albers in Bottrop*, March 18-April 15, 1973. Catalogue with text by Jürgen Wissmann

Galerie Beyeler, Basel, *Albers*, March-April 1973

Galerie Gmurzynska, Cologne, *Josef Albers*, September 12-October 25, 1973. Catalogue with texts in English and German by Tom Hess and Wieland Schmied

York University, Downsview, Ontario, *Homage to Josef Albers*, October 26-November 16, 1973. Catalogue with text by Michael Greenwood

Galerie Melki, Paris, *Albers*, November 13-December 8, 1973. Catalogue with texts by Max Imdahl, Karl Ruhrberg and Werner Spies

The American Academy and Institute of Arts and Letters, New York, *Josef Albers, Leonid Burman, Mark Tobey*, March 14-April 30, 1977

Yale University Art Gallery, New Haven, *Albers*, February 22-March 26, 1978. Catalogue with texts by Gene Baro, Fronia Wissmann and the artist

Galerie Christel, Stockholm, *Albers-Paintings*, January-February 1980

Moderne Galerie, Bottrop, West Germany, *Josef Albers: Werke aus dem Besitz der Stadt Bottrop*, December 17, 1980-February 6, 1981

Montclair Art Museum, New Jersey, *Josef Albers: His Art and His Influence*, November 15, 1981-January 17, 1982. Catalogue with texts by Nicholas Fox Weber and Alan Shestack, and statements by several of Albers's former students, including Richard Anuskiewicz, William Bailey, Kent Bloomer, Robert Engman, Erwin Hauer, Richard Lytle, Stephanie Scuris, Robert Slutzky, Julian Stanczak and Neil Welliver

 David L. Shirey, "The Many Legacies of Josef Albers," *The New York Times*, January 10, 1982, p. XI-26

Goethe House, New York, *Josef Albers: Graphics and Paintings*, May 3-June 11, 1983

Sidney Janis Gallery, New York, *Paintings by Albers*, October 4-November 3, 1984. Catalogue with text by Nicholas Fox Weber

 Vivien Raynor [review], *The New York Times*, October 19, 1984, p. III-30

Margo Leavin Gallery, Los Angeles, *Josef Albers*, January 8-February 9, 1985

 Suzanne Muchnic [review], *The Los Angeles Times*, January 18, 1985, p. IV-16

Gimpel Fils Gallery, London, *Josef Albers: Homage to the Square*, May 8-June 1, 1985

 Paul Overy, "Josef Albers," *Art Monthly*, no. 87, June 1985, pp. 8-9

Sidney Janis Gallery, New York, *Works in All Media by Albers*, February 1-March 8, 1986. Catalogue with text by Kelly Feeney

 Vivien Raynor [review], *The New York Times*, February 28, 1986, p. III-21

 Eric Gibson, "Josef Albers: In the Engine Room of Modern Art," *The New Criterion*, vol. 4, April 1986, pp. 34-41

Satani Gallery, Tokyo, *Josef Albers: Homage to the Square*, April 4-26, 1986

Galerie Hans Strelow, Düsseldorf, *Josef Albers: Homage to the Square, Bilder aus dem Nachlass*, February 19-March 28, 1987

Galerie Denise René, Paris, *Albers*, May 14-July 15, 1987

 Daniel Dobbels, "Albers carrément bon," *Libération*, June 26, 1987, p. 26

 Annick Pély-Audan, "Hommage au carré: Albers ou l'ambiguïté," *Cimaise, Art Actuel*, Summer 1987, pp. 99-100

The American Federation of Arts, New York (organizer), *The Photographs of Josef Albers: A Selection from the Collection of The Josef Albers Foundation*, The Mary and Leigh Block Gallery, Northwestern University, Evanston, Illinois, June 15-August 9, 1987; Des Moines Art Center, August 23-October 18; Allen Memorial Art Museum, Oberlin College, Ohio, November 8, 1987-January 3, 1988; The Museum of Modern Art, New York, January 27-April 5; The Denver Art Museum, July 24-September 18; The Montreal Museum of Fine Arts, January 8-March 5, 1989; The Milwaukee Art Museum, March 26-May 21. Catalogue with text by John Szarkowski

The bibliographical and biographical sections of this catalogue were compiled by Kelly Feeney and Nicholas Fox Weber of The Josef Albers Foundation. They acknowledge the following sources in particular:

 Josef Albers, Gene Baro and Fronia Wissmann, *Albers*, exh. cat., New Haven, Yale University Art Gallery, 1978

 Irving Leonard Finkelstein, *The Life and Art of Josef Albers* (Ph.D. dissertation, New York University, 1968), microfilm, Ann Arbor, Michigan, University Microfilms International, 1979

 Neal D. Benezra, *The Murals and Sculpture of Josef Albers*, New York and London, Garland Publishing, Inc., Outstanding Dissertations in the Fine Arts, 1985

Photographic Credits

The Solomon R. Guggenheim Foundation

EXHIBITION 88/1

4,000 copies of this catalogue,

designed by Malcolm Grear Designers and

typeset by Schooley Graphics/Craftsman Type,

have been printed by Eastern Press

in February 1988 for the

Trustees of The Solomon R. Guggenheim Foundation

on the occasion of the exhibition

Josef Albers: A Retrospective.

4,000 hardcover copies have been printed

for Harry N. Abrams, Inc., Publishers, New York

Schmitt